VOID

D0907446

NN 959357

Welcome to
BODY ART 3

It has been an exciting time for body art, with the development of cutting-edge techniques and new icons. Join us in celebrating its advances

CONTRIBUTORS

PICTURES: STEVE NEAVES, ABBIE TRAYLER-SMITH

MARK BERRY
Mark hails from Bristol, UK, but now lives in LA snapping weird photo features for *Bizarre*.

Hot-cherry.co.uk

ABBIE TRAYLER-SMITH
Abbie is a multi-award winning photographer based in London, UK.

Abbietraylersmith.com

REGIS HERTRICH
Regis is a London-based photographer who shoots bands, performances and freak shows.

Cremaster.org.uk

JOHN STONE
John is an Australian photographer in Japan, focusing on youth culture in Tokyo.

mail@joncojp.com

BODY ART 3
Contents

FEATURES

From ears grown on arms and faces that look like donuts, to 3-D and pixel tattoos – we've got the best new body art discoveries covered…

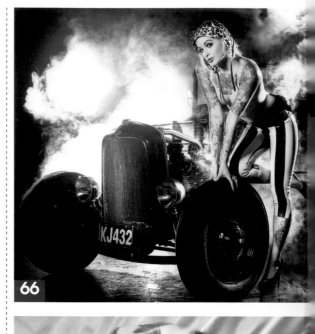

66

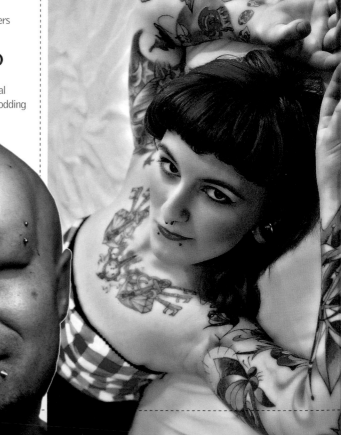

PICTURES: JOHN STONE; STEVE NEAVES; MARK BERRY; MARIO ROSENAU

Contents

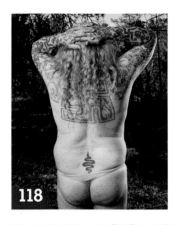

118

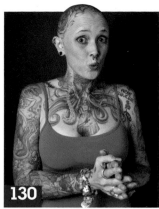

130

INKED ICONS

We get under the skin of some of the biggest personalities in body modification and introduce you to its brightest new stars


24 LA NEGRA
This feisty Argentinian has horns in her head and passion in her heart

66 MAUREEN VAN MORTIS
She wears her life story on her skin – meet the new Queen Of Ink

92 THE SCARY GUY
The tattooist-turned-motivational speaker is coming to get you

118 MANWOMAN
Covered in swastikas and convinced he's both genders, he's a man on a mission for peace

130 JINXI BOO
She's a modded mum who's living her life to the full


Mod Fact

Look for the tattoo and piercing trivia scattered throughout this book, to learn about body mods in the past and present

YOUR TATTOOS

From evil faces to sexy pin-up girls, a selection of the best tattoos sent in to the pages of *Bizarre*


18 **SKULLS**
30 **ANIMALS**
46 **FANTASY**
60 **GIRLS**
72 **LETTERING**
86 **HORROR**
98 **FLOWERS**
112 **THE REST**
124 **YOUR MODS**


BODY MOD MASTERCLASS

Our guides to the most exciting procedures in the body mod world


22 **3-D TATTOOS**
34 **FINGER PIERCING**
50 **BRANDING**
64 **EYEBROW REMOVAL**
76 **PIXEL TATTOOS**
90 **PRISON TATTOOS**
102 **NIPPLE REMOVAL**
116 **SURREAL TATTOOS**
128 **BLACK LIGHT TATTOOS**
144 **EAR LOBE RECONSTRUCTION**


BODY ART 3

EDITORIAL
Editor Eleanor Goodman
Deputy Editor Kate Hodges
Senior Writer Denise Stanborough
Staff Writer Alix Fox

ART
Art Director Roelof Bakker
Art Director At Large Dave Kelsall
Picture Editor Emily McBean
Bizarra Archive Tom Broadbent

COVER PHOTOS
Steve Neaves, Martin De Pozo and Eduardo Baez Arias, Maria Rosenau, John Stone

CONTRIBUTORS
Photos: Adam at Bodymod.org, Boucherie Moderne, Mark Berry, Adam Futcher, Steve Haworth, Regis Hertrich, Zen Inoya, Lane Jenson, Lars Krutak, Shannon Larratt, Nora Lezano, Steve Neaves, Joe Plimmer, Martin De Pozo and Eduardo Baez Arias, Mario Rosenau, John Stone, Richie Streate, Abbie Trayler-Smith, Lukas Zpira
Words: Stephen Daultrey, Maki, Emma Mendes da Costa (Mod Facts), Ben Myers, Pete Newstead
Special thanks: Darren Brooke, Dave Kinnard, Katie Brooke (repro superstars); David McComb


We occasionally use material we believe has been placed in the public domain. Sometimes it is not possible to identify and contact the copyright holder. If you claim ownership of something we have published, we will be pleased to make a proper acknowledgement. All letters received are assumed to be for publication unless otherwise stated. *Bizarre* cannot be held responsible for unsolicited contributions.


ISBN: 9780857680822

Published by Titan Books
A division of Titan Publishing Group Ltd
144 Southwark St
London SE1 0UP

First Titan edition: March 2012
10 9 8 7 6 5 4 3 2 1

Body Art 3 copyright © 2012 Dennis Publishing


This book is published under license from and with permission of Dennis Publishing Limited. All rights in the material and the title trademark of this magazine belong to Dennis Publishing Limited absolutely and may not be reproduced, whether in whole or in part, without prior written consent.


Did you enjoy this book? We love to hear from our readers. Please e-mail us at: **readerfeedback@titanemail.com** or write to Reader Feedback at the above address.
To receive advance information, news, competitions, and exclusive offers online, please sign up for the Titan newsletter on our website: **www.titanbooks.com**


No part of this publication may be reproduced, stored in a retrieval system, or transmitted, in any form or by any means without the prior written permission of the publisher, nor be otherwise circulated in any form of binding or cover other than that in which it is published and without a similar condition being imposed on the subsequent purchaser.


A CIP catalogue record for this title is available from the British Library. Printed in China.

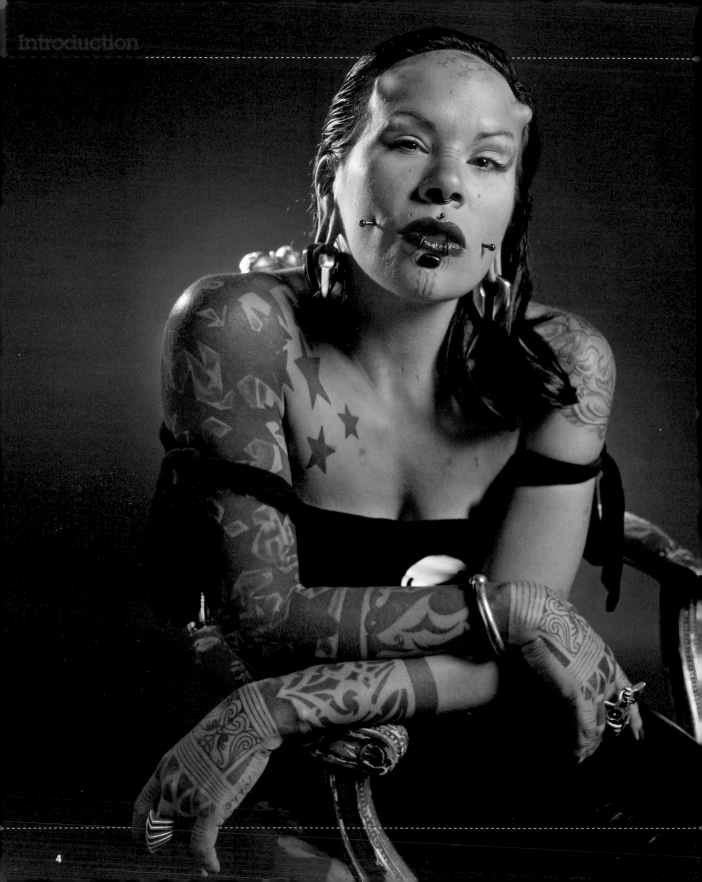

NEW BLOOD

Since *Body Art 2*, we've seen loads of exciting mod advances, from new techniques such as 3-D tattoos, to inked icons who are changing the world with a flash of their tatts or shining piercings. Here are the developments that have blown our minds…

INKED ICON **The Scary Guy** MOD MASTERCLASS **3-D Tattoos** FEATURE **Ultra Vixen Tattoos**

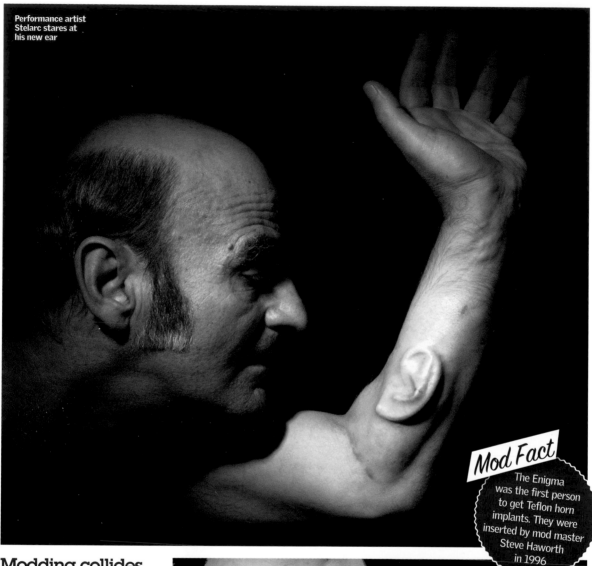

Performance artist Stelarc stares at his new ear

Modding collides with technology

Want a vibrating cock? Samppa Von Cyborg is making it a reality with help from academics, while performance artist Stelarc is having surgery to grow an ear on his arm. When the modding community and scientists work together, the results are like sci-fi movie inventions. **See them on p42.**

See them on p42.

Mod Fact

The Enigma was the first person to get Teflon horn implants. They were inserted by mod master Steve Haworth in 1996

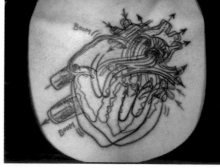

3-D tattoos

Using red and blue outlines, mod pioneer Jef from Boucherie Moderne Salon in Belgium has worked out how to create 3-D and animated tattoos. If the viewer moves sheets of acetate over his images or looks through 3-D glasses, they'll see them spring to life. Watch a pair of scissors cutting and a heart beating on p22.

Watch a pair of scissors cutting and a heart beating on p22.

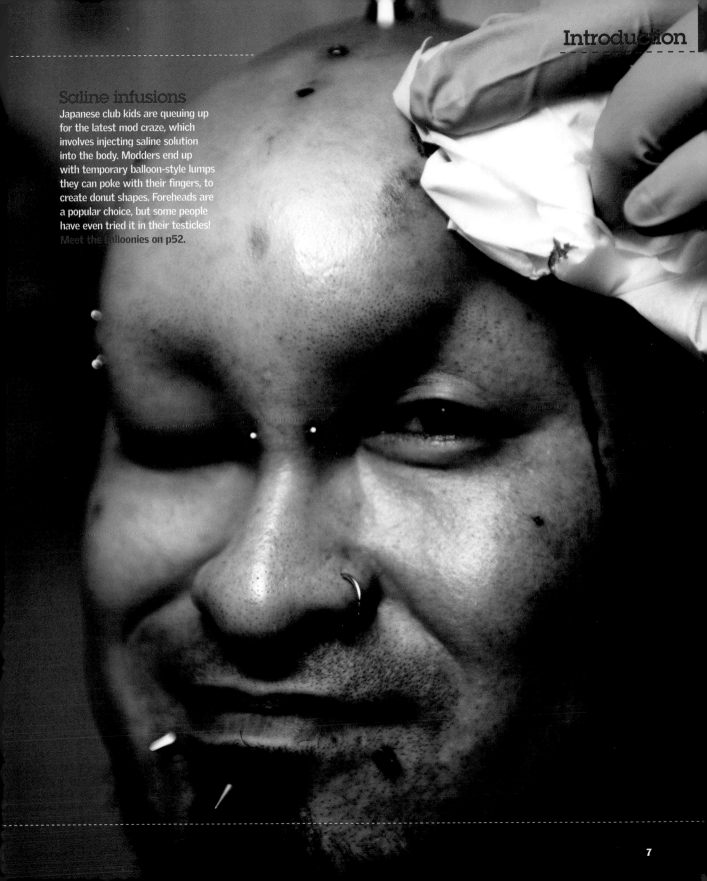

Saline infusions

Japanese club kids are queuing up for the latest mod craze, which involves injecting saline solution into the body. Modders end up with temporary balloon-style lumps they can poke with their fingers, to create donut shapes. Foreheads are a popular choice, but some people have even tried it in their testicles! Meet the balloonies on p52.

Introduction

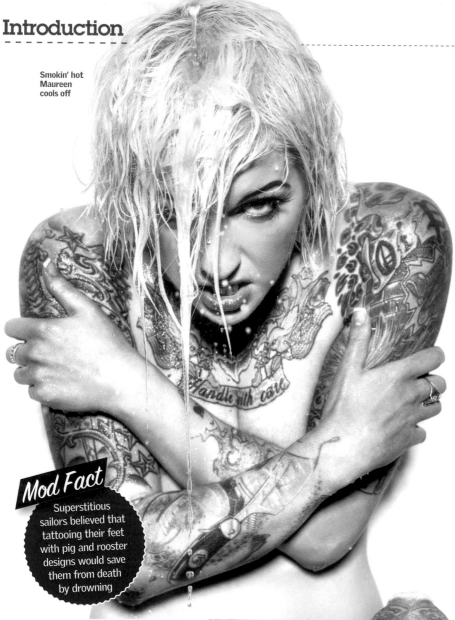

Smokin' hot
Maureen
cools off

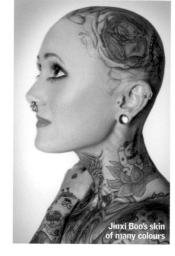

Jinxi Boo's skin
of many colours

Wild women

Joining the ranks of Kat Von D and
Isobel Varley are our new female
inked icons. Queen Of Ink Maureen
Van Mortis wears her life story
on her skin (**p66**), vegan mother
Jinxi Boo has championed body
modification on US *Wife Swap*
(**p130**), while horned goddess
La Negra has helped spread the
mod gospel in Argentina (**p24**).

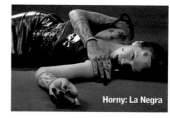

Horny: La Negra

Mod Fact

Superstitious
sailors believed that
tattooing their feet
with pig and rooster
designs would save
them from death
by drowning

The Scary Guy

He might look scary, but this man
calls himself, "the new face of love
worldwide". Born as Earl Kenneth
Kaufmann in 1953, he changed his
name to The Scary Guy ten years
ago and is now a public speaker
who's talked to over seven million
people about tolerance. A former
tattooist, he now tattoos "the hearts
and minds of millions of people".
Meet him on p92.

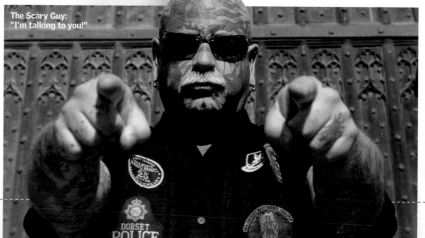

The Scary Guy:
"I'm talking to you!"

Only a handful of artists can rightly be considered body mod pioneers. Meet the...

METAL GURUS

WORDS **BEN MYERS**

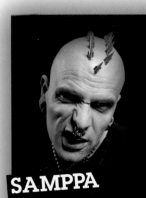

SAMPPA

As inventor of Mad Max Bars and leader of performance group the Psycho Cyborgs, Samppa knows his mods

STEVE

Anyone and everyone cites Steve as an influence, thanks to his work in ear pointing, laser branding and 3-D art

SHANNON

Founder of modding community BMEzine.com, Shannon's allowed an exchange of ideas, and seen every development

LUKAS

An intellectual who turned to modding after a career in art, Lukas is driven by the idea of changing the body beyond evolution

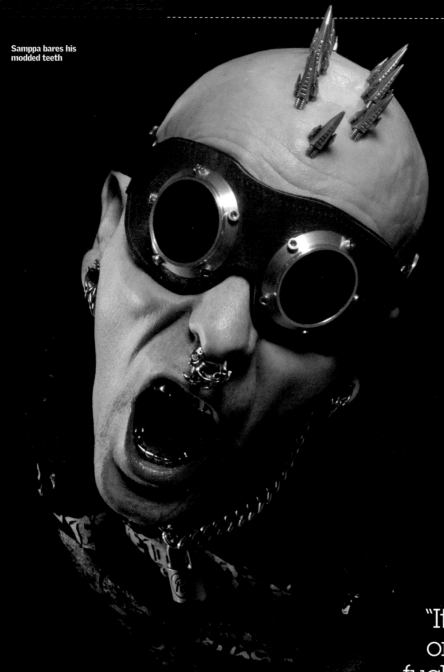

Samppa bares his
modded teeth

"It'd only take
one person to
fuck up a body
modification and
it'd be spoiled
for all of us"

SAMPPA
VON CYBORG

Real-life cyborg with metal coming out of his head

Born in Finland and based in London, UK, Samppa Von Cyborg is one of the most recognisable faces in extreme body modification. He invented flesh coils, flesh stapling, navel pocketing and Mad Max Bars – and performs body mods as founder of performance group Psycho Cyborgs. Samppa also designs jewellery and band merchandise, and is working on top-secret projects that'll push the body mod envelope even further.

When did you move from conventional mods, such as piercings, to more extreme interests?
I started piercing professionally in 1990 – I was one of the first in Finland. After a while I got bored with it because nothing was really happening with body modification. Then in 1998 the internet allowed for a greater exchange of information. I started making my own jewellery and, around 1999, I created multiple surface piercing and the Mad Max Bar (a long piece of zigzag-shaped steel that weaves under the skin's surface and out again). Actually, Brian Decker in New York was the first, but I modified the process.

You also pioneered flesh stapling.
Yeah – it was a development of 'pocketing'. Pocketing is when a straight bar is inserted under the surface of the skin, but it created too much pressure on the skin and would often be rejected. I decided to create a whole *new* fucking idea for them instead! That was in 2000.

How does flesh stapling work?
It's basically like a staple – jewellery used in pocketing is straight, but in flesh stapling the ends of the piece of jewellery are bent and go under the skin to hold the mod in place, and the centre of the jewellery is visible above the skin. Like all piercings, it should work on most body parts if it's done properly. The problem was, people started copying me but not doing it properly. That's the downside of the internet. When I saw what some people were doing with flesh stapling, I was like, "Fucking hell, that looks so shit!"

Can the internet be blamed when mods go wrong?
Sometimes, because the internet is full of inaccurate information that people assume is fact. I've stopped posting film clips of my body work now, because I want

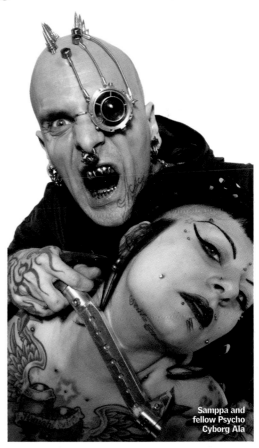

Samppa and fellow Psycho Cyborg Ala

no part in those mistakes. You know, it'd only take one person to really badly fuck up a body modification, and it'd be spoiled for all of us.

Who else do you rate in the body mod world?
Steve Haworth is the father of modern extreme body modification and a true pioneer. Brian Decker's a very clever guy, Ryan Ouelette in New Hampshire is one of the best scarification artists, while Quentin at Kalima in Worthing, UK, is sensible and well-informed. Lukas Zpira really took scarification to the next level and is clever too – like all of us old school artists! →

PICTURES: JOE PLUMMER

STEVE HAWORTH

The ultimate pioneer and a truly dedicated artist

From a family of medical device pioneers, Steve Haworth has been inventing mods such as ear pointing and laser branding since 1990. In 1994 he created the concept of implanting steel beneath skin to create 3-D body art, which led to the surface bar, subdermal implants and the fantastic metal mohawk. In 1999 he made it into *Guinness World Records* as the "world's most advanced body modification artist".

Steve retired from piercing in 2005 but continues to innovate via his two companies – Kaos Softwear for silicone body jewellery and New Hole for piercing products. "The only people whose opinion I care about are the people in the body mod community," he told Bmezine.com. "My art is about extreme individualism."

Bmezine.com founder Shannon Larratt credits Steve with kick-starting the scene as we know it: "One could make the argument that Steve Haworth birthed the entire modern body modification community – before him there was simply piercing, scarification, and tattooing – all merely modern implementations of traditional art forms. In fact, Steve Haworth's development of '3-D art' implants is the single most significant thing to happen to body modification in the last 5,000 years."

His influence is pervasive – Samppa Von Cyborg says Steve inspired him to be an artist: "He's the most important, most respected body modder out there." →

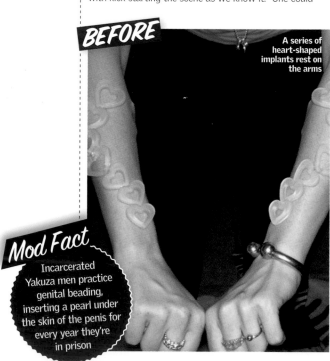

BEFORE

A series of heart-shaped implants rest on the arms

Mod Fact

Incarcerated Yakuza men practice genital beading, inserting a pearl under the skin of the penis for every year they're in prison

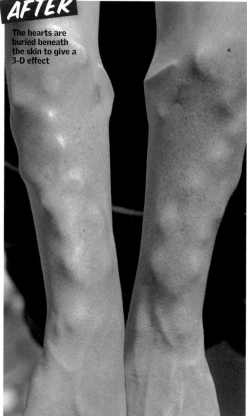

AFTER

The hearts are buried beneath the skin to give a 3-D effect

PICTURES: STEVE HAWORTH

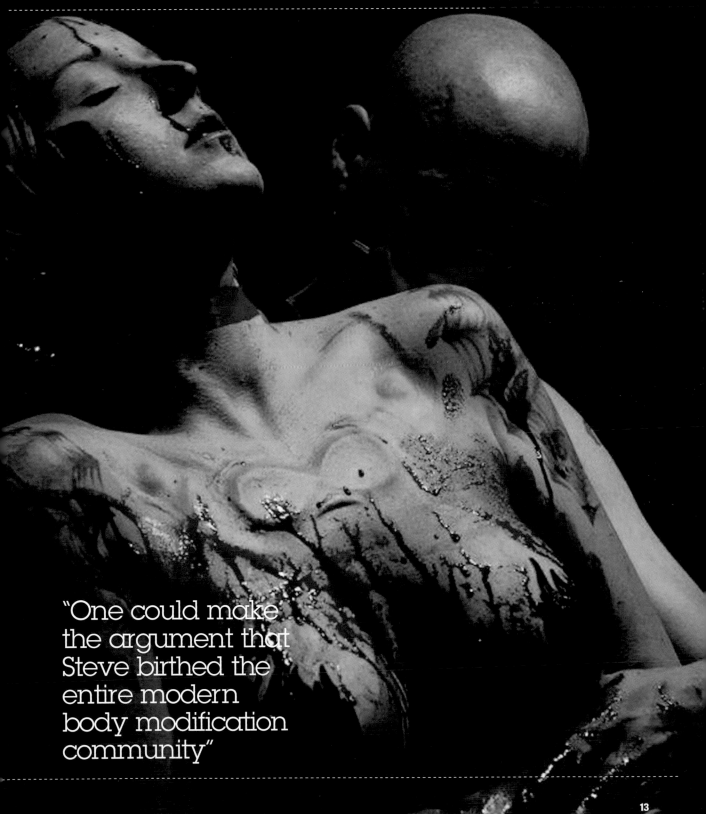

"One could make the argument that Steve birthed the entire modern body modification community"

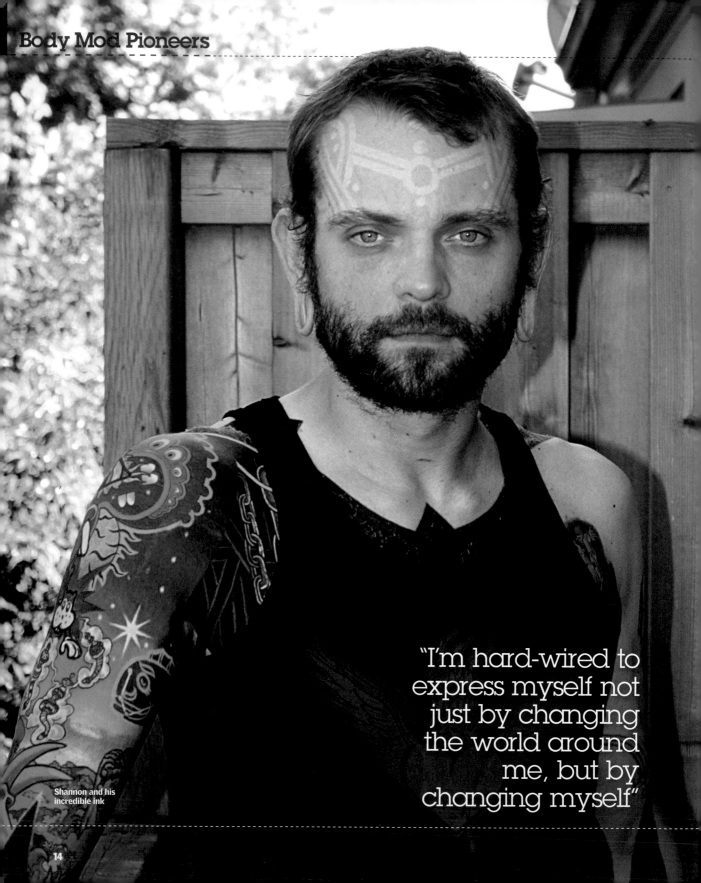

Shannon and his incredible ink

"I'm hard-wired to express myself not just by changing the world around me, but by changing myself"

SHANNON LARRATT

Founder of the body mod scene's biggest website

Shannon Larratt is not a body mod artist, but as founder of Body Modification Ezine (BMEzine.com) he's responsible for bringing together a disparate community and providing *the* authoritative meeting place for those interested in the scene. Shannon is working on a number of books, including one on male genital modification.

What drew you to body modification?
Instinct – something deep inside. I'm hard-wired to express myself not just by changing the world around me, but by changing myself physically as well. This instinct involved both ritual – temporary and experiential body play – and permanent body modification. It manifested itself when I started play-piercing myself (using needles without inserting jewellery) aged 10, and then doing scarification, long-term piercings, and DIY tattoos at 15. I never felt a connection to a body mod 'world' because I was just a kid living on a farm in rural Ontario, Canada, and even in the city, tattoo studios were rare. It wasn't until I was much older that I understood that other people had the same drives.

When and why did you set up BMEzine.com?
I set it up in 1994. Talking to other people into body modification was the main reason I got online, via the Usenet news group Rec.arts.bodyart. As the internet got bigger, I set up a site that had pictures and stories about my own body mods, with a note along the lines of, "If you'd like to share your experiences, please send them to me and I'll post them". Almost immediately, the site grew to immense proportions. I was at the right place at the right time I guess, and BMzine.com and the community grew together, each pushing the other along.

Who are the pioneers of the body mod world?
Not to downplay the many brilliant body artists working today – at no point in human history have we seen anything like this – but for the last half-decade body modification has been relatively stable, without any major developments. So I don't really think there are any 'pioneers' these days.

What are you working on right now?
I'm working on book projects, so I'm not doing any web projects right now, nor am I even blogging about body mods. But I think it's safe to say that when this period's up, I'll take a serious look at starting a new site. →

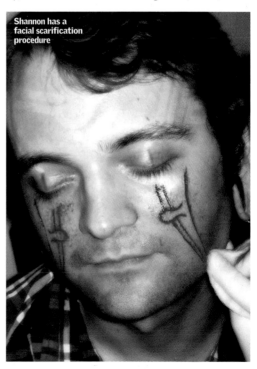

Shannon has a facial scarification procedure

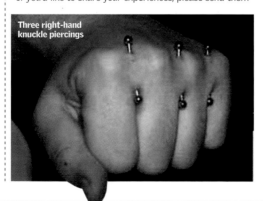

Three right-hand knuckle piercings

LUKAS ZPIRA

Body artist and scarification king

Lukas Zpira is a rarity in the body mod scene. He began his career as a fine artist influenced by Dadaism and Surrealism, but in 1992 at age 25 he reinvented himself as a body mod artist. His work has spanned a range of disciplines, from running France's first body mod studio Body Art/Weird Faktory in the 1990s to suspension, scarification and rope bondage performances with his wife Satomi. He coined the term 'body hacktivism' to describe his form of evolutionary experimentation.

What inspired you to make the leap from fine art to body mods?
Necessity! I entered the traditional art world because I had something to express. I began without any academic knowledge and spent many years experimenting with various media, but after a while I felt I'd reached the limit and needed to move on. The idea of using the body came to me at that time. The Viennese Actionists (transgressive 1960s art movement) had used the body in their performances, but the field remained relatively unexplored. Expressing oneself through this medium feels strong – aesthetically, morally and politically.

Was the first body modification you undertook a life-changing experience?
I got my first implants in 1996. It was a step that let me develop concepts concerning mutation and, by such transformations, try to modify the image we have of ourselves, our potential and our future. So, yes!

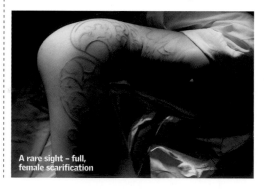

A rare sight – full, female scarification

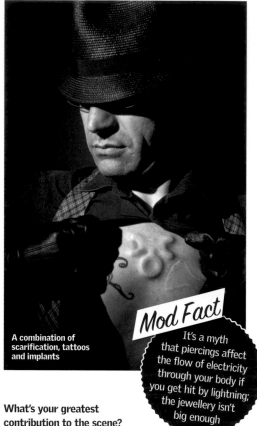

A combination of scarification, tattoos and implants

Mod Fact
It's a myth that piercings affect the flow of electricity through your body if you get hit by lightning; the jewellery isn't big enough

What's your greatest contribution to the scene?
Scarification. When I started I had no idea what was being done by my peers and, using my artistic background, I was able to do more complex, graphic pieces as opposed to the more 'normal', basic, simple lines and shapes found in scarifications of that period. I also began to research alternative healing techniques – which have become today's standard aftercare. Before that, people used to scratch their scabs with toothbrushes! I'm also proud of my 'transformation' – body mod work that I call 'body hacking'. But I think my biggest contribution is still to come.

Your essay, *Putting An End To Baudrillard*, says your greatest creation is actually 'Lukas Zpira'...
Maybe, but *you* said it – this way, for once, nobody can accuse me of being arrogant! I love this text but unfortunately I don't think many people understood it. I'm not that inspired by the body mod scene and the whole anthropological speech kinda bores me. I get a lot more out of a Barbara Kruger piece that says, 'Our body is a battleground' than from someone telling me how to rip off such-and-such tribe's heritage. Ⓑ

PICTURES: ZEN INOYA, LUKAS ZPIRA

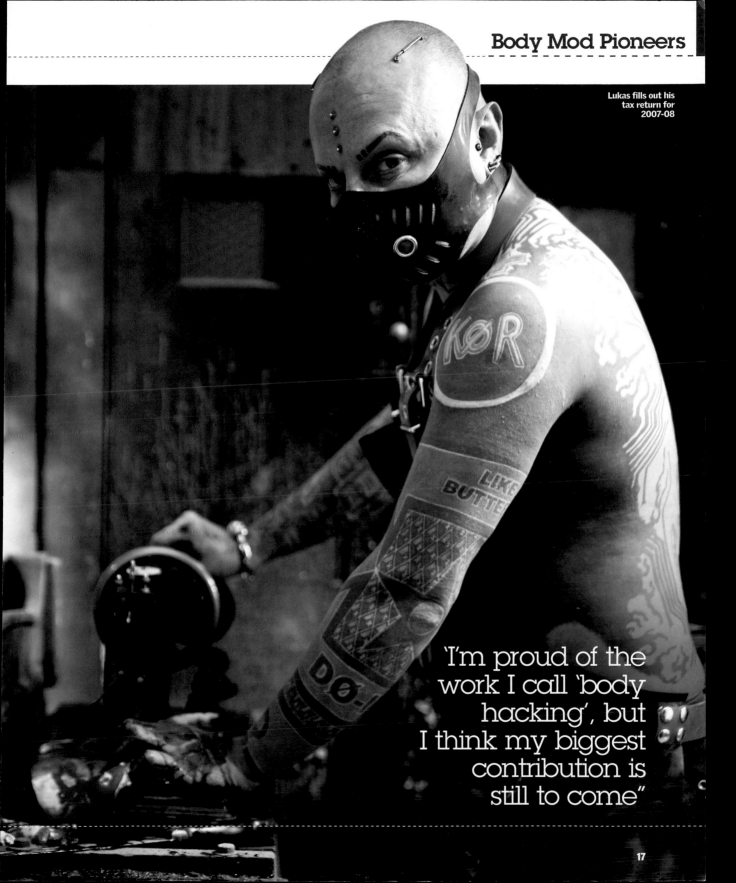

Lukas fills out his
tax return for
2007-08

'I'm proud of the
work I call 'body
hacking', but
I think my biggest
contribution is
still to come"

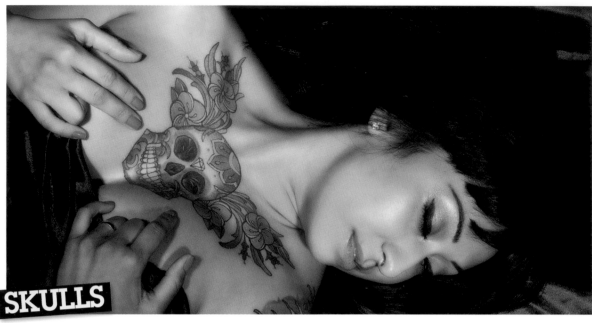

SKULLS

The symbol of death is always popular

ALIVYA V FREE

Tattoo by Steve Lyons, Blue Banana, Lincoln, UK

What is it? Three skulls.
Why did you choose it?
Because it's bold, awesome and unique – it was designed by an old friend of mine.
What response do you get from people?
They usually agree with me, which means it must be good!
What does your family think about it?
They're OK now, but were a bit worried that it'd affect my modelling.
Would you change or add anything?
Nope. Well, maybe some UV ink for fun.

LAUREN MCINTYRE

Tattoo by Guy Tinsley, Mad Creature Creations, Rotherham, UK

What is it? Two skull and crossbones. The first one is a female skull on my right leg and the second is a male skull on my left leg (right).
Why did you choose it?
I've always been really fascinated by the human skeleton. I got the first to celebrate completing my Masters Degree in human osteology.
Have you got more ink planned? I'm just in the process of having some large, black wings inked on my back. I might have another skull between them.

HENRY 'SWAMPY' MOORE
Tattoo by himself

GLEN
Tattoo by Carmine Morgano, First Class Tattooing, New Jersey, USA

What is it? An *Evil Dead* skull.
Why did you choose it? Because it looks cool!
What response do you get from people? "That looks sick," pretty much covers it.
What does your family think about it? They like it. What they complained about is that I tattooed myself.
What do you like about having it? Tattoos can have meaning but they don't have to, and no one can steal them.

What is it? The skull and cross bolts. It's the Death By Stereo band logo.
What response do you get from people? A positive one, especially from other fans.
What does your family think about it? My older brother and mum hate it.
Have you got any more ink planned? I want a sleeve on my right arm, starting with a Gallen Priory Cross to emphasise how Christians have co-opted pagan traditions in order to rake people in.

LEIGH SHELTON
Tattoo by himself

What is it? An evil skull.
Why did you choose it? I guess I'm drawn to evil skull-type things! I wanted one done but I was really skint at the time, so I did it myself with a stencil.
How do you feel about it now? I think it's my best work as it was the hardest to do. Tattooing the back of your own calf gives you a very strange sensation, let me tell you. You're the one making the pain but also the recipient of it. At least I could stop working on it when I wanted to!

JENNIFER NOEL TELLO

Tattoo by Rene, Red Skull Tattoo, El Paso, Texas, USA

What is it? A skull with flowers on the side.
Why did you choose it? I got divorced so I was finally free to do what I wanted. It was a new beginning for me.
What response do you get from people? Staring and judgements!
How do you feel about it now? I've had to cover it up for work and it's a commitment, but I don't mind.
Would you change or add anything? No, nothing! Getting my tattoos has helped me to accept who I am.

BONNIE BONES

Tattoo by Joao Bosco, Self Sacrifice, London, UK

What is it? A skull plus a cobweb.
Why did you choose it? I wanted to get it to remind me that life is uncertain and could end unexpectedly soon.
What does your family think about it? My mum cried! She doesn't like skulls.
What do you like about having it? My tattoos remind me of a certain period of my life. As Hannibal Lecter said in *Red Dragon*, "Our scars have the power to remind us that the past was real."

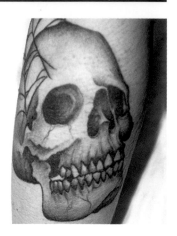

POLLY PHLUID

Tattoo by Steve, Scorpio Tattoo, Selby, UK

What is it? It's a female and male symbol around a skull, with an Adam Ant-style cross and heart make-up, and a 'P' symbol inside.
Why did you choose it? It's the logo of a band I was in for 11 years.
What response do you get from people? "Ow, I bet that hurt!", which it did! The ribs are a daft place to have ink, but it was worth it.
How do you feel about it now? It's a record of a chunk of my life. When I see it, I think about the band and smile.

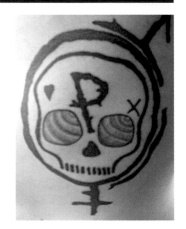

JESS JADE VOGEL

Tattoo by Duncan Letts, South Africa

What is it? It's part of an overall work – my collective impression of a fantasy garden.
Why did you choose it? I've always been fascinated with nature and the beauty that lies in creation.
What response do you get from people? Once, this old guy came up to me and kissed it!
What do you like about having it? That it's mainly my design. I love the way all my concepts fit together, creating my own trippy little garden story...

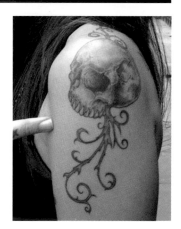

EMILY J SCHONEMAN

Tattoo by Adam Williams, Theory Tattoo, Everett, Washington, USA

What is it? A death lily.
Why did you choose it? I needed to cover up a tiny heart tattoo that I had done when I was 15. I saw this image on a comicbook cover.
What does your family think about it? They'd like me to stop smoking pot before I make these decisions.
Have you got any more ink planned? I'm also going to get a lotus flower for my daughter and I've just joined a roller derby team, so I'm sure I'll get one associated with that.

JOHN SCARFF

Tattoo by Kev, Kev's Ink Fix Tattoo, Hadleigh, Essex, UK

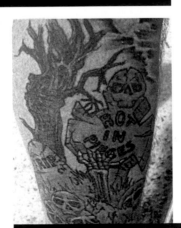

What Is it? A graveyard, on my leg.
Why did you choose it? I had it done a few years ago to celebrate my divorce! The words 'Rot In Pieces' are dedicated to my ex-wife and her initials are on one of the headstones. Not that I'm bitter about it all! It made me feel better.
What response do you get from people? People look at me oddly, and don't know what to say when I explain the meaning behind it. I sent a picture to my ex-wife but she didn't like it.

JUSTIN WADMORE

Tattoo by Howard Lee, Droylsden Tattoo, Manchester, UK

What is it? Skull and wings surrounding a Celtic cross.
Why did you choose it? I wanted an existing tattoo improved, and saw something similar to this in one of Howard's books.
What does your family think about it? My dad and brother think it's fantastic, but my mum doesn't like it.
Would you change or add anything? Yeah, I think it'd look brilliant with some more smoke and skulls.
What do you like about having it? It looks cool!

"I got an existing tattoo improved with a skull and a pair of wings"

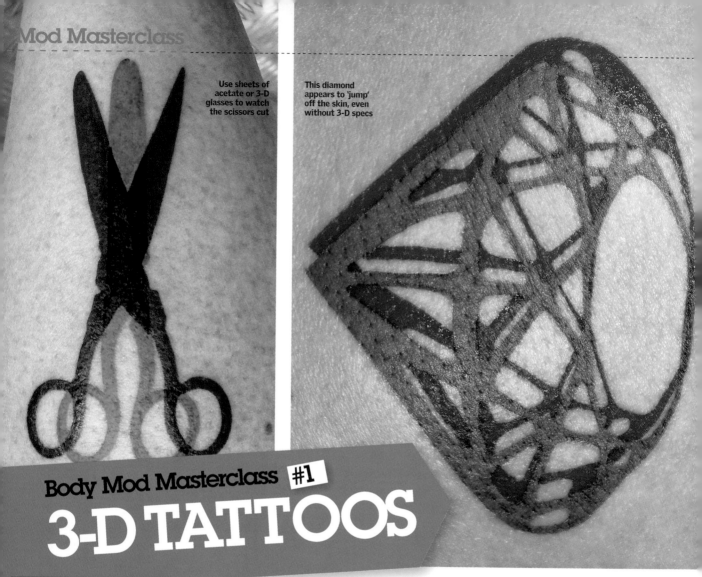

Use sheets of acetate or 3-D glasses to watch the scissors cut

This diamond appears to 'jump' off the skin, even without 3-D specs

Body Mod Masterclass #1
3-D TATTOOS

IMPORTANT!
DON'T TRY THIS AT HOME

IT'S DANGEROUS! IF YOU WANT TO MODIFY YOUR BODY IN ANY WAY, SPEAK TO A PRO

When tattoo flash looks like flash animation

Can you imagine having a tattoo that looks as though it's moving? Tattoo artist Jean-François Palumbo – AKA Jef – can. He works at the Boucherie Moderne Salon in Brussels, Belgium, and came up with the idea of an animated tattoo when he remembered some picture cards that came free with a brand of yoghurts he loved as a child. The images on the cards changed when he moved them from side to side, as if an unexplainable force was at work. "As a kid it seemed magical, and I wanted to transfer some of that magic to someone's skin," he explains.

The first designs he came up with were a pair of scissors and an anatomical heart. When you switch sheets of blue and red acetate over the top of them – or wear 3-D glasses and wink alternate eyes – the

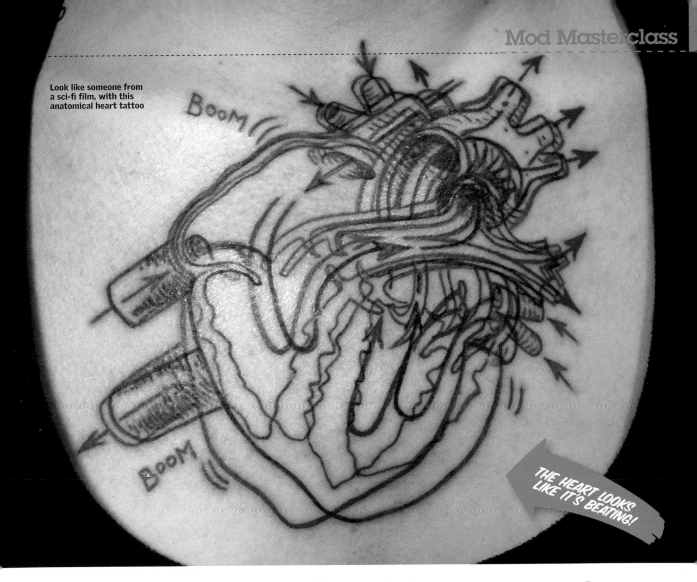

Look like someone from a sci-fi film, with this anatomical heart tattoo

BOOM

BOOM

THE HEART LOOKS LIKE IT'S BEATING!

pictures jump to life: the scissors snip-snip-snip, and the heart boom-boom-booms. The colours of the ink have to match the acetate for the illusion to work, though. Jef used Premium Inks, which contain lots of fine pigment, and tested out different hues with tattoos he was already working on to pinpoint the precise shades he needed. For example, he trialled red inks while he was inking a commission of a tiny bunch of roses. He also experimented with illustrations by making sketches and then manipulating them on a computer to see what'd look most effective.

The diamond design uses the same blue and red shades, but to different effect. Put on a pair of 3-D glasses and the stone looks as though it's jumping out at you. In fact, this 3-D optical illusion works to some extent without the specs.

The pictures move when you wear 3-D glasses and wink alternate eyes

Jef's now planning even more advanced animated and 3-D tattoos. "I'd like to create something more complex in my next tattoo," he says. "Fish that appear to be swimming beneath a 3-D layer of water, an alarm clock design that moves to show different hours, or a hand that shifts between a peace sign and a raised middle finger."

The last idea might be insulting if viewed from the wrong angle, but at least you could take comfort in the fact it'd be gone in the blink of an eye. ⑬

PICTURES: BOUCHERIE MODERNE.BE

La Negra

This Argentinian devil has her
horn-implanted head screwed on
when it comes to modding

WORDS **DENISE STANBOROUGH**
PHOTOS **MARTIN DE POZO AND EDUARDO BAEZ ARIAS**

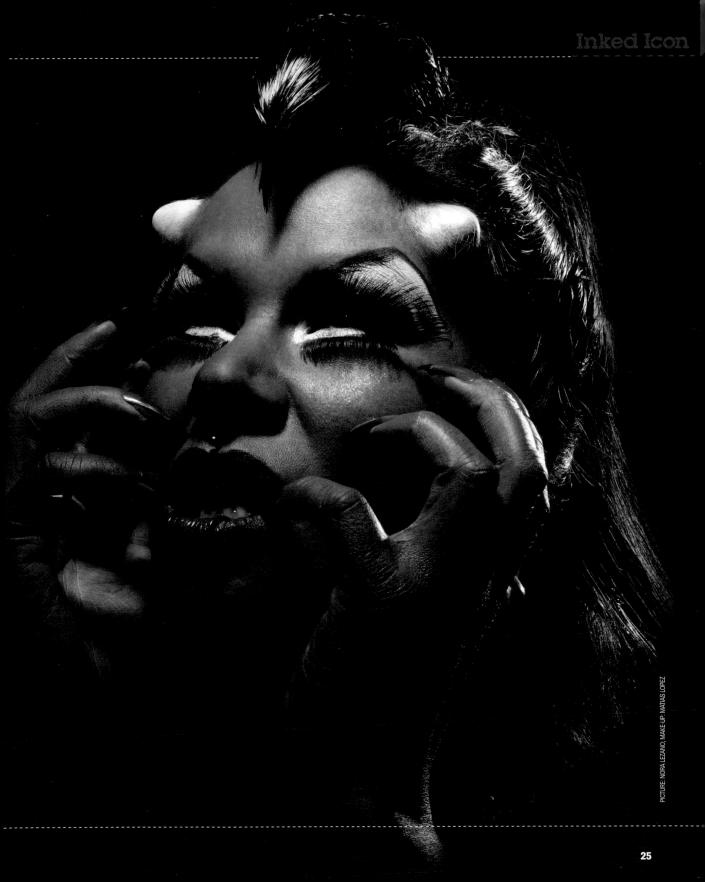

PICTURE: NORA LEZANO, MAKE-UP: MATIAS LOPEZ

A NEGRA IS A POSTER GIRL FOR MODIFIED ladies. She has horns, tattoos, scarification, branding, a split tongue – and she's as sexy as hell. Her journey into modding started at the tender age of 14, when she walked into a tattoo parlour in Buenos Aires, the capital of Argentina, plucked a standard design off the wall, and had it etched onto her right shoulder. Fast-forward 16 years and she's still exploring the world of body art, pushing boundaries with piercings and becoming an ambassador for freaks in her home country and across the world...

How did your body modification journey begin?
I remember seeing a tattoo for the first time on the forearm of my grandmother's second husband, who was in the marines. My own personal contact with ink started as a teenager, living in Buenos Aires. My family had moved from the countryside to the city because Argentina had been hit by a financial crisis, and I landed a job handing out flyers. I did it on a street corner next to a tattoo studio and I really liked seeing all the tattooed guys walking past. So a few months later I found myself wandering in for my first tattoo.

Up close and personal with La Negra

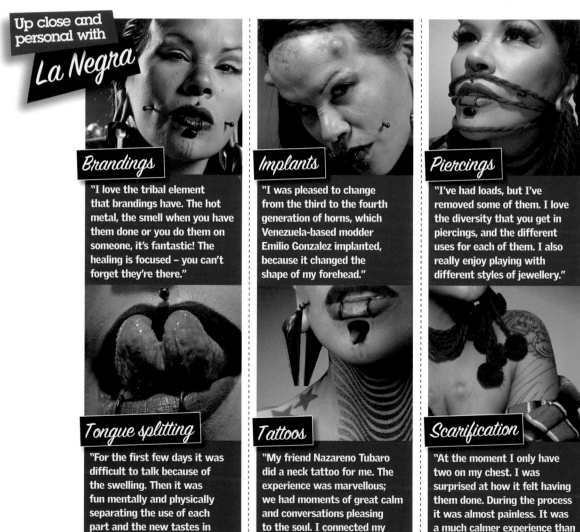

Brandings
"I love the tribal element that brandings have. The hot metal, the smell when you have them done or you do them on someone, it's fantastic! The healing is focused – you can't forget they're there."

Implants
"I was pleased to change from the third to the fourth generation of horns, which Venezuela-based modder Emilio Gonzalez implanted, because it changed the shape of my forehead."

Piercings
"I've had loads, but I've removed some of them. I love the diversity that you get in piercings, and the different uses for each of them. I also really enjoy playing with different styles of jewellery."

Tongue splitting
"For the first few days it was difficult to talk because of the swelling. Then it was fun mentally and physically separating the use of each part and the new tastes in the middle of my tongue."

Tattoos
"My friend Nazareno Tubaro did a neck tattoo for me. The experience was marvellous; we had moments of great calm and conversations pleasing to the soul. I connected my head with my body."

Scarification
"At the moment I only have two on my chest. I was surprised at how it felt having them done. During the process it was almost painless. It was a much calmer experience than I could ever have imagined."

Do you have fond memories of your first tattoo?
I chose a winged heart design from one of the studio's folders, which is something I never did again! I was 14 years old at the time, but looked older so the tattooist started etching on my right shoulder. Soon afterwards my younger-looking friend came in and the tattooist asked me for my real age. Luckily, I managed to convince him to finish it for me and he's now a good friend of mine.

How did this experience affect you?
That year was the beginning of my independence. I moved away from home and started working in that same tattoo studio. I was supporting myself, going out at night, and having my first sexual experiences.

Was it easy to build up your ink collection while you were working at a tattoo studio?
It was tempting! In the first years I concentrated on decorating my body rather than my face, and had work on my arms and legs, plus a few genital piercings. Between the ages of 16-19 I didn't get any tattoos or piercings – I was too dedicated to my studies, and had an apartment and a boyfriend. But when the simple, 'happy life' didn't work out, I left it all behind and got →

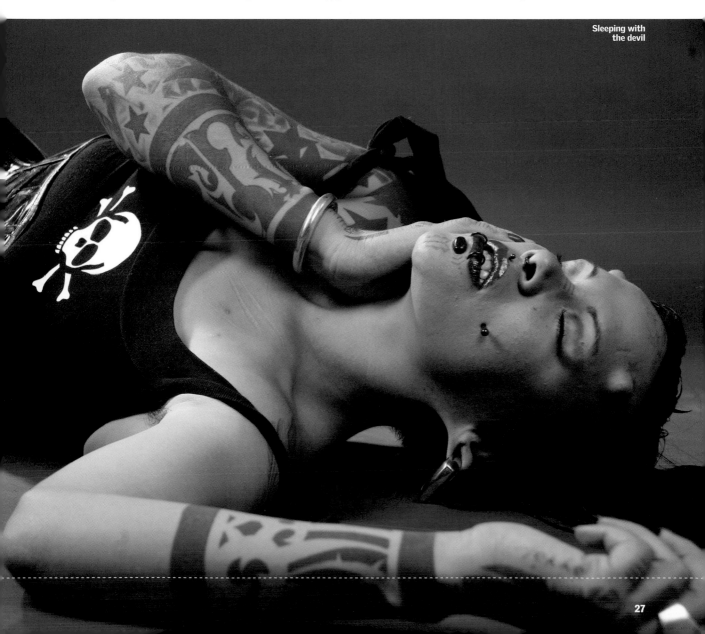

Sleeping with the devil

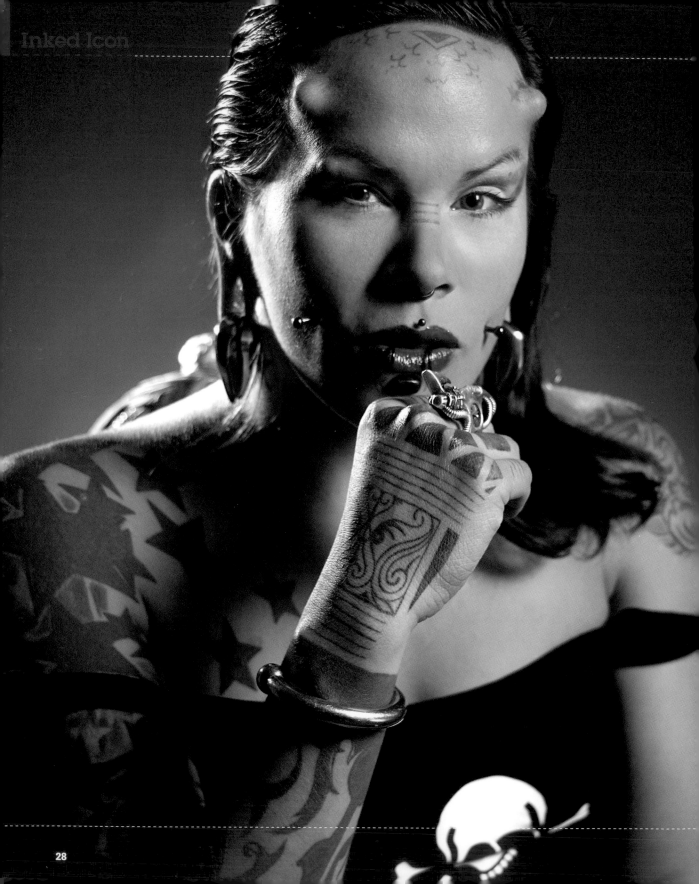

tattooed again for my 19th birthday. When I was 20 I pierced my face for the first time, and I didn't stop. I also became acquainted with other forms of body art. In 2001 I discovered brandings through friends from San Pablo and became curious. Then in 2002, when I was 24, I got my first forehead implants. It's difficult to remember every mod I've had, because I've been doing them for over half of my life.

Why did you get horn implants?
The body modification scene in Buenos Aires is mixed. You'll see people with tattoos and piercings on the street, on the subway, in the supermarket or in the bank – but there aren't many people with implants. I chose my horn implants firstly out of curiosity and secondly because I hadn't seen them in Argentina. I was involved in arranging the first ever body art convention in Buenos Aires and that's where I had them done. I thought it would be a good way to spread the word, and I love the way they look and feel under my skin. They change the anatomy of my forehead.

Do you have trouble sleeping because of them?
No, I haven't had any problems. But life with horns means life without hats, wigs or fringes!

What about your other body modifications?
I have two scarifications on my chest at the moment – I did them myself during a body art performance. They were pretty spontaneous and I hardly felt them the day after. My friend Andre Fernandez from Brazil did my other one, which took place in an enchanting and gentle one-and-a-half hour session.

Talking of performances, how did you get into body suspension shows?
Initially I was fascinated with the idea of taking my feet off the ground and being lifted from my own state. I've tried suspension in many different positions because each time there's a different pressure on the body and therefore a different feeling. All my public performances are unique and one-offs. I formed a group called Amor Infame Tormento (Vile Tormenting Love) with Ego Kornus and Angela Urondo. Our performances were based on Ego's poems and incorporated different disciplines such as suspensions and play spears. I see suspensions as an act of love to myself.

How do people respond to your body mods?
You're always going to find someone who's looking at you. People are curious to see what they like and what they don't, in who or what's in front of them. I don't take it personally – I think everyone's unique and responds in different ways.

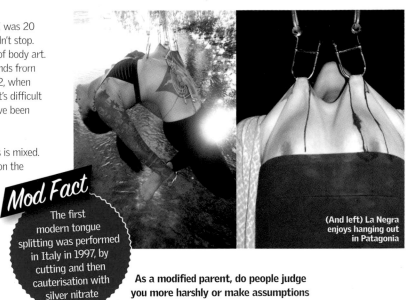

(And left) La Negra enjoys hanging out in Patagonia

Mod Fact
The first modern tongue splitting was performed in Italy in 1997, by cutting and then cauterisation with silver nitrate

As a modified parent, do people judge you more harshly or make assumptions about your parenting skills?
Not really. Every school has an interview beforehand to get to know the parents, and in those chats they evaluate the dedication and level of interest that you have in raising your child. My daughter has attended school for seven years and it's never been a problem. During the year you get to know the other parents and the teachers, and in that environment the common theme is the well-being of our kids. What a woman walking down the street thinks of me when she sees me with my daughter doesn't matter to me, nor does it affect any part of my life.

> "What a woman walking down the street thinks of me doesn't matter"

What comes after the horns? Wings?
I'm actually going to remove my horns at some point, but I have my first exhibition, *Traccion a Fe* (*Drawn To Faith*), due to open this year. It includes videos, photos and objects based on what I see as human faith. I don't feel my body modifications are something external that changed my life, but as something internal that manifested through the use of external elements. For me, the transmutation never ends. Ⓑ

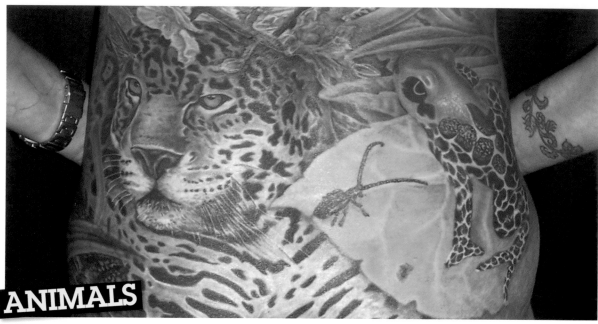

ANIMALS

Tributes to giant beasts and tiny insects

THAMASIN
Tattoo by Jon Nott, Trollspeil studio, Guildford, UK

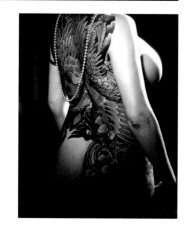

What is it? It started as a phoenix. The design then started to expand with Japanese flowers, clouds and waves.

Why did you choose it? I wanted something to represent the fact that I re-invent myself on a yearly basis.

What response do you get from people? Some ask if they can take their photo with me, but people have shouted insults too. They normally ask the same questions – how much did it set you back? Did it hurt? How far does it go?

MIKE MANSFIELD
Tattoo by Nikole Lowe, Into You, London, UK

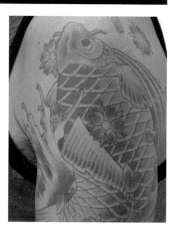

What is it? A koi carp.

Why did you choose it? I didn't know what tattoo to have, but I had a chat with Nikole and we decided on this. I really like its orange scales and its fishy tail.

What response do you get from people? They say, "Nice fish!"

What does your family think about it? My mum likes it.

How do you feel about it now? I think it needs some company.

Would you change or add anything? I'd like more splashing waves.

DUM DUM
Tattoo by himself

BING
Tattoo by Chad Stewart, Ace Custom Tattoo, Charlotte, North Carolina, USA

What is it? A Japanese-style tiger on my chest.

Why did you choose it? I love Japanese tattoo artwork and it fitted perfectly in the space left by my Japanese chest piece.

What does your family think about it? They love my ink. They're constantly asking me to add more to theirs.

Have you got any more ink planned? I've got a few I'd like to try but I don't have much room left, so it's become a big decision!

What do you like about having it? I love the contrasting colours.

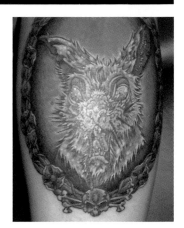

What is it?
A 'wererabbit' on my leg.

Why did you choose it?
It all started with a conversation about the mad old rabbit from *Watership Down* and, as the whiskey went down, the design evolved.

What does your family think about it?
My parents ignore and hate all my tattoos.

Have you got any more ink planned? I'm going to have a mirror image of this tattoo on my other calf, but inside the frame I'll have a werebadger!

SIAN COX
Tattoo by Ben, Lifetime Tattoo, Derby, UK

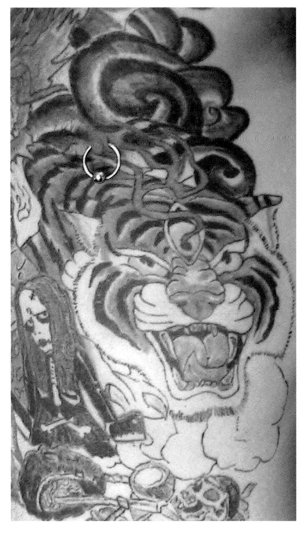

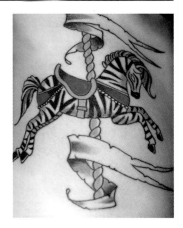

What is it?
A carousel zebra.

Why did you choose it?
I've always loved carousels. The design started as a horse, but I couldn't decide on a colour, so I made it into a zebra instead!

What response do you get from people?
My friends love it.

What does your family think about it? My dad says I look like council house trash – ha!

Would you change or add anything? If I have kids, I'll put their names inside the banners.

LISA ROBINSON

Tattoo by Gail, Feline Tattoo, Sheffield, UK

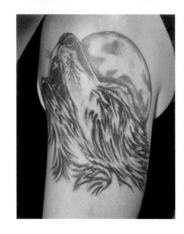

What is it? A wolf howling at a full moon.

Why did you choose it? My partner's biker name is 'Greywolf', and this was the image on the first Christmas card he sent to me.

Would you change or add anything? Nothing – it's perfect!

Have you got any more ink planned? Gail's putting a massive phoenix down my ribcage and leg, which will take 10 hours.

What do you like about having it? I think it reflects my individuality.

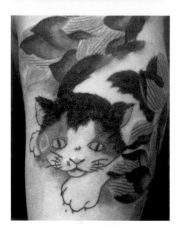

TY SIMS

Tattoo by Luci Lou, Diamond Jacks, London, UK

What is it? It's my cat and magnolias.

Why did you choose it? Because I love my cat.

What response do you get from people? People stop me on the street to ask who did it!

Have you got any more ink planned? I'm getting a sleeve down my right arm, with a heart and the words, 'love hurts'. It's going to have a heart, skulls, roses and daisies, so far...

What do you like about having it? It means something special to me and it makes me smile.

RIA OSBORNE

Tattoo by Valerie Vargas, Frith Street Tattoo, London, UK

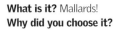

What is it? Mallards!

Why did you choose it? I love all things kitsch and English. I was having a picnic with a friend and she was wearing a mallard brooch, when two mallards flew over us – we agreed that it'd make a good tattoo.

What does your family think about it? It just confirmed their suspicions that I'm a fruitloop. I drunkenly blurted out the news about my new additions on Christmas Eve. Suffice to say, Christmas dinner was a bit strained!

ANDY LINDSAY

Tattoo by Chris Sanders, Permanent Productions, Cincinnati, Ohio, USA

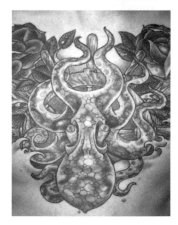

What is it? An octopus around the helm of a boat with some waves and roses.

Why did you choose it? I wanted a tattoo that's oriented towards the beauty of sea life.

What response do you get from people? Usually one of two. People either accept it as an attempt to add shock value to my body and think I'm mad, or they appreciate its detail. Both are justified.

How do you feel about it now? I'm still crazy about it after years!

JOHN PAINE
Tattoo by Rob Ratcliffe, Border Rose Tattoo, Manchester, UK

What is it? A pit bull from the cover of *Thunderdome, Vol 3*, a gabba album.
Why did you choose it? The energy in the image is what I feel when that area of my body is active. It's something to do with the Manipura Chakra, apparently. I included the number 13 because it was 13 May, I was 13st and 13lb when I woke up, and I missed my train at Leeds and had to get one from platform 13.
What response do you get from people? I got positive comments.

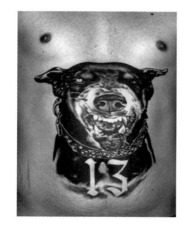

HELENA FORROW
Tattoo by Tuk

What is it? It's a symbol of a Mongolian horse.
Why did you choose it? I lived in Mongolia for many years, and when I was out there, most of my favourite moments were related to horses.
How do you feel about it now? I like it a lot as it makes me think of Mongolia when I see it, which always cheers me up.
What do you like about having it? No-one else I know has the same tattoo as me.

MARIE POYNTER
Tattoo by Jim Gambell, Ritual Art Tattoo, Rainham, UK

What is it? A rainforest.
Why did you choose it? I had some old tattoos that I wanted covered up. I spoke to Jim about something with an animal theme, so he started drawing. The original concept didn't include the tattoo going all the way over my arse, though. We just carried on going!
Have you got any more planned? Yes, we're currently carrying on with the rainforest theme down my left arm and into a full sleeve.
What do you like about having it? It's completely unique to me.

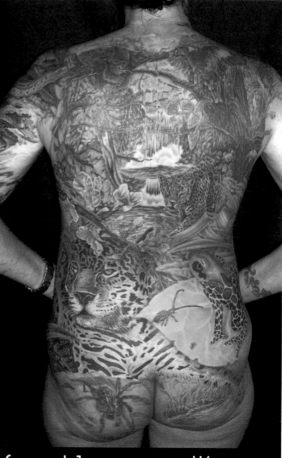

"I like my rainforest because it's completely unique to me"

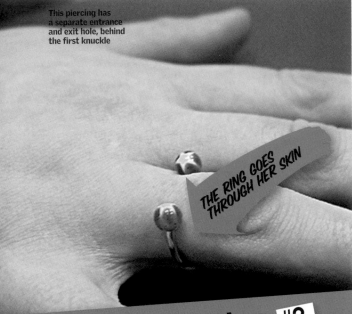

This piercing has a separate entrance and exit hole, behind the first knuckle

THE RING GOES THROUGH HER SKIN

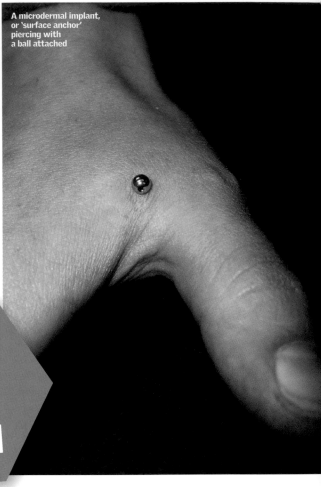

A microdermal implant, or 'surface anchor' piercing with a ball attached

Body Mod Masterclass #2

FINGER PIERCING

Put your hands together for decorated digits

You might have seen temporary piercings in nails before, but did you know you can pierce hands? It's difficult to pierce them successfully because they come into contact with all sorts of surfaces, which means they can easily become infected with bacteria or catch on things. But they look great when they're done properly.

If you've accepted that hand-based piercings are high-maintenance but still want one, you'll need to decide what type to get. Lane Jensen from Dragon FX body mod studio in Alberta, Canada, recommends a microdermal implant, also called a 'surface anchor'. A tiny flat plate is inserted under the skin and a single screw sticks out of the surface, so a jewel, ball or charm can be attached. The plate sometimes has holes in it, so scar tissue can grow through and help hold the jewellery in place.

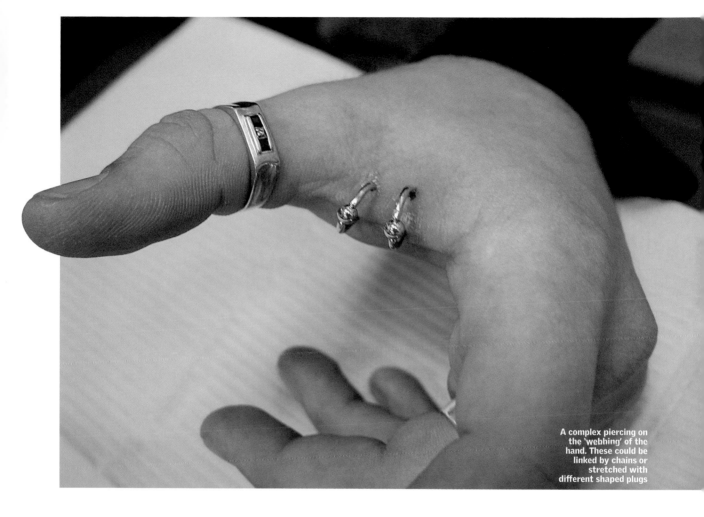

A complex piercing on the 'webbing' of the hand. These could be linked by chains or stretched with different shaped plugs

Piercings with a separate entrance and exit hole, to hold bars or rings, are also possible – but they're trickier. "I've seen 'transfinger' piercings, where a straight bar runs horizontally right through the tip of a finger, but I prefer to stay behind the first knuckle," explains Lane. "The number of nerves and tendons above that makes things risky. You also have to take great care when piercing the webbing between fingers; an inexperienced modder could cause nerve damage."

To help the piercing heal, you should elevate the hand above the heart after the procedure to reduce swelling. You should also cover the area with sterile gauze to stop contaminants getting in, and keep everything clean while avoiding harsh antibacterial solutions that might aggravate the skin. If you treat hand piercings carefully they can heal in 6-8 weeks – although they can take up

If you have a surface anchor, a jewel, ball, or charm can be attached

to three months. Once healed, they usually stick around for nine months to a few years.

If a single piercing isn't enough to satisfy your hankering for hand modding, Lane has some interesting advice: "You could try linking several rings together with chains, stretching web piercings with different shaped plugs, or having beading or silicone implants," he says. "Heck, you could even make a finger ribbed for your lady's pleasure! The technology is at your fingertips." Ⓑ

PICTURES: LANE JENSEN

Don't get
modded
until you've
read these
expert tips…

Steel
yourself!

WORDS **BEN MYERS**

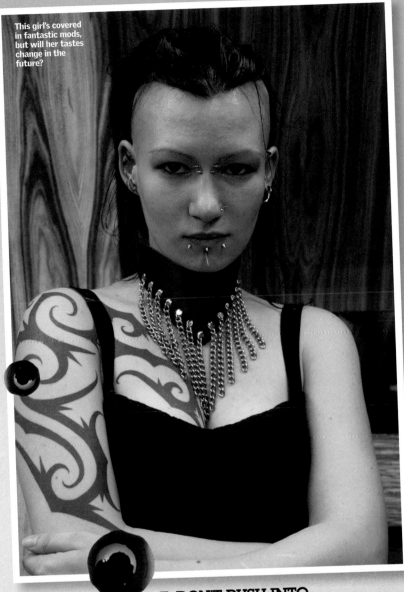

This girl's covered in fantastic mods, but will her tastes change in the future?

1 DON'T RUSH INTO BODY MODIFICATIONS WHEN YOU'RE YOUNG

Just as your taste in music, clothes or people will change over time, your interest in body modification may differ as you get older. Take your time. "I see kids – mainly girls – who rush out and get a full sleeve of ink straight away and it just seems wrong," says body mod expert Samppa Von Cyborg. "Really, your body should be like a life story. Add new chapters to it gradually." →

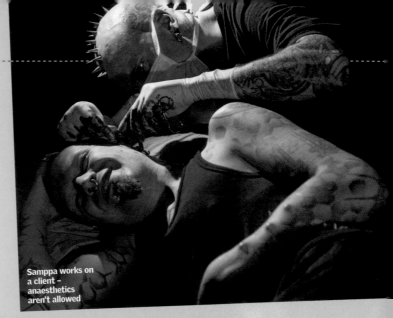

Samppa works on a client – anaesthetics aren't allowed

Rate: ★★★★☆ 33 ratings Views: 63,132

Share Favourite Playlists Flag

Send Video Facebook Bebo more share options

2 DON'T RELY ON THE INTERNET ALONE FOR BODY MOD INFORMATION

"Never forget that most information on the internet is written by people who aren't professionals in the field," says Samppa. "If enough people say, 'you can drill through the brain,' people believe it. Or a two-hour procedure might be edited down to a five-minute video clip – it can be misleading. Don't assume anything you see or read is fact. Do your research and question everything: the body mod scene is full of urban legends. Don't try and score scene points. Use common sense."

3 PREPARE YOURSELF FOR PAIN

Body mod artists are not legally allowed to give anaesthetics, so you'll be conscious throughout all possible procedures – whether you're getting a minor piercing or a metal mohawk. You may experience a lot of pain. In fact, if you're offered an anaesthetic, the body modder is breaking the law and you should not accept it.

4 YOUR BODY IS ALWAYS CHANGING...

Be prepared for your body to dictate the success of the work you have done. "Scarification relies on how the body receives it," says London-based scarification expert and Psycho Cyborg extreme performance group member Iestyn. In some cases, such as implants, your body may reject the modification outright. "The body is ever-changing, so results depend upon the individual," Iestyn says. "It's an organic process."

A client receives stitches... but will the mod heal?

5 ... AND SO IS THE BODY MOD WORLD

Body mod techniques and the understanding of the body's capabilities are being improved at a great pace. Today's procedures will be surpassed immeasurably in a decade – a good reason to wait for the mod you really want. →

Neon tubes have been threaded through the skin, to create a glow

Mod Fact

Eyeball tattoos aren't as new as you think – doctors in the 19th century used them to correct corneal scarring

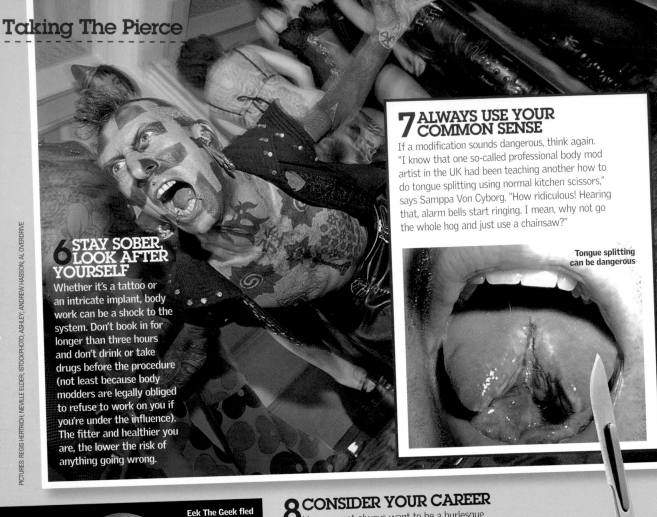

PICTURES: REGIS HERTRICH; NEVILLE ELDER; ISTOCKPHOTO; ASHLEY; ANDREW HASSON; AL OVERDRIVE

6 STAY SOBER, LOOK AFTER YOURSELF

Whether it's a tattoo or an intricate implant, body work can be a shock to the system. Don't book in for longer than three hours and don't drink or take drugs before the procedure (not least because body modders are legally obliged to refuse to work on you if you're under the influence). The fitter and healthier you are, the lower the risk of anything going wrong.

7 ALWAYS USE YOUR COMMON SENSE

If a modification sounds dangerous, think again. "I know that one so-called professional body mod artist in the UK had been teaching another how to do tongue splitting using normal kitchen scissors," says Samppa Von Cyborg. "How ridiculous! Hearing that, alarm bells start ringing. I mean, why not go the whole hog and just use a chainsaw?"

Tongue splitting can be dangerous

8 CONSIDER YOUR CAREER

You may not always want to be a burlesque performer and the circus may not always have vacancies. You don't see politicians with metal mohawks. So consider whether a mod will prevent you from getting a job in the future, and remember that people judge on appearances. "It doesn't matter what qualifications you have – no-one wants to hire someone with spikes in their head," says Samppa. And he should know.

9 WATCH OUT FOR COWBOYS

There are, unfortunately, some body mod artists who carry out sub-standard work. Always ask to see a body modder's work first – they should have photos. "A scalpel in the wrong hands is so fucking dangerous," says Samppa. "A scalpel can kill. All artists need a proper grounding of anatomy as well as a steady hand."

Eek The Geek fled the circus to become an inked lawyer!

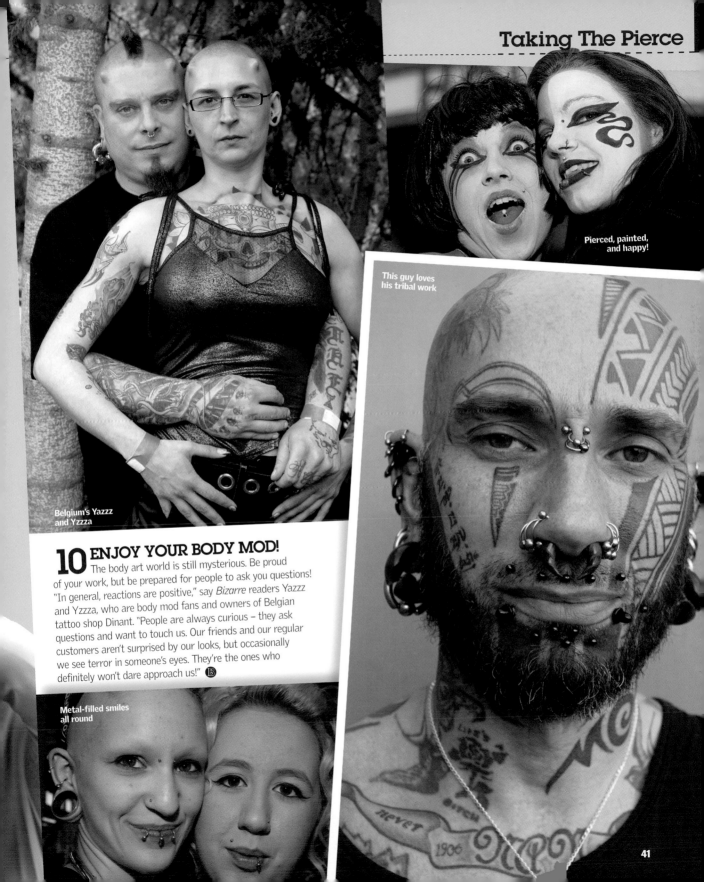

Pierced, painted, and happy!

This guy loves his tribal work

Belgium's Yazzz and Yzzza

10 ENJOY YOUR BODY MOD!

The body art world is still mysterious. Be proud of your work, but be prepared for people to ask you questions! "In general, reactions are positive," say *Bizarre* readers Yazzz and Yzzza, who are body mod fans and owners of Belgian tattoo shop Dinant. "People are always curious – they ask questions and want to touch us. Our friends and our regular customers aren't surprised by our looks, but occasionally we see terror in someone's eyes. They're the ones who definitely won't dare approach us!" B

Metal-filled smiles all round

MODERN WORLD

Meet three pioneers with weird ideas about the future of body modification

WORDS **BEN MYERS**

Body modification may be as old as known civilisations, but it remains an ever-evolving subculture. Where once it was a world confined to ink guns, scalpels and primitive surgical techniques, recent advancements in new technologies have brought the body mod scene and the scientific world together through an exploration of cybernetics. Robotic limbs, microchip implants and the harnessing of magnetic field frequencies via inserted magnets are only just the beginning. Now, as science fiction becomes science, white-coated doctors, professors and academics may, excitingly enough, find themselves working on collaborations with select leftfield body mod artists and practitioners.

STELARC

The performance artist with an ear on the future

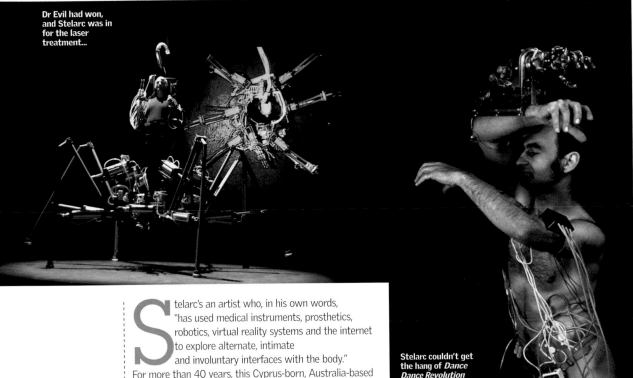

Dr Evil had won, and Stelarc was in for the laser treatment...

Stelarc couldn't get the hang of *Dance Dance Revolution*

PICTURES: SIMON HUNTER; IGOR SKAFAR; NINA SELLARS

Stelarc's an artist who, in his own words, "has used medical instruments, prosthetics, robotics, virtual reality systems and the internet to explore alternate, intimate and involuntary interfaces with the body." For more than 40 years, this Cyprus-born, Australia-based pioneer of suspensions has performed all over the world, using creations such as a third hand, a virtual arm and a prosthetic head. He's held a number of academic and artist-in-residence positions, and continues to explore the body via projects that combine art and science.

When did you first become interested in the capabilities of the human body?
I've always been envious of dancers and gymnasts because they use their bodies as their medium of expression, coupling experience of the body and expression with the body.

Which projects are you the most proud of?
Each project has its moment. 'The Stomach Sculpture' – a capsule I swallowed that opened inside me – was challenging: to design a simple, reliable, operational object that could be inserted inside the soft, vulnerable and wet body. 'Blender' was the inverse. Here, a machine installation became the host for a liquid body. This was a collaboration with artist Nina Sellars; we had surgical procedures such as liposuction to extract 4.6 litres of biomaterial – blood, fat and tissue. This was placed in the 'Blender' installation; every five minutes, compressed air made the blender blades move.

Given that the human body is organic, which project was the most problematic?
The 'Extra Ear' project has taken the longest to realise. I first had the idea in 1996, but it wasn't until 2006 that I had the first procedures to construct the ear on my arm.

How did you grow an extra ear?
A silicone skin expander was implanted in my forearm. Then saline solution was injected, which made the implant stretch the skin, forming excess skin that was then used to construct the ear. Then I had another procedure to insert a tissue-reconstruction scaffold, and the skin was suctioned over it. Over six months, cell growth occurs in →

the porous scaffold, fixing it in place. The third surgical procedure will lift the helix of the ear, construct a soft ear lobe, and inject stem cells for better definition. The final procedure will implant a miniature microphone that, with a Bluetooth transmitter, allows a wireless connection to the internet, making the ear a remote listening device.

What are the most exciting steps in cybernetics?
'Organ printing', which is a hybrid of rapid prototyping techniques and tissue engineering. Instead of printing an image with cartridges of coloured ink, you're able to print an organ, layer upon layer, using cartridges of living cells.

What are the implications of this?
We'll no longer be an age of bodies without organs, but rather an age of organs awaiting bodies.

Do you think the body will be able to transcend death or, is, as you put it, the body obsolete?
When I say 'the body is obsolete' I mean this body with this form and with these functions. To increase a body's longevity significantly might mean engineering a body that does not have to breathe and whose heart does not have to beat. A synthetic skin permeable to oxygen would be a start. The body will not need lungs to breathe, a stomach to ingest nor a circularity system to convey oxygen and nutrients throughout the body. We could hollow out a human body. And a hollow body would be a better host for all the technology we could plug into it, ha, ha!

Mod Fact
The world record for the longest suspension is held by Matt Zane, who hung for six hours in January 2008

SAMPPA VON CYBORG

The performer and body modder vibrating with ideas

Piercing pioneer, jewellery designer and founder of extreme performance group the Psycho Cyborgs, Samppa Von Cyborg's interest in body modification encompasses the development of new possibilities – most notably a vibrating penis implant.

Samppa's cock implant started vibrating unexpectedly...

PICTURE: JOE PLIMMER

Can you tell us about your vibrating penis implant?
It works on the same principle as a vibrating mobile phone. The major obstacle so far has been the power supply. We started by using kinetic energy, then tried something powered by a thermal generator: an implant fuelled by the human body. And now we've created a wireless implant with a range of 10m. So if you walk into the same room as the transmitter, your penis will vibrate. My colleague on this is studying cybernetics under Professor Kevin Warwick (opposite).

Do you want to manufacture and sell these implants in the future?
These things need years of testing before they can be declared safe, so I want to keep these ideas within a small group of people. The implant's actually pretty cheap but as there's only one company in the world that makes them, and since demand is still very small, it isn't very cost-effective at this stage to mass-produce.

In what other directions do you see body modification heading?
I think that things that we now class as body modification – or indeed, certain aspects of science fiction – will, in 10 or 15 years, be commonplace. For example, I think we'll soon be able to have mobile phones under our skin.

PROFESSOR KEVIN WARWICK

An artificial intelligence egghead

A s professor of cybernetics at the University Of Reading, UK, Kevin Warwick is at the forefront of developing artificial intelligence, robotics and biomedical engineering. During his experiments he's implanted devices linking the nervous system to computers, set up the first electronic communication between two human nervous systems, and created numerous cyborgs.

Which project, experiment or invention are you most proud of?
In 2002, I had an implant consisting of 100 electrodes (pins) fired into my nervous system by surgeons. With that in place I was able to control a robot arm directly from my brain signals via the internet, and to experience a new ultra sonic sense – like a bat. Best of all, though, was when my wife had electrodes inserted in her nervous system and we communicated electronically for the first time in the world – directly between our nervous systems. It was a new telegraphy.

What's the most exciting or significant new development in the world of cybernetics?
What I really find exciting is growing new brains from rat brain cells and enabling them to live in a robot body, so that the robot has a biological brain. It won't be too long before human brain cells are used for this instead.

Are there any people working in cybernetics or body modification who you admire?
I admire the digital artist Stelarc (see previous pages). He challenges the scientific world as much as the artistic one.

Will the human body ever transcend death?
We are really our brains – our bodies are mainly a life-support mechanism for them. So for me, the main questions are: 'Can we keep a human brain alive outside its present biological body? Can we replace brain cells before they die off so that our personality, memory, etc, remain essentially intact?' I believe that with stem cells, the answer to the latter question will be yes – in, say, 20 years. That still leaves the first question, though. And I can't see that happening in the next 20 years. But in the next century? Well... you never know! 🅑

FANTASY
Dungeons and dragons made flesh

JENNIE SPOONER
Tattoo by Dan at Skin Graffiti, Wigan, UK

What is it? A fairy.
Why did you choose it?
I'm in the process of having a fantasy sleeve. I got the most painful bit over with first.

What does your family think about it?
My Mum and Dad are cool with it. They told me it's my body to do what I like with. Other family members are not sure about it, though.

Have you got any more ink planned?
Some shading to go with it. I'm also planning to add winged horse Pegasus and a dragon.

LOU HAKANSSON
Tattoo by Woody, Woody's Tattoo Studio, High Wycombe, UK

What is it? An angel.
Why did you choose it?
It's in memory of some friends. I had the idea and a friend designed it.

What response do you get from people?
A good response; people seem to really like it, but it's personal so I don't show it off often.

Would you change or add anything? I'd like to build on it some more.

Have you got any more ink planned?
I'm working on two sleeves at the moment, but they're in a more cartoonish style.

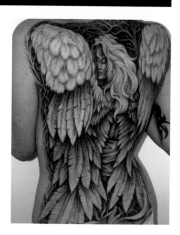

PHIL GARNER

Tattoo by Richard Beston, Triplesix Studios, Sunderland, UK

What is it? Ludo from *Labyrinth* on my leg.
Why did you choose it? It's my favourite childhood movie.
What response do you get from people? People say, "Duuuuude, can I take a photo?" because they have fond memories of the film.
How do you feel about it now? I love it. I'm working on a leg sleeve. So far I have Ludo and The Worm, and Didymus is coming.
What does your family think about it? They think it's a little crazy, but they love it.

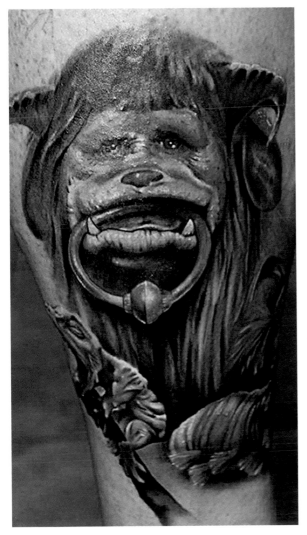

ERIN LARGE

Tattoo by Kat, Old London Road Tattoos, London, UK

What is it? A sexy *Alice In Wonderland* piece.
Why did you choose it? It mirrors a crazy point in my life, and reminds me why life is beautiful.
What response do you get from people? Some tourists once stopped me in Hyde Park so they could take a picture with me.
What does your family think about it? They don't like any of my tattoos – it's rebellion!
How do you feel about it now? I love looking at it every day, and I will until I'm in my grave.

VICTORIA JOHNSTONE

Tattoo by Moby, New Order Tattoos, Chester, UK

What is it? A dragon.
Why did you choose it? I needed something quite big to cover up two smaller tattoos on each shoulder blade. I wanted something with wings and came to the conclusion a dragon would look quite cool.
What response do you get from people? Positive ones. My mum thinks it's good, and that's saying something!
What do you like about having it? Everything. The colours are awesome and I think it's a good talking piece.

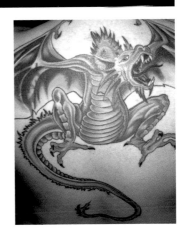

CHRIS BAILEY

Tattoo by Rob Williams, El Diablo Tattoos, Machynlleth, Wales, UK

What is it?
A Japanese dragon.
Why did you choose it?
I've always liked Japanese art.
Would you change or add anything? I'd like to add some clouds in the background.
Have you got any more ink planned?
A Japanese water sleeve. After that I plan to cover the rest of my back.
What do you like about having it? I like the fact that it's not on display to the public.
How do you feel about it now? I love it!

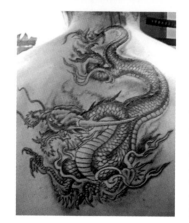

KAREN CANN

Tattoo by Phil York, Tattoo Mania, Gateshead, UK

What is it? A *Lord Of The Rings* back piece.
Why did you choose it? I love the fact this piece is custom and unique, plus it's obvious I'm a big fan of the film!
What response do you get from people? Positive comments.
What does your family think about it? They're cool with it.
How do you feel about it now? I love each one of my tattoos.
Would you change or add anything? I'm having more ink added on my chest.

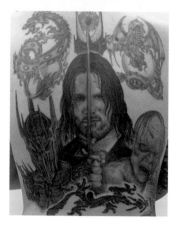

ROGER PRITTING

Tattoo by AJ, Broadway Tattoo Lounge, Sayreville, New Jersey, USA

What is it? A winged demon with horns.
Why did you choose it? I wish I could tell you a meaningful *Miami Ink* type of reason for getting it, but the truth is that I just liked the way the picture looked.
What does your family think about it? My mother has stopped speaking to me.
Have you got any more ink planned? Next I'm going to continue the horror theme I've started, by getting a tattoo of a werewolf defiling a young maiden.

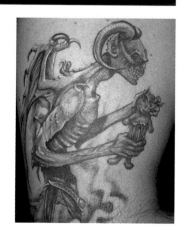

JESSICA TIPTON

Tattoo by Jeff Stevens, Budo Tattoo Studio, Jackson, Tennessee, USA

What is it? A snow leopard gryphon holding an ankh, with the wings of the goddess Isis.
Why did you choose it? I drew the tattoo and created it for personal reasons referring to my inner spirit animal.
Would you change or add anything? It needs more colouring to complete it.
Have you got any more ink planned? I plan on getting the Eye Of Ra under my right wrist.
What do you like about having it? I like the fact it's my own artwork.

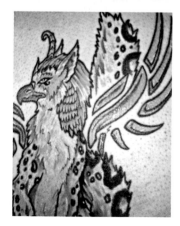

PIPPA STATHAM

Tattoo by Tony Laurenson, 14 Tattooing, Ilfracombe, UK

What is it? A phoenix, cherry blossoms and a fire fairy underneath.
Why did you choose it? I plan to make this an oriental-themed leg. I had the fairy and thought the rest would look good.
What response do you get from people? Usually positive, but the ones that don't like it probably wouldn't say anything to my face!
Would you change or add anything? It's one of my favourite tattoos, but I'd like a koi carp on the other side.

LESLEY MILLER

Tattoo by Infinite Ink, Hamilton, Lanarkshire, Scotland, UK

What is it? It was originally a Tinker Bell tattoo on my ankle, but I got it covered with an angel that was drawn freehand by the artist.
Why did you choose it? It's in memory of my aunt who died from pancreatic cancer. I added a purple cancer awareness ribbon to the branch the angel's on.
What does your family think about it? They aren't keen on it as it's so big. People at work are sometimes shocked as they don't expect it from me.

JULIA WIGGINS

Tattoo by Nick Wiggins at The Mark Of Cain Tattoos, Champaign, Illinois, USA

What is it? A lesbian vampire back piece.
Why did you choose it? I think women are beautiful. I also have a female fairy with pixies on my left thigh, a seahorse with a naked mermaid wrapped around him on my right thigh, another female fairy on my right arm, and Queen Akasha from vampire film *Queen Of The Damned* on my left arm.
What does you family think about it? My husband tattoos me, and my children and family don't mind them. My art is a part of me.

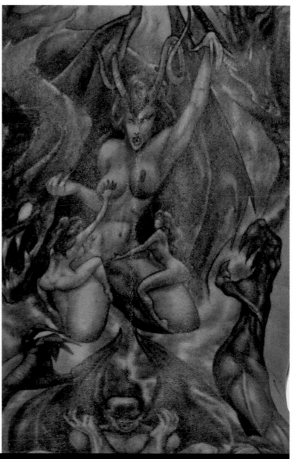

"I think women are beautiful, so I got a lesbian vampire piece"

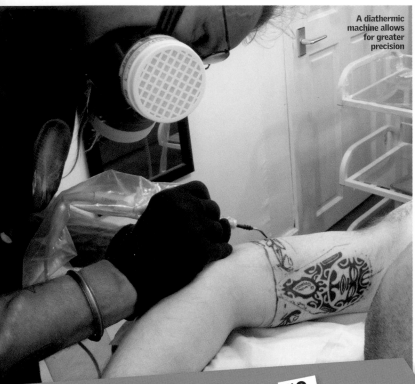

A diathermic machine allows for greater precision

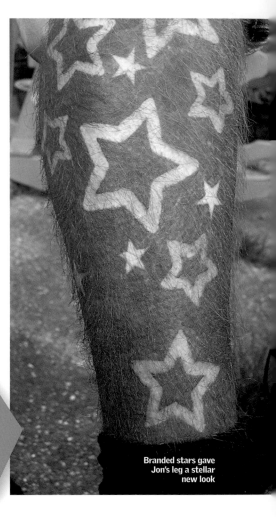

Branded stars gave Jon's leg a stellar new look

Body Mod Masterclass #3
BRANDING

Feel the burn of having a brand new mod

Ink isn't the only way to mark the skin, and branding's becoming a popular alternative. Tattoo artist Quentin, who heads up the Kalima body mod studio in Worthing, UK, began performing brandings with a cautery pen – the type used by surgeons to control bleeding during operations. Then he realised that the heat spreads out from the point the pen touches the skin, so lines could end up three times thicker than their original width. To get around this problem, Quentin switched to a diathermic machine, which uses an electric current passed through an electrode to successfully 'cut' skin away from the body.

"Do you remember that line from *Apocalypse Now* – 'I love the smell of napalm in the morning'?" he asks. "As a branding expert, my day is more likely to start with the smell of sizzling skin. My partner Ami and

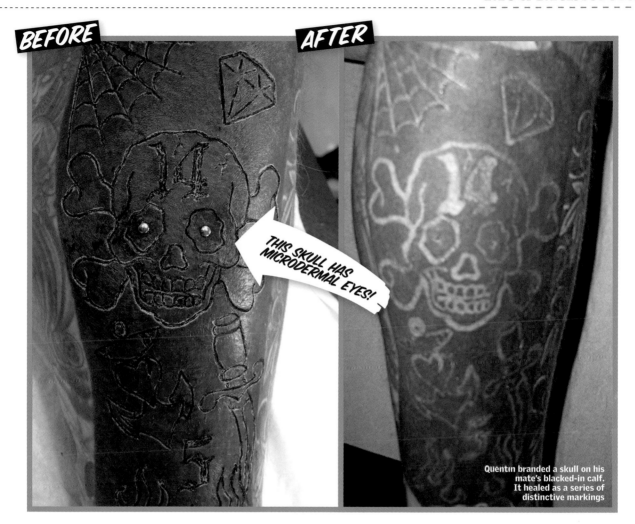

BEFORE

AFTER

THIS SKULL HAS MICRODERMAL EYES!

Quentin branded a skull on his mate's blacked-in calf. It healed as a series of distinctive markings

I are used to the odour now. I've found that vegetarians don't mind the stench of burning human flesh, yet meat eaters find it repulsive – odd, huh?"

Many people have patterns branded onto untouched skin, but you can also brand over tattooed areas. Quentin has even experimented with branding over black work. "Branding over tattooed black work is particularly successful, as the bright, white markings look striking against a dark background," he says. "I'm currently blacking in my own leg ready to burn some flowers and the Indian goddess Kali into it, while my mate Richard blacked in his calf so we could scorch a skull into it and put microdermal implants in its eyes."

If you've got a tattoo you regret, you can re-work it by zapping it off using a diathermic machine – then tattooing over the top. It takes a few goes if you want the

"Branding over tattooed black work leaves striking bright, white markings"

new piece to have a rich colour, but as long as the brand has been properly cared for and had time to heal, the ink will go in. Quentin added branded star shapes to a solid black cover-up on his friend Jon Thor, from Scart Tattoo in Iceland. He laughs: "I was over there in mid-summer, when the sky glows with light throughout the brief 'night'. So if anyone wanted to gaze at the stars, having a peek at Jon's branding was the closest they were able to get." B

BALLO

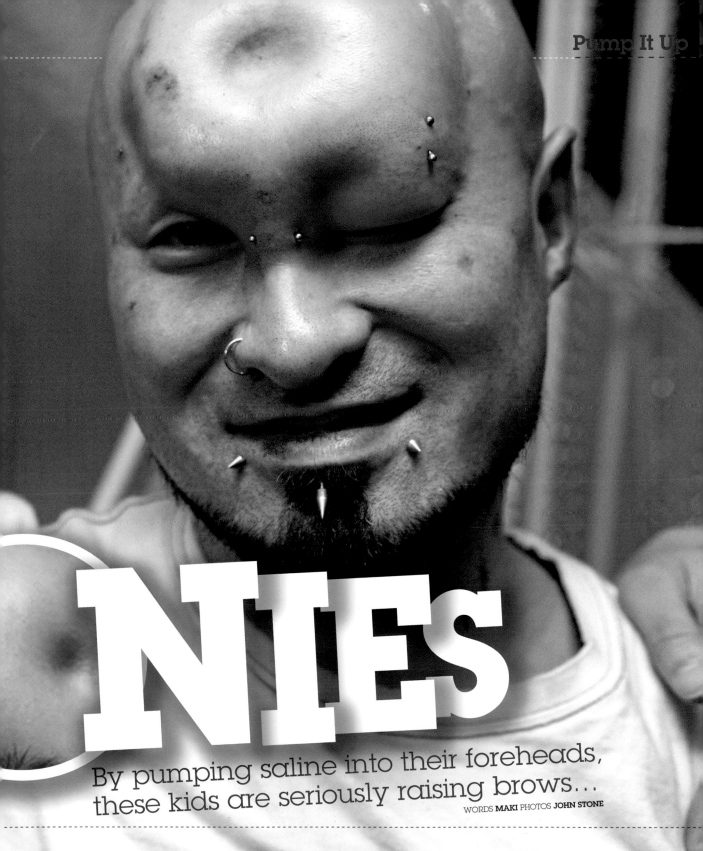

NIES

By pumping saline into their foreheads, these kids are seriously raising brows...

WORDS **MAKI** PHOTOS **JOHN STONE**

Pump It Up

PICTURE THE SCENE: there are five people, each with hideously distorted heads, tubes sticking into their faces. Reminiscent of a medical experiment gone hideously wrong, you'd be forgiven for thinking they had a gross infection or disease. They look like alien abductees, fresh from invasive research by their interplanetary masters. But these are Japanese club kids, deliberately disfiguring themselves by experimenting with saline inflations. This extreme body modification isn't new, but it's growing in popularity – particularly across Japan in cities such as Tokyo and Osaka where modders are converging on clubs, eager to swell themselves. Sites such as BMEzine.com are full to bursting with photos of engorged body parts – heads, tits and arses.

Play-Donut

This surge in popularity on the alternative club scene could be due to the fact saline inflations aren't permanent. BMEzine.com founder Shannon Larratt reckons that tens of thousands of people have tried inflating themselves. "It's primarily a play activity," he says. "I think most of the time it's done on its own, rather than with other types of play. I've seen people combine it with play piercing but, on the whole, that's not something I'd recommend because of infection risks."

Saline inflations first hit the big time in 2002 when Shannon's book, *ModCon: The Secret World Of Extreme Body Modification* was published. It documented three years of Shannon's annual invite-only body mod convention in Toronto, Canada, and the cover showed performance artist Jerome Abramovitch looking like the devil, with what resembled a bagel wedged under his skin on his

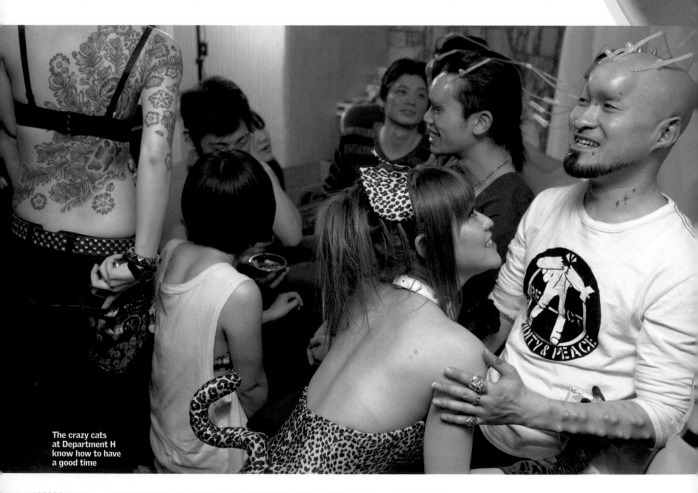

The crazy cats at Department H know how to have a good time

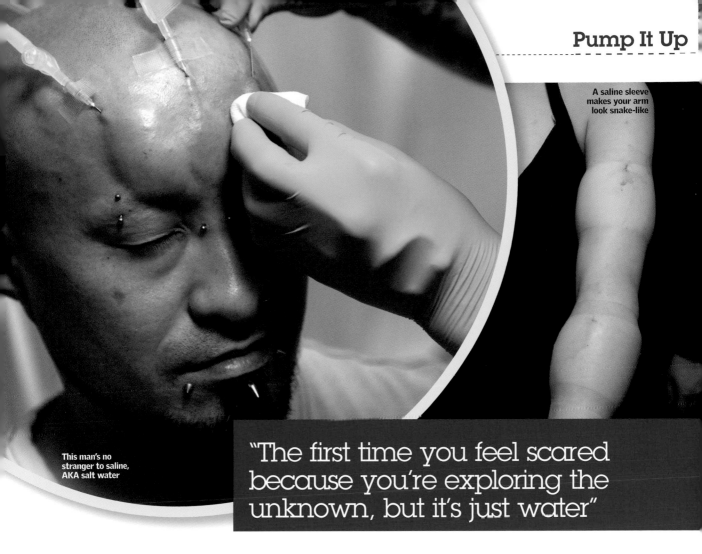

A saline sleeve makes your arm look snake-like

This man's no stranger to saline, AKA salt water

"The first time you feel scared because you're exploring the unknown, but it's just water"

forehead. He'd performed the saline injection in 2000, but the publication of the pictures captured the imaginations of fetish clubbers worldwide and the art of skin inflating looked set to rise (and rise).

Photographer Ryoichi 'Keroppy' Maeda has been covering the body mod scene since 1992, translated *Modcon* into Japanese and has written his own book – *Scar Factory* – about underground modding. He understands why saline infusions have become popular. "Things like suspensions are really quick. But saline infusion is a gradual process and you become a freak progressively. That's the joy of it,"

he explains. "You can enjoy it by having a few drinks and gradually seeing a transformation, but if you're looking all the time, you can't see the difference. If you meander off and come back, it's a real surprise."

H marks the spot

For people keen to experience the inflating world for themselves, Keroppy advises a trip to Tokyo's Department H. It's a long-running club that has an 'anything goes' policy. There, you'll find lines of experimentalists getting injected in their foreheads, arms and hands and waiting for the effects to take hold. "It takes about two hours to inflate,

and then takes about a night to diffuse," Keroppy explains. "It appears prominently in some areas and in others it gets absorbed. In the forehead it's easy to see, whereas the arm absorbs it quite quickly."

In February, Keroppy and *Bizarre* body mod favourite Samppa Von Cyborg held a *Dolphin vs Birds* night, which pitched the saline enthusiasts (dolphins) against the hook suspensionists (birds). Although the techniques are radically different, they both hold the same appeal – the temporary transformation of the body. Keroppy likens the experience of suspension to bungee jumping and the infusions to scuba diving: →

Pump It Up

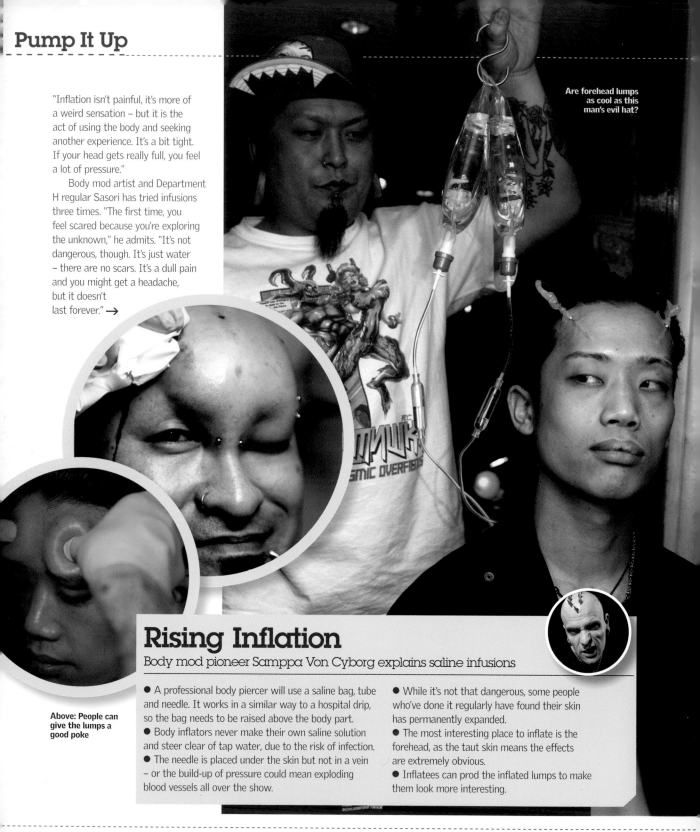

"Inflation isn't painful, it's more of a weird sensation – but it is the act of using the body and seeking another experience. It's a bit tight. If your head gets really full, you feel a lot of pressure."

Body mod artist and Department H regular Sasori has tried infusions three times. "The first time, you feel scared because you're exploring the unknown," he admits. "It's not dangerous, though. It's just water – there are no scars. It's a dull pain and you might get a headache, but it doesn't last forever." →

Are forehead lumps as cool as this man's evil hat?

Above: People can give the lumps a good poke

Rising Inflation
Body mod pioneer Samppa Von Cyborg explains saline infusions

- A professional body piercer will use a saline bag, tube and needle. It works in a similar way to a hospital drip, so the bag needs to be raised above the body part.
- Body inflators never make their own saline solution and steer clear of tap water, due to the risk of infection.
- The needle is placed under the skin but not in a vein – or the build-up of pressure could mean exploding blood vessels all over the show.

- While it's not that dangerous, some people who've done it regularly have found their skin has permanently expanded.
- The most interesting place to inflate is the forehead, as the taut skin means the effects are extremely obvious.
- Inflatees can prod the inflated lumps to make them look more interesting.

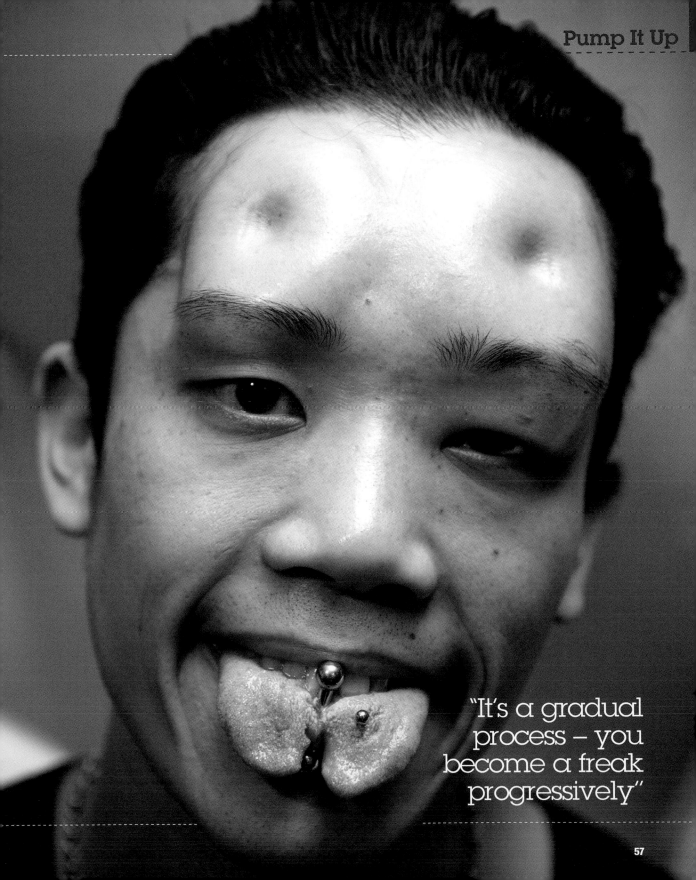

"It's a gradual process – you become a freak progressively"

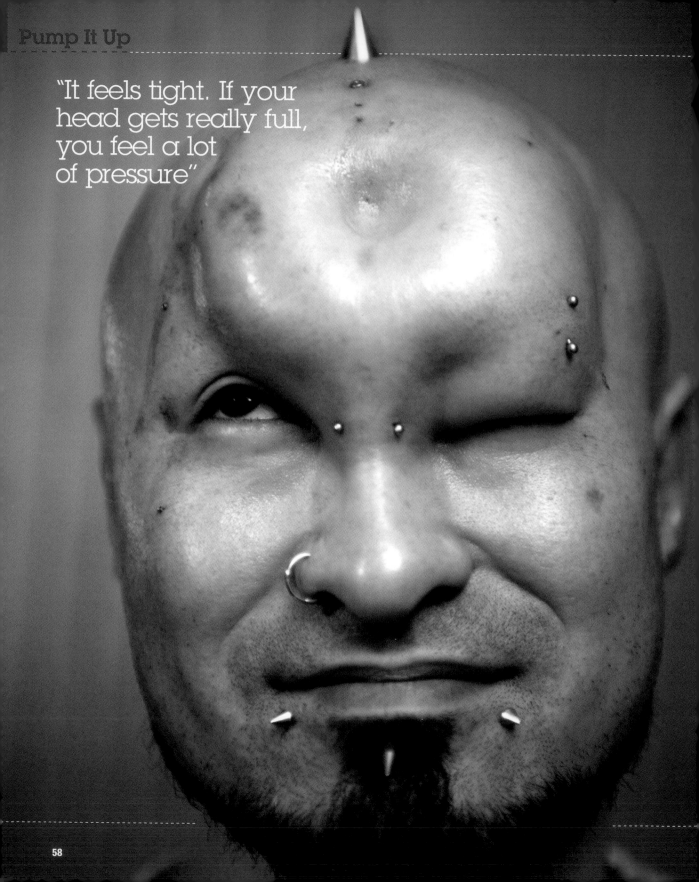

"It feels tight. If your head gets really full, you feel a lot of pressure"

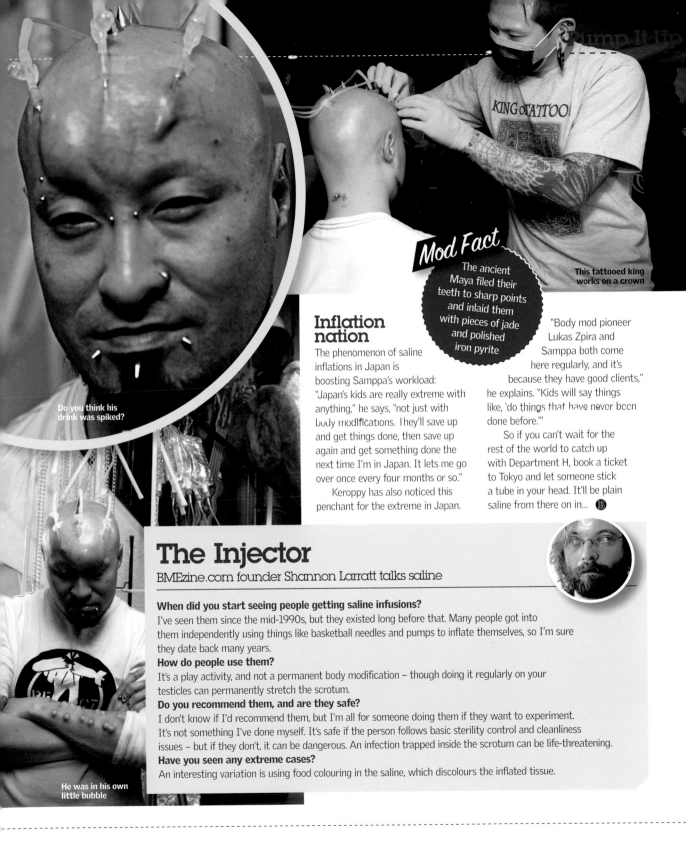

Do you think his drink was spiked?

This tattooed king works on a crown

Mod Fact
The ancient Maya filed their teeth to sharp points and inlaid them with pieces of jade and polished iron pyrite

Inflation nation

The phenomenon of saline inflations in Japan is boosting Samppa's workload: "Japan's kids are really extreme with anything," he says, "not just with body modifications. They'll save up and get things done, then save up again and get something done the next time I'm in Japan. It lets me go over once every four months or so."

Keroppy has also noticed this penchant for the extreme in Japan.

"Body mod pioneer Lukas Zpira and Samppa both come here regularly, and it's because they have good clients," he explains. "Kids will say things like, 'do things that have never been done before.'"

So if you can't wait for the rest of the world to catch up with Department H, book a ticket to Tokyo and let someone stick a tube in your head. It'll be plain saline from there on in... Ⓑ

He was in his own little bubble

The Injector

BMEzine.com founder Shannon Larratt talks saline

When did you start seeing people getting saline infusions?
I've seen them since the mid-1990s, but they existed long before that. Many people got into them independently using things like basketball needles and pumps to inflate themselves, so I'm sure they date back many years.

How do people use them?
It's a play activity, and not a permanent body modification – though doing it regularly on your testicles can permanently stretch the scrotum.

Do you recommend them, and are they safe?
I don't know if I'd recommend them, but I'm all for someone doing them if they want to experiment. It's not something I've done myself. It's safe if the person follows basic sterility control and cleanliness issues – but if they don't, it can be dangerous. An infection trapped inside the scrotum can be life-threatening.

Have you seen any extreme cases?
An interesting variation is using food colouring in the saline, which discolours the inflated tissue.

GIRLS

Here come the sexy, scary and funny girls

HOLLY LARGE

Tattoo by Roy Priestley, Skinshokz, Wyke, Bradford, UK

What is it? A zombie pin-up girl.

Why did you choose it? I like horror and pin-ups!

What response do you get from people? Some people think it's weird that I have a hot dead girl on my body.

How do you feel about it now? I still love it!

Would you change or add anything? I'm planning on getting a cartoon horror-themed sleeve adding to it.

What do you like about having it? It shows the subjects I'm interested in – pin-ups and zombies!

GEMMA

Tattoo by Erik Grieve, Tribe 3, Edinburgh, UK

What is it? Dita Von Teese standing inside a half moon.

Why did you choose it? I love Dita Von Teese and I've always wanted a pin-up tattoo. I saw this image in her book and knew it was perfect.

What response do you get from people? People take pictures of my back when they think I'm not looking!

Have you got any more ink planned? I'd like to get a 'make-up' sleeve with lipstick, splashes of colour, powder puffs, brushes and a mirror.

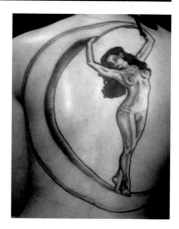

KAT HAZELTON

Tattoo by Rachael Huntington, Rampant Ink, Nottingham, UK

What is it? A beautiful gothic burlesque cat lady.
Why did you choose it? I've loved Rachael's artwork for some time, and got excited when I found out she'd become a tattoo artist. I was delighted to commission some of her work on my body.
What response do you get from people? Everyone's gobsmacked, and I've had loads of lovely comments from both men and women. Even Leonard Nimoy from *Star Trek* said it was a pure work of art! Now that's a compliment.

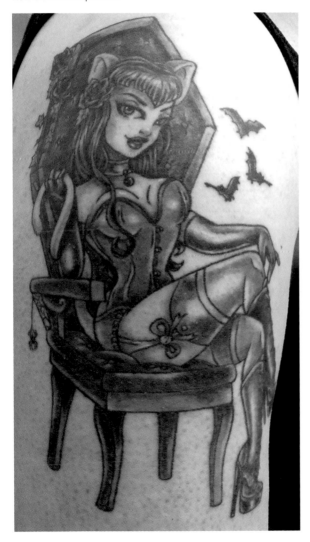

TONY DESTEFANO

Tattoo by Angel, Lady Luck Tattoo, Spokane, Washington, USA

What is it? A painting Tara McPherson did for the Melvins. It's on my left leg.
Why did you choose it? I love art. I love tattoos. It seemed like a good fit!
What does your family think about it? My parents prefer it when I wear something that covers it up! The rest of the family thinks it's pretty sweet.
What do you like about having it? I love this piece, and each piece of art that's put on to my body comes with a story about my life.

ERIC SAVARD

Tattoo by Will, Monster Ink Tattoo, St Paul, Minnesota, USA

What is it? It's chicks with guns and skulls on the left side of the middle of my back.
Why did you choose it? I got the basic idea from a Cut & Sew shirt by Marc Ecko that I got in Las Vegas.
What response do you get from people? They usually ask me who the portraits are of and I usually say, "Just chicks with guns, man."
What does your family think about it? I have so many tattoos that my mum and dad don't notice new ones!

MIKE LLOYD

Tattoo by Anthony, Cover'd Tattoo Studio, Exeter, UK

What is it? A devil girl in the style of alt.artist Coop's work, on my lower stomach.

Why did you choose it? I love the bold and fun nature of Coop's work and wanted to be able to take a piece around with me wherever I go. This tattoo reminds me not to take life too seriously.

What response do you get from people? No-one's reacted badly. My girlfriend likes it.

Have you got any more ink planned? Yeah, I've got a pretty big list of ideas – I think I'm going to end up multi-coloured.

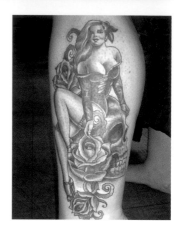

CLARE AFSHAR

Tattoo by Tommy Gunn, Tommy Gunn's Belfast City Skinworks, Belfast, UK

What is it? A sexy pin-up girl sitting on a skull and roses.

Why did you choose it? I've always loved looking through old posters and photos of pin-ups from the early 1940s and 50s; I love the hair, make-up, clothes, and their cheeky, innocent smiles.

What response do you get from people? They say, "Nice boobs!"

What does your family think about it? My mum loves her, but it's embarrassing when she gets me to show her friends when we're out!

BECCA 'TWINKLE' DAVIES

Tattoo by Mark, a friend

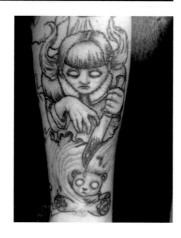

What is it? A Paul Booth piece on my left arm.

Why did you choose it? I love Paul's work, and this image jumped out at me and stuck with me for months. I just couldn't resist its dark, yet innocent, impact.

What response do you get from people? Some people can't understand why I have something so 'scary' tattooed on me, but everyone's entitled to an opinion and I'm glad my tattoos made them think for a moment.

LYLA GRAVES

Tattoo by Emma Kierzek, Aurora, Lancaster, UK

What is it? It's my little Russian doll, Stalin!

Why did you chose it? I love Russian dolls and had a rubbish Virgo symbol I wanted to cover up!

What response do you get from people? It's amazing how many old people stop me and say they like it!

What does your family think about it? They're accepting. Even my grandma likes it.

Have you got any more ink planned? Lots! My next tattoo will be Tara McPherson's *Bird Girl*.

LIAM ARTHUR

Tattoo by Rosca, Living Canvas, Eltham, Australia

What is it? A cartoon of the fetish model Amalthea. The original art was done by Boo (Theboo.deviantart.com).
Why did you choose it? I love fetish photography.
What response do you get from people? My folks flat-out hate tattoos, but everyone else I know loves it.
How do you feel about it now? I love it, but my only regret is that I can't get a full back piece now.
Have you got any more ink planned? I'd like a sleeve of traditional tattoos on my left arm.

DOM WARD

Tattoo by Adam Da Punk, New Wave Tattoo, London, UK

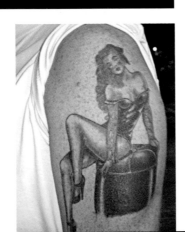

What is it? A 1940s pin-up girl.
Why did you choose it? I had a small tattoo that I wanted covering, and I love the pin-up art of Peter Driben.
What response do you get from people? Even people who don't like tattoos think it's cool.
What does your family think about it? They're surprisingly easy-going about it.
Would you change or add anything? I'd get the colouring touched up where it cracked slightly during healin

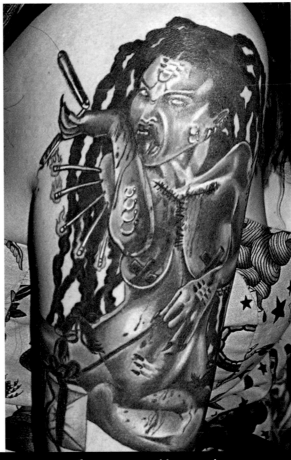

LISA KOZIOL-ELLIS

Tattoo by Su Houston, Chicago, Illinois, USA

What is it? It's a painting by Dorian Cleavenger called 'The Gift'.
Why did you choose it? It's glorious!
What response do you get from people? They're fascinated by it.
What does your family think about it? They despise it.
How do you feel about it now? It makes my vagina quiver.
Would you change or add anything? It's amazing the way it is.
What do you like about having it? I have my favourite piece of art with me all the time!

"I love having my favourite piece of art with me all the time"

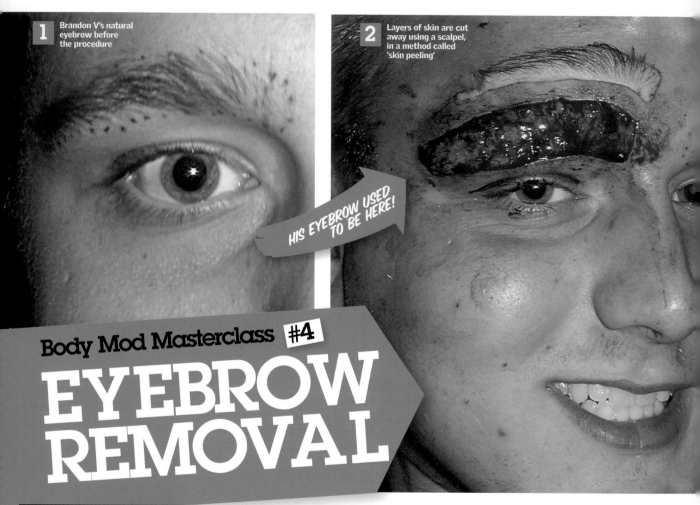

1 Brandon V's natural eyebrow before the procedure

2 Layers of skin are cut away using a scalpel, in a method called 'skin peeling'

HIS EYEBROW USED TO BE HERE!

Body Mod Masterclass #4
EYEBROW REMOVAL

Witness the changing face of body modification

Want to see a mod that's guaranteed to raise eyebrows? Check out Brandon V: he's a body piercer at Fillmore Tattoo & Piercing in California, and asked boss and friend Shawn O'Hare to rid him of his right brow.

"I've disliked the natural appearance of my eyebrows for as long as I can remember," Brandon explains. "I thought about tattooing the skin under them, but I didn't want the hassle of plucking or shaving to keep the ink visible. I considered a scarification design running through them, but I'd still have to trim and tweeze the hairs growing round the scar tissue. I settled on removing my brows completely, leaving eyebrow-shaped scars."

Shawn knew he had to proceed with caution and called his mentor, Steve Haworth, the mod legend who

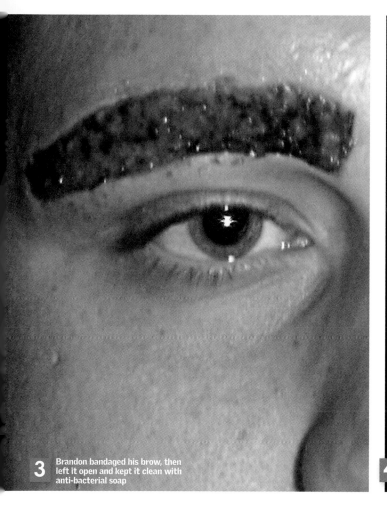

3 Brandon bandaged his brow, then left it open and kept it clean with anti-bacterial soap

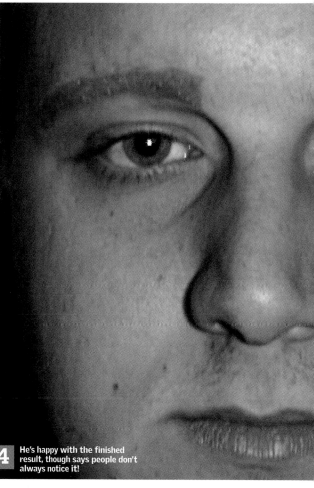

4 He's happy with the finished result, though says people don't always notice it!

invented the 'metal mohawk' – rows of transdermal scalp implants – and who's known for his surgical precision (p13). They agreed on a method called 'skin peeling', where areas of skin are completely cut away with a scalpel, rather than just sliced into. The mod was complicated because the skin around the eye moves a lot, making it hard for Shawn to cut out an accurate shape. Eyebrow hair follicles are also deeply rooted, so he had to cut further into the skin than usual.

Brandon has had extensive amounts of scarification elsewhere on his body, but had to treat his eyebrow removal differently. "You can purposefully irritate scarification wounds to make the resulting scar more raised, but I chose not to do that on my face," he reports. "Instead, I kept my ex-brow bandaged for the first few days to stop it bleeding and weeping

The skin around the eye moves, making it hard to cut an accurate shape

into my eye. As soon as it scabbed over, I left it open and kept it clean with gentle anti-bacterial soap."

Now he's planning to remove his left eyebrow – as soon as he's forgotten how much the right one hurt. "It's the most painful mod I've experienced," he admits. "I'm really happy with it, though. Weirdly, my missing brow tends to be one of the last things people notice about me. But perhaps that's not so odd considering I have a large, star-shaped sub-dermal forehead implant!" **B**

WITH THANKS TO ADAM AT BODYMOD.ORG

Maureen
Van Mortis

The new Queen Of Ink wears
her life story on her skin, and
she's had one hell of a ride

WORDS **ELEANOR GOODMAN** PHOTOS **STEVE NEAVES**

KJ432

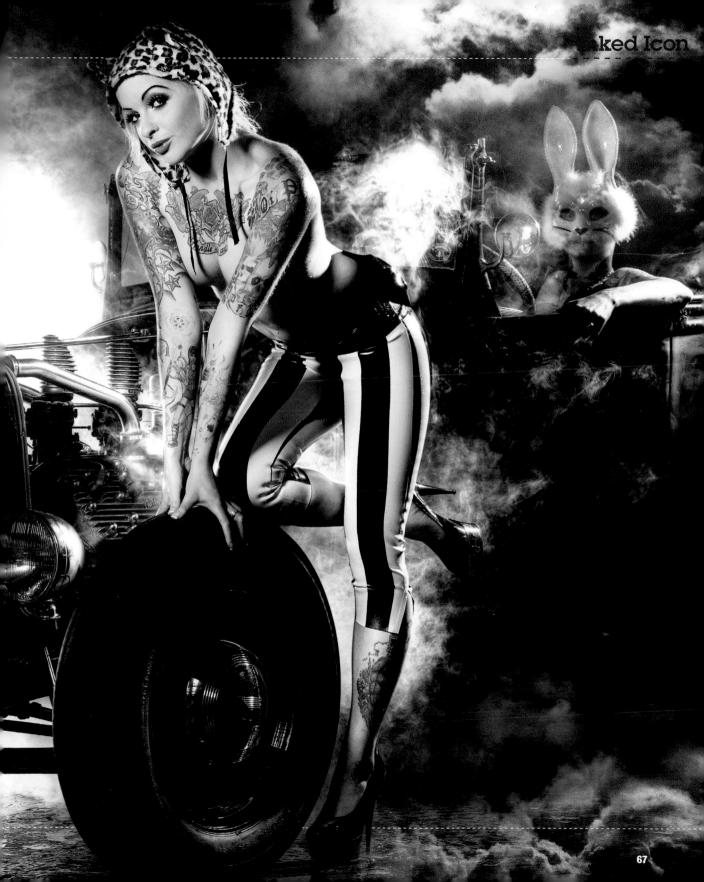

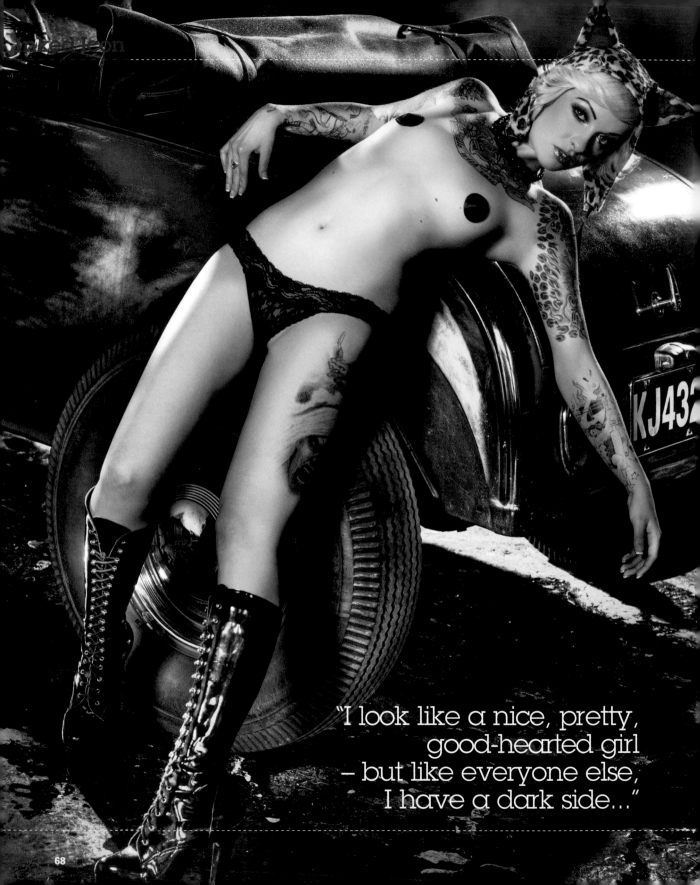

"I look like a nice, pretty,
good-hearted girl
– but like everyone else,
I have a dark side..."

W HEN MAUREEN VAN MORTIS moved from Slovakia to Vienna as a teenager she had to learn a whole new language, and found sanctuary in alt.club Arena. Here, she made friends with punks, got addicted to ink and carved out a life for herself. She began modelling in late 2007 and has been on the pages of fetish fashion magazine *Marquis*, shot a video clip with the Pander Brothers for their graphic novel *Tasty Bullet Girl* and has set her sights on Tinseltown. This 22-year-old's living life in the fast lane – and she won't slow down for anyone.

What was your childhood like?

My dad is Hungarian and my mum's Slovakian, so me and my sister went to a Hungarian school in Slovakia. We grew up with two languages, but we moved to Vienna with our mum when our parents divorced, so we had to learn German. I was 12 and other kids were mean to me.

When did you get your first tattoo?

I found a club in Vienna called Arena. So I went there with my bad German and got drunk, and started talking to people! It's where alternative people go and they used to stage punk rock festivals there. There was a security guy who was covered in tattoos and I was fascinated. Then I got my first tattoo when I was 17, through a friend-of-a-friend. I got an Agnostic Front boot and skulls because I was hanging out with street punks at the time. It made me feel cool – I finally had a punk rock tattoo!

What did your mum think?

I came home with the first three skulls and she said, "You're not going back to the tattooist!" So I said, "I can't leave it like this – I've started it, so I have to finish it." So she said, "OK, you can finish it but that's it – no more tattoos." But since I was 13 I've been doing what I want – I used to have 10 piercings in my face!

What made you get more ink?

I always have a tattoo when something happens in my life. I already had tattoos on my left arm, and wanted something on my right, so I got a heart with a dagger and a crying eye. I was in a long-distance relationship and we were apart, so it was a hard time. I combined it with angel wings because I got interested in Renaissance art.

What does your chest piece mean?

I was in fashion school, but I dropped out and began to sell all my stuff so I could go away and live with my long-distance boyfriend. Then we broke up and I was left with nothing. If you believe in something and it breaks down like a house of cards, it's hard. And I remember it because it broke my world. So I had this tattoo for myself, to start anew. After this tattoo my mum started to cry again, and then she stopped and said, "You're old enough now."

What did you do then?

I started working as a security guard at Arena. I was working, and after work I was drinking, doing crazy stuff, and talking too much! The next day I'd hold my head and think, "Oh my God, I did that?" That's the point where I said to myself, "Do I really need this?" So I started a hairdressing course.

Is that a self-portrait on your right forearm?

That's me! That was in 2006. I did the hairdressing course and a make-up course, but I didn't finish them. They didn't teach me enough and I was sure I'd fail my exams, so I had to leave.

When did you start modelling?

It was at the end of 2007, when a photographer called Lemontied found me on MySpace while he was looking for tattooed girls. I stopped drinking and started to eat healthily. Now I can't imagine not being a model. →

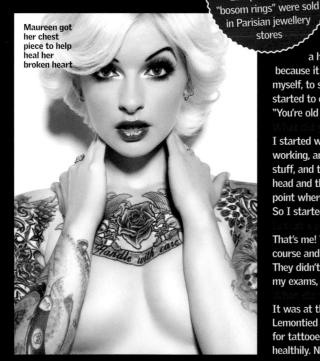

Maureen got her chest piece to help heal her broken heart

Mod Fact

In the 1890s nipple piercing was common among European society; "bosom rings" were sold in Parisian jewellery stores

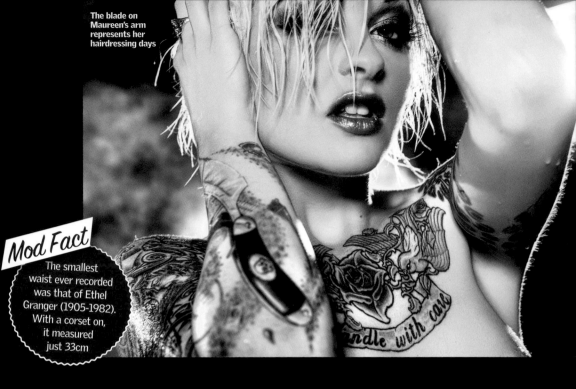

The blade on Maureen's arm represents her hairdressing days

Why have you got a vampire on your left leg?

I got it after I started modelling. I look like a nice, pretty, good-hearted girl, but everyone has a dark side to them – and I like vampires. They live for blood, come out at night and are so mystic. I'm not a big freak, but if I had to choose I'd just watch vampire movies. I love *Queen Of The Damned* and *Blade*! I'm thinking of doing the other leg differently so it has a 'good' theme. Then I'll have a bad leg and a good leg!

Have you ever tattooed anyone?

Myself, on my leg! It's under the vampire but you can still see it. Me and my tattooist decided to play noughts and crosses. I asked the artist, "Can I have a go with the tattoo machine?" I thought I'd at least win the game on my leg, but nobody did!

Do people ever stop you in the street to look at your tattoos?

Yes, especially if it's summer. Sometimes older people take my hand and say, "Wow!" I understand that they're curious. When I first got my tattoos everyone was looking, but I think times have changed. It's my story on me, and if someone asks about the meanings behind my tattoos then I'll tell them parts of it – but not the bits that are personal to me.

What was it like working with the Pander Brothers?

We shot a clip for a viral advertising campaign for their graphic novel *Tasty Bullet*, where I had to dress up. It was great to walk down the street in Santa Monica, wearing a pink wig! People came and took pictures of me. It was a similar feeling to walking down Hollywood Boulevard and seeing Batman or Jack Sparrow from *Pirates Of The Caribbean*. There was a guy who yelled from his car, "Britney!" Just because she's worn a similar wig!

What projects have you got coming up?

I'm going to play a drummer in a band in a movie called *The Blue Of Noon*. I can play already! It's my dream to be a great actress and live in LA. I love modelling, but I'd love to do movies too.

How do you think you'll feel about your tattoos when you're older?

If I meet someone who's 30 or 40 and has an old tattoo that's gone grey, it's nice, because they're still proud of it. Because of my body art, I can read myself like a book. When I get to 50 or 70 I'll remember my life because I'll know exactly why I wanted my tattoos, why I wanted Agnostic Front boots or punks, or the hairdresser – and I'll know it was a fun time. ⑬

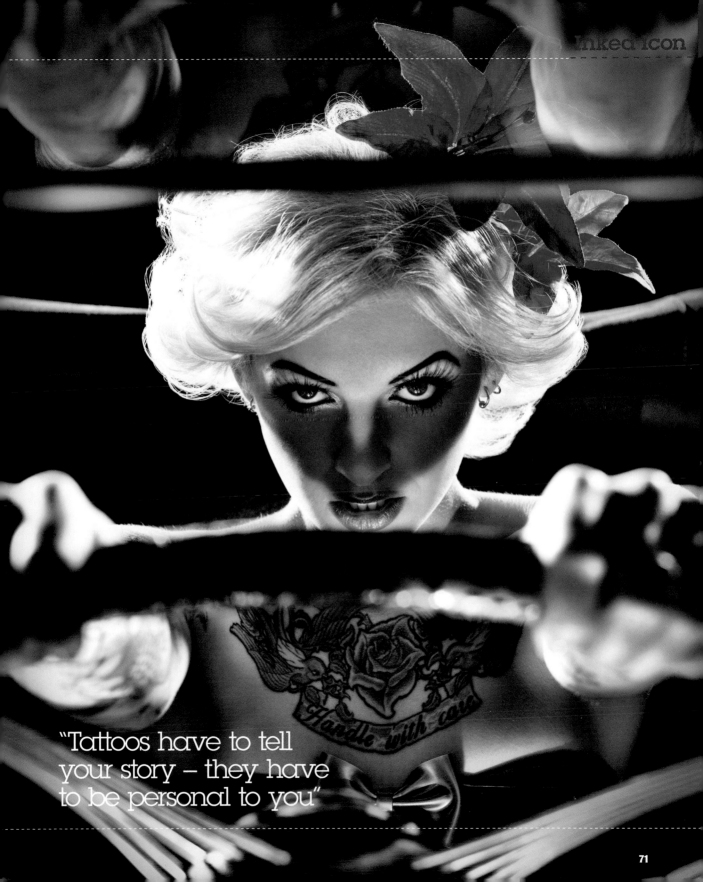

"Tattoos have to tell your story – they have to be personal to you"

LETTERING

Your favourite words as script or scrawls

AMELIA KNIGHT

Tattoo by Lars Pearson, Milton Keynes, UK

What is it?
A dedication to someone that I love.

Why did you choose it?
I didn't chose any of my tattoos – they chose me!

What response do you get from people?
Women always comment about how feminine it is. Men are visual creatures so they look anyway.

How do you feel about it now? I love it more and more every day.

What do you like about having it? Tattoos are like 6in heels – they make you feel sexy when you wear them.

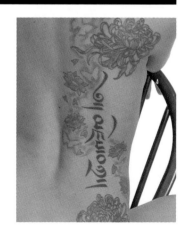

LLAMA

Tattoo by Evil From The Needle, Camden, London, UK

What is it? A Gumball 3000 logo.

Why did you choose it? It's a big passion of mine to race the Gumball.

What response do you get from people? I've had good reactions.

What does your family think about it? I don't think my dad knows yet, my mum doesn't like it.

Would you change or add anything? I want to add a Lamborghini Concept S and a Bugatti Veyron to it.

What do you like about having it? It shows I have a passion.

TOXIC ANGEL

Tattoo by Racheal Huntington, Rampant Ink, Nottingham, UK

What is it? The words, 'Toxic Angel'.

Why did you choose it? It's my alt.model name and it represents my personality – a little bit naughty and a little bit nice.

What response do you get from people? "Wow, that's amazing!"

Would you change or add anything? A shadow is on the cards, but I'm happy with it at the moment!

What do you like about having it? It's personal, and it peeks out under my top, which makes people want to know what it is.

ERICA JOANNE

Tattoo by Jonathan Napier

What is it? It's a rose, heart and skull with some lettering.

Why did you choose it? I wanted something that represented how I felt at the time, as well as something that would look nice. The words are from some of my favourite lyrics.

What response do you get from people? They ask what 'free again' means.

What do you like about having it? It reminds me of a time I was low and picked myself up, and how strong I am.

KAT REYNOLDS

Tattoo by Mick, Spellbound, Huntingdon, UK

What is it? The word 'Sycophant'.

Why did you choose it? I designed it because I was bored one night. I like the word's meaning, and it's a warning to be aware of sycophants. Plus, I like the inaccurate idea that people think I'm labelling myself.

How do you feel about it now? I don't like it until I see it, and then I get excited about it again. I added the Slipknot logo above it, and I think it puts the size of 'Sycophant' in perspective.

KRISTA NICOLEZOMBIE

Tattoo by Pablo, Impact Body Art, Calgary, Canada

What is it? A paisley half sleeve, with 'Hate' script on my left wrist.

Why did you choose it? It started out as just the word 'hate' on my wrist, but I wanted to cover up a bunch of scars from my self-harming past, so I got the paisley piece.

What does your family think about it? My brother's down with it, my mum understands the reasons behind it.

What do you like about having it? It took something that was hurtful and ugly, and made it beautiful.

HANNAH GREEN

Tattoo by Endre Szabo, Tattoo End, London, UK

What is it? An eagle feather from a Native American headdress with a banner reading 'Poppa', on my foot.

Why did you choose it? My Grandfather had Native American roots and passed away from cancer 5 years ago.

What response do you get from people? They comment on how realistic and detailed it is.

What does your family think about it? They love it! My Mum has a portrait of him on her arm and my Nana wants one – she's 83!

MELANIE LIDDELL

Tattoo by Jerry, Archangel, Glasgow, UK

What is it? A banner that's self-explanatory and represents me and my lifestyle.

Why did you choose it? I think you get some of the best fun from following the saying!

What response do you get from people? My close friends think it's really 'me'. Others look at me in a peculiar manner!

Would you change or add anything? I wouldn't change it for the world, but I'm considering getting whips or chains across my hips.

DANI GRAVES

Tattoo by Juan, Ultimate Skin, Leeds, UK

What is it? A Seasick Steve song title.

Why did you choose it? To remind me that, no matter how hard life gets, I came into this world with nothing – so I have more now than I did then.

How do you feel about it now? It's currently my favourite tattoo.

Have you got any more ink planned? I'm going to turn my left arm into a sleeve, get a Vincent Price tattoo, and a pint of Guinness. I'm slowly becoming a picture book of my life story.

PATT FOAD

Tattoo by Woody, Brighton, UK

What is it? Lyrics from Benjamin Britten's 'Corpus Christi Carol' as sung by Jeff Buckley.

Why did you choose it? I chose it when I was feeling deep remorse about people who've had their lives taken away, when they had so much to live for and give. We took individual letters from Jeff Buckley's handwriting and re-arranged them.

What response do you get from people? People don't realise it's a tattoo; they think I've scribbled on my arm.

JUDAS PISSED

Tattoo by Ginny, The Ink Pot Tattoos, Oldham, UK

What is it? A Crusader Cross, with a banner reading, 'And did those feet...'

Why did you choose it? It's the first line of the hymn *Jerusalem*. I love that period of history and I'm also a regular churchgoer. I would've loved to have been a Crusader – even if we did lose in the end!

What response do you get from people? They're impressed by the size (my back is 81cm across), and by the fact that the cross looks quite unique.

CARRIE CHAOS

Tattoo by Kat Kirk, Mastermind Tattoos, Huntsville, Alabama, USA

What is it? The seven deadly sins.
Why did you choose it? I'm fascinated with each sin.
What response do you get from people? Some are sickened, but others think that it's beautiful.
How do you feel about it now? I love it more every day. It's like having an art gallery with me at all times.
Would you change or add anything? I'm going to add some shading to look like bruising.

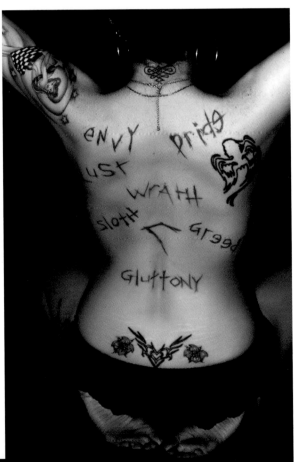

"I'm fascinated with each sin and love my tattoo more every day"

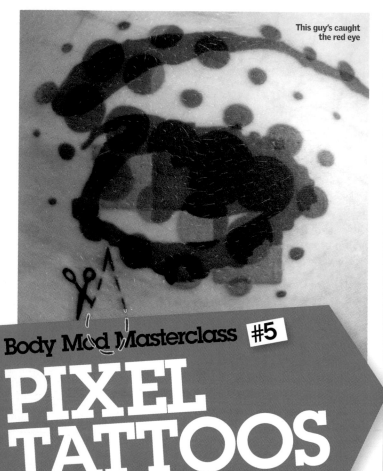

This guy's caught the red eye

A pixelated skull with surreal crossbones

Body Mod Masterclass #5

PIXEL TATTOOS

Transfering images from the screen to the skin

W hether it's a picture of Pinhead, a bloodied Joker or Kurt Cobain, portrait tatts can be found on many bodies. But now one artist has found a way to stop people taking faces at face-value, by pixelating them as if they were digital images. Jef at the Boucherie Moderne Salon in Brussels, Belgium, was inspired to experiment with pixels after seeing photos of singer Debbie Harry in a magazine. He drew her face several times, scanned the sketches into a computer, and manipulated them until he had a dotted effect. He then asked his colleague Kostek to tattoo the idea on his calf during a competition in Ireland, and they won a prize!

He's since repeated the process with recognisable figures such as Mr T from *The A-Team*, Frankenstein's

Starsky and Hutch: Bum chums

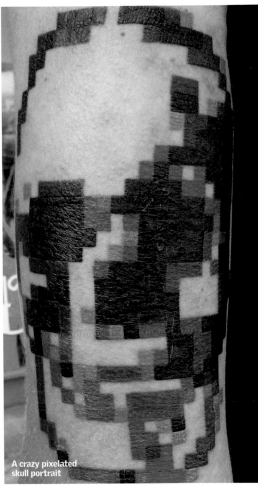

A crazy pixelated skull portrait

...Mary...

Jesus...

...and Frankenstein's monster

monster, the kids from *Little House On The Prairie*, and brothers Arnold and Willis from *Diff'rent Strokes*. "I prefer to draw kooky, kitsch and cult characters because I think tattoos should be joyful," explains Jef. "Ink isn't something you *need* – it's something you choose to have. We're lucky our lifestyles go beyond merely the struggle to survive and we can decorate ourselves, so we should have fun with it."

Jef's a real party monster and, since he left the Sint-Lukas art school in Brussels 18 years ago, he hasn't stopped feeling like a teenage student who's having exciting experiences and feeling inspired. "My life still revolves around rock concerts, travelling from place to place, meeting new people, and gathering ideas for illustrations wherever I go," he says. "Although these days I don't run after so many girls or smoke so much grass!"

Jef drew pixelated portraits of Starsky and Hutch on a friend's bum

This sense of humour is what prompted Jef to do his most ridiculous pixelated tattoo yet – portraits of 1980s cop show stars Starsky and Hutch on his friend's bum. They plan to add the words: 'Na-na na-na na-na na-na...' in red underneath, as if someone's singing the theme tune. Jef's also mixed the pixel technique with his surreal tattoos (p116) to unique effect, juxtaposing several unrelated images. It's all in keeping with his philosophy: "We have to build the future with brand new ideas." Ⓑ

PICTURES: BOUCHERIEMODERN.BE

IN YOUR FACE

Meet the people who've got one of the boldest and bravest body modifications – facial tattoos

WORDS **DENISE STANBOROUGH**

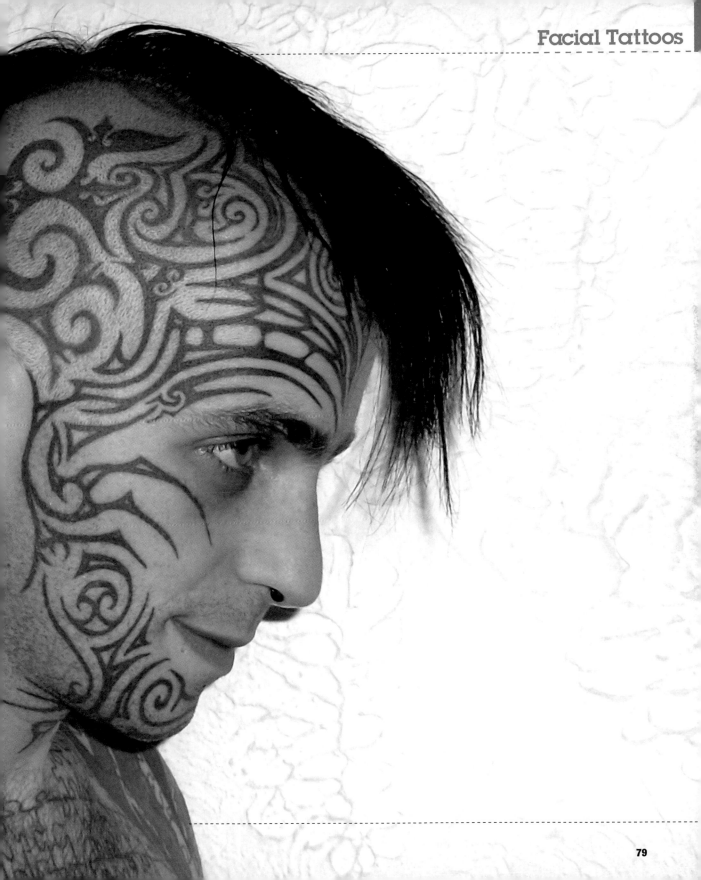

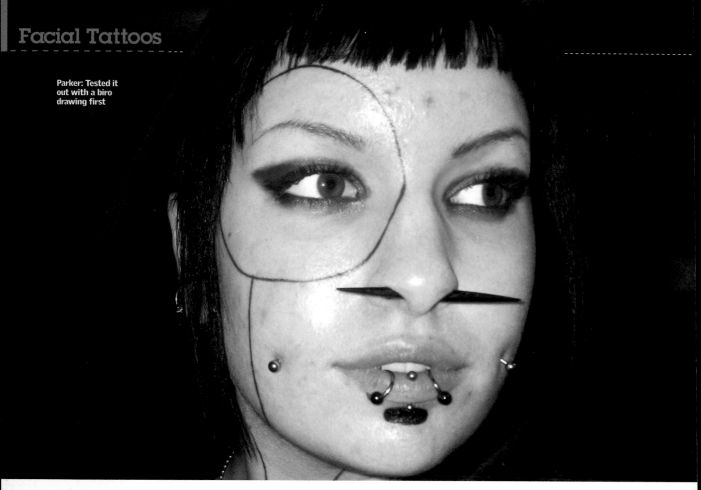

Parker: Tested it out with a biro drawing first

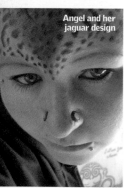

Angel and her jaguar design

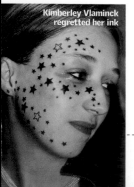

Kimberley Vlaminck regretted her ink

EARLIER THIS YEAR, 18-YEAR-OLD Kimberley Vlaminck emerged from her local tattoo studio in Belgium with 56 black stars cascading down her left cheek. She claimed she'd only asked for three, and that the tattooist had mistakenly inked the others on her face as she slept. Kimberley later admitted the truth – that she *had* asked for 56 – but her tale illustrates how popular inked icons such as Kat Von D, who has a constellation tattooed around her left eye, are influencing a generation who aren't afraid to put their face under the needle.

About face

Facial tattoos always make a statement, but people get them for different reasons. Pineapple Tangaroa, a 27-year-old from Austin, Texas, was influenced by his grandfather who'd received a tā moko tattoo on his face as a youngster – a marking associated with the indigenous Maori people of New Zealand. From a young age Pineapple wondered what it'd be like to have his own ink, but his first tattoo was far from Maori; instead, it was an image more important to a typical American boy…

"When I was 12, I paid a drunk hobo to help me find a tattooist who'd ink underage clients," he says. "And I got a really bad Thundercats logo on my leg!"

The tattoo gave Pineapple the bug, and he began a quest to have his face marked for life. "Two years ago, I had the design marked out through scarification first, just as my grandfather did. Then the tattoo went over the top to frame the scars," he explains. "It took five weeks to complete and when I saw the finished piece, I nearly broke down – it was fantastic."

Two years later, Pineapple is still happy with his design, but emphasises he did 10 years of research before having it. "Kids who jump into something like this don't realise how it'll affect their life," he says. "Recently, someone approached me in a shop to ask why I hated myselfso much that I did this to my body. I'm lucky – my wife and stepkids love me for who I am. Getting my face tattooed was the best decision I've ever made."

Angel Morris, 33, from Louisiana, was also interested in tattoos from a young age. She soaked up body art culture by spending most of her youth hanging around a tattoo studio in Seattle. After getting a blue rose inked on

PICTURES: EUROPICS

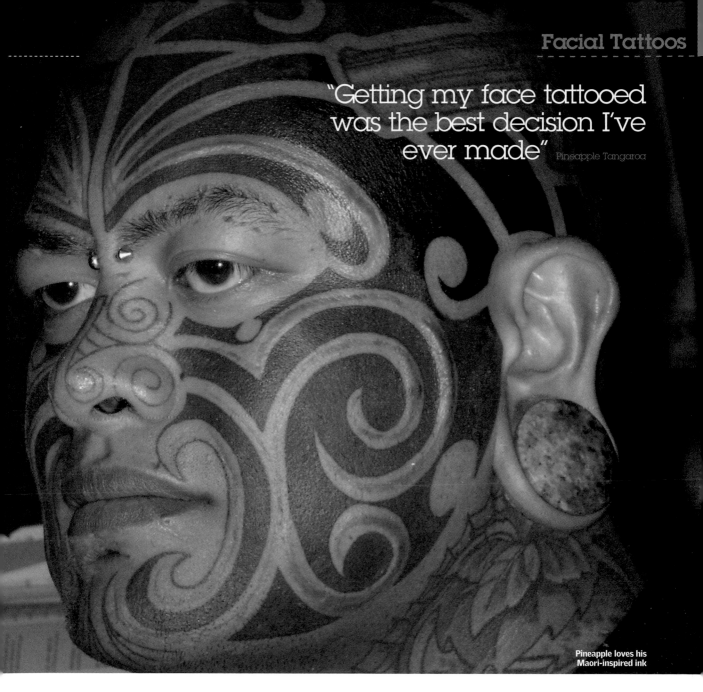

"Getting my face tattooed was the best decision I've ever made" *Pineapple Tangaroa*

Pineapple loves his Maori-inspired ink

her arm, Angel – who now works as a body modification artist – then got her chest, legs and neck inked, and finally had her entire forehead covered with a distinctive jaguar print design. She'd studied the animal's fur pattern for five years before she took the plunge.

"The jaguar is a graceful and mysterious creature, and those qualities inspired me to choose this design," she explains. "I knew it wouldn't be socially acceptable to get my face inked. People have made fun of me to my face, and I tend to get negative comments in big cities – but I'm strong. I can handle being different."

Marks on your mug

Another woman who clearly isn't afraid to be different is 21-year-old Parker Griffin from Texas. She had a simple black circle inked around her left eye after doodling →

Insectavoria unleashed at Coney Island

PICTURE: BETTINA MAY

the design on her face first. "I drew it on my face with a biro and left it for about two weeks to see how I felt about having it 24/7," she says. "I said to myself, 'Am I prepared to live under a bridge and eat squirrels to have this facial tattoo?' My answer was, 'yes!'"

But she's faced shocked, and sometimes aggressive, reactions from others. "One girl tried to start a fight with me in a bar by calling me Fido. I just said 'Arf!'" she laughs. "But I've thought about covering it up sometimes, because my folks gets embarrassed. They're hesitant to let me see extended family."

Bizarre reader Alex Hilpert was turned on to tatts after watching his favourite TV show, *The X Files*. While admiring the jigsaw-patterned full body suit of The Enigma in one episode, he was inspired to imitate it. "I started a jigsaw tattoo from my toes up to my neck soon after," he says. Alex finally gave

"The vibration of the tattoo machine made my eyeball rattle'" Insectavora

up his face to the needle in 1997 at a Borneo tattoo convention, and went for a tribal design. Originally from Switzerland, Alex now lives in Wolverhampton, UK, where he feels there's less prejudice. "The Swiss mentality is that only crooks, criminals and scum of the earth have tattoos," he says. "But on the plus side, you always get a seat on the bus!"

Alex has learned the hard way that reactions to his facial tattoos differ from culture to culture. "I went to Turkey, and within two hours of arriving I was beaten up by seven guys," he says. "They have strict views on tattoos over there and thought I was taking the piss."

On the job

And even if you're working in a field that's sympathetic to ink, you may still be unprepared for the physical act of getting a facial tattoo. Razor blade-muncher and fire eater Insectavora thrills the crowds at Brooklyn's Coney Island, but recalls the strange experience of going under the needle. "Getting my eyelids inked was weird!" she says. "You can't tattoo on the soft part, so they stretched my lid over my cheekbone. My eyeball kept drying out and the vibration of the tattoo machine was making my eyeball rattle around in the socket – it's the strangest thing I've ever felt!" →

Meet some old faces

A brief history of people who've toyed with their mugs…

Paul Sayce is the curator of the Tattoo Club Of Great Britain and runs Tattoo.co.uk. He knows his onions when it comes to the history of facial tattooing...

"Tattooing is one of the oldest forms of self-expression. In tribes, certain lines and patterns could tell a person whether you were a chief, a priest or even where your father came from. The earliest documentation we have about it is from 325AD when Constantine The Great of Rome banned it. After that it went underground.

"In the 1780s and early 1800s, explorers killed many inked tribes people just for their heads. The Maori tā moko designs were achieved by carving skin away and rubbing pigment in the wounds, and a decorated face became a prized possession.

"Between 1840 and 1950, inked freak show performers became popular. The Great Omi had thick, black swirls covering his face, and he claimed – falsely – that he'd been kidnapped by savages and forcibly tattooed.

"The 1970s punk scene saw a new wave of facial tattoos because kids wanted to rebel against society. There's definitely a resurgence of facial tattoos today, but it's long way off being totally acceptable. So, don't do it unless you've given it plenty of thought."

A tattooed Maori head

Mod Fact
The beauty spot on Dita Von Teese's left cheekbone is actually a tiny tattoo. She had it inked in California when she was 17

The Great Omi always got the chicks

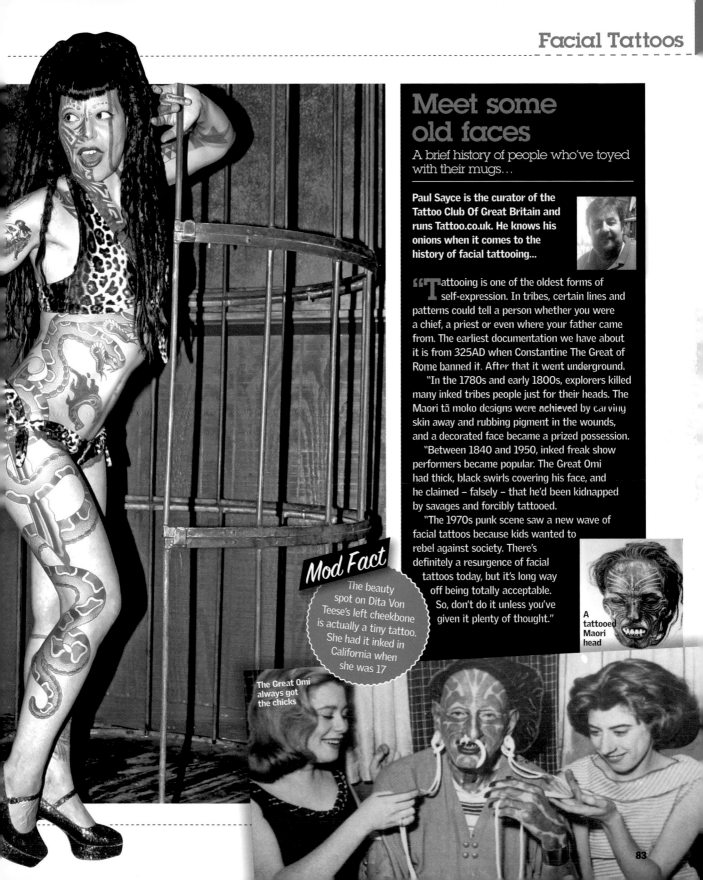

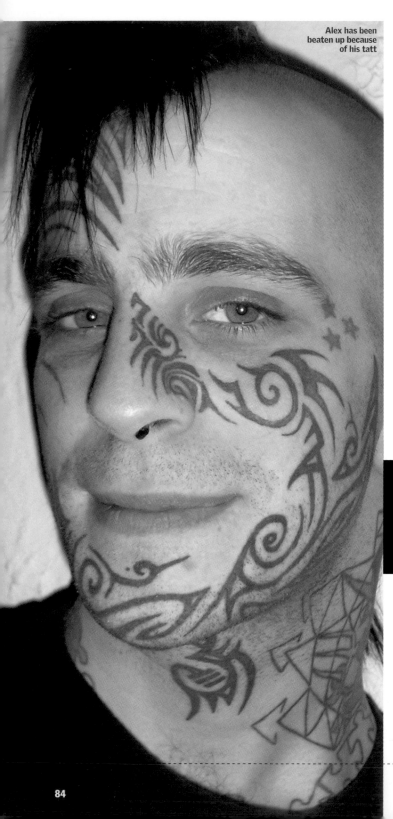

Alex has been beaten up because of his tatt

Close to the edge

However, despite the defiantly positive attitudes of the people on these pages, there's a darker side to having facial tatts. Some academic studies have made a link between people with tattoos and higher suicide rates. A study by Dirk Dhossche in 2000 concluded that tattoos were a possible marker of risk for young people, and another study in 2006 by researchers at Fordham University, New York, found a higher incidence of attempted suicide among tattooed modders.

Psychologist Dr Stuart Ross began studying people with ink after he counselled his tattooist, a man named Ian, who later committed suicide. "Ian was a close friend of mine who had 95 per cent tattoo coverage, including some on his face," he says. "Three days after he'd finished my tattoo, Ian hung himself."

Dr Ross has a theory about the correlation between those with facial tattoos and high suicide rates – though admits the link is anecdotal, and difficult to statistically verify. "I've known many people with facial tattoos," he says. "A few of them were tattooists who, like Ian, have taken their own lives. I'm not certain that getting a facial tattoo could influence someone's decision to commit suicide. But it could be argued that someone who does so would have the type of personality that engages in risky behaviour and has low levels of the chemical serotonin, which regulates impulsivity and is linked to suicide. The impulsivity that goes along with getting tattoos may also be linked to the tendency to end it all without working through the wider consequences."

"I psyched myself up for 10 years before I got it" Alex Hilpert

Stories like these are a wake-up call to those who want to cover their face in ink. "I psyched myself up for about 10 years," says Alex. "But even then I still wondered if I'd wake up and think, 'What the fuck have I done?' You've got to be so sure. Every day people make comments about me behind my back." But for Parker, the decision to mark her face permanently has only made her stronger. "It's made me more secure in myself," she says. "When I'm 80, I'll be in a nursing home just like you – but I'll have more visitors because I'll be the cool old lady with the tattooed face!" **ⓑ**

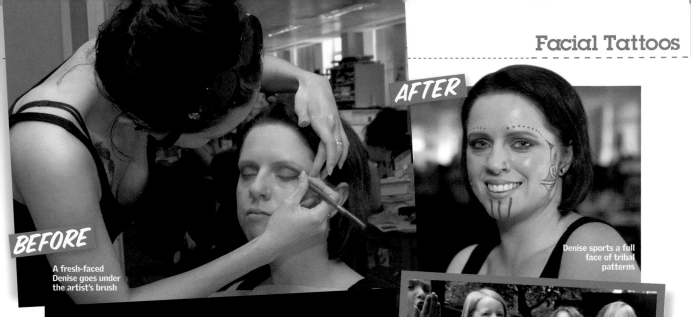

AFTER

BEFORE

A fresh-faced Denise goes under the artist's brush

Denise sports a full face of tribal patterns

Inked for a day

Bizarre writer Denise gets a fake faceful of tattoos and hits the streets to test people's reactions

"After grilling folk about their facial tattoos, it seemed only fair that I should get a taste of life with an inked face. In the make-up chair for my 'fakeover', I'm transformed from a plain Jane to someone that'd look at home on BMEzine.com's Modblog. But will people treat me differently? I hit the streets of London to do some face-to-face investigations...

"Leaving the security of Bizarre Towers, I skip off to the British Museum and bump into a gaggle of kids on a school trip. 'Why did you have that done?' asks a little girl with plaits. 'I think you look like a boy,' remarks one lad. 'You look like a Red Indian!' shouts another – and then the whole group start jumping around, whooping and patting their mouths while making a racket. No one runs away crying so I think I got the thumbs up.

"Next, it's time to hit the elegant shops along New Bond Street. The doorman at Louis Vuitton doesn't falter in greeting me as 'Madam' as I walk in – and the manager in luxury shop Asprey humours me as I request prices of obscenely-sized diamonds. In the posh Burlington Arcade, an elderly man tells me that the designs are good, but 'not on the face, love'. Then I wander into a shoe shop, and straight into a heated debate. 'I don't agree with what you've done to yourself,' says Dorothy, a perfectly-coiffed lady who's visiting London from South Africa. 'God gave you that body and you've defaced it.'

"Not even the revelation that my facial tattoos are fake calms her down. Apparently, my real facial piercings are defacement, too.

"After these grillings, I'm ready to wipe my kisser clean. I'm surprised and pleased that I engaged positively and negatively with many more people than I would on a normal day, but I've discovered that living comfortably with facial ink requires a thick skin, utter self-acceptance and oodles of self-esteem. Now, where did I put my wet wipes?"

PICTURES: JOE PLIMMER

The Red Indian with the red hair

"You need a flat cap to complete your look!"

Making some new friends

HORROR

From movies to monsters, it's your scary skin

MISS MONSTER

Tattoo by Cheryl at Amorphous, Swadlincote, Derbyshire, UK

What is it?
Frankenstein's monster.
Why did you choose it?
I love the Universal monster films, so I decided to get a sleeve with all the monsters on. This is my favourite one.
What response do you get from people?
I mostly get nice comments but some people say, "Urgh, why did you get that?"
What does your family think about it?
They love it, especially my 7-year-old sister!
How do you feel about it now? I still love it.

GARETH GLOYNE

Tattoo by Andy Robbins Tattoo Studio, Grimsby, UK

What is it? A werewolf in a graveyard with the moon in the background.
Why did you choose it?
I've always been a big fan of horror, and of werewolves in particular.
What response do you get from people?
They love all the detail.
How do you feel about it now? I love it and want it extending to get rid of the tribal that goes across my shoulders.
Would you change or add anything? I'd like to get the writing gone over in black, as it was from a previous tattoo.

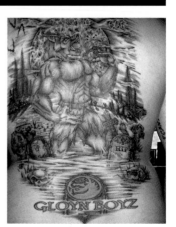

TERRY HAWKINS

Tattoo by Tom, Urban Image, Dorset, UK

ZARA RHODES

Tattoo by Hazel Nicholls, Design 4 Life, Liverpool, UK

What is it? The Gill-Man, AKA the creature from the black lagoon!
Why did you choose it? I love all the Universal horror movies!
What response do you get from people? People think it's wicked but they usually haven't seen *The Creature From The Black Lagoon.*
How do you feel about it now? I love it!
Have you got any more ink planned? A lot! I'm getting 10 Bats on my head around *The Omen* '666' tattoo I have, to go with the three bats behind my ear.

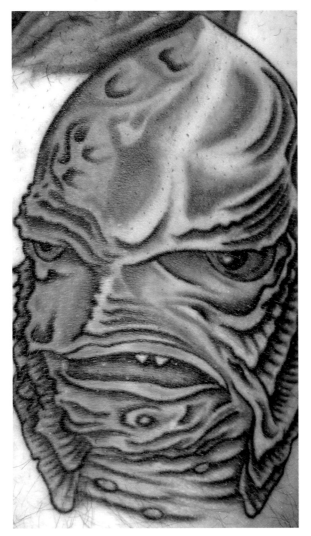

What is it? A zombie baby in the womb, eating its own arm!
Why did you choose it? Hazel drew it up and asked if I wanted it. I said yes because I love it! It was done at Northlakes Tattoo Show, Carlisle, UK.
What response do you get from people? It's like Marmite – people either love it or hate it.
How do you feel about it now? I love it!
What do you like about having it? It freaks people out, especially my mum's Christian friends!

BOZMAN

Tattoo by Andy at Gecko Images Tattoo Studios, Easington, County Durham, UK

What is it? A theme based on The Three Wise Monkeys, called 'See No Evil, Speak No Evil, Hear No Evil'.
Why did you choose it? It was specially designed for me by my artist friend Gavin Mayhew. (Artist-gavinmayhew. co.uk).
What response do you get from people? Some love it, but some are freaked out by it.
What does your family think about it? Shhhhh, they don't know!
How do you feel about it now? It's groovy.

MARTIN DUGDALE
Tattoo by Lynn Akura, Magnum Opus Tattoo, Brighton, UK

What is it?
Jesus metamorphosing into Satan. It's based on the inlay artwork of Cephalic Carnage album *Xenosapien*.
Why did you choose it?
The piece symbolises the hypocrisy within the Christian Church, and how Christianity is incrementally mutating into LaVeyan Satanism.
What response do you get from people?
People are surprisingly positive about it and usually amazed, but my mother despises it with her whole heart.

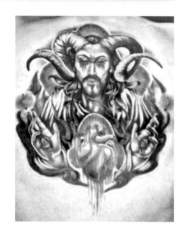

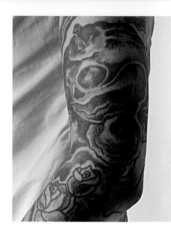

JODY COOMBES
Tattoo by Steve Byrne, Ultimate Skin, Leeds, UK

What is it? A scary pumpkin and roses.
Why did you choose it?
I love horror films, and the roses were inspired by Type O Negative.
What response do you get from people?
People love the imagery, and have interpreted it in their own ways.
What does your family think about it?
My mum didn't know about it until a year later. She was shocked.
What do you like about having it? It reminds me who I am and inspires my design work.

PHIL NICHOL
Tattoo by Lee Aitken, Retro Rebels, Aberdeen, Scotland, UK

What is it A Bat clutching a coffin over a *fleur-de-lis*-style cross on my thigh.
Why did you choose it?
I love vampire movies and it was a great image to turn into a tattoo.
What response do you get from people?
Friends say the detail looks really good.
What does your family think about it?
They've always known I was a little strange but the tattoo confirmed it.
Have you got any more ink planned? A gothic cross on my other thigh.

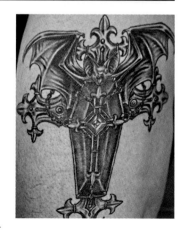

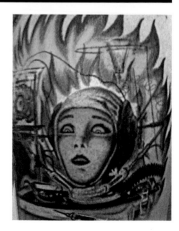

LAYNE D'ANGELO
Tattoo by Michael C, Last Angels Tattoos, Dallas, Texas, USA

What is it? A movie poster from the 1959 cult classic, *The Brain That Wouldn't Die*.
Why did you choose it?
I'm a horror movie freak.
What response do you get from people?
They comment on how beautiful the colours are.
What does your family think about it?
They don't like my ink.
What do you like about having it? The incredible colours, the fact it was done by someone I love dearly, and that every piece gets me closer to covering my thigh.

CHRIS HODSON

Tattoo by Chris Long, Room 16 Tattoo Studio, Ebbw Vale, Wales, UK

What is it? A black and grey demon face.

Why did you choose it? It's part of an ongoing design of demons and other devilish creatures.

What response do you get from people? Everybody who's seen it seems to like it.

What does your family think about it? My grandmother is religious and I think she fears I'll go to hell.

How do you feel about it now? It's amazing. When I've added to it I'll look like a hellish Sistine Chapel. I can't wait!

IAN PETRIE, AKA 'REAPER'

Tattoo by Vision Ink, Hucknall, Nottinghamshire, UK

What is it? The grim reaper.

Why did you choose it? I have a thing for him.

What response do you get from people? People think it's amazing, wicked, and ace.

What does your family think about it? They wish I was normal – they don't understand the goth image.

Would you change or add anything? I'd love to get a graveyard under it, which would go up to two gothic sleeves.

What do you like about having it? It suits me.

TOM WELLS

Tattoo by Kevin Paul, 7th Day Tattoo, Derby, UK

What is it? Ripped skin on my inner arm.

Why did you choose it? I'm a big fan of Kevin Paul's ripped skill – he's by far the best at horror stuff in the UK. I told him what I wanted, and he just got a pen on my arm and made it happen.

What response do you get from people? They just love it, because it looks real.

How do you feel about it now? I love it and I'm definitely going to get some more work by Kev.

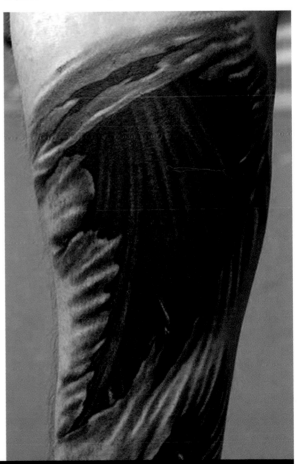

"People just love my ripped skin, because it looks so real"

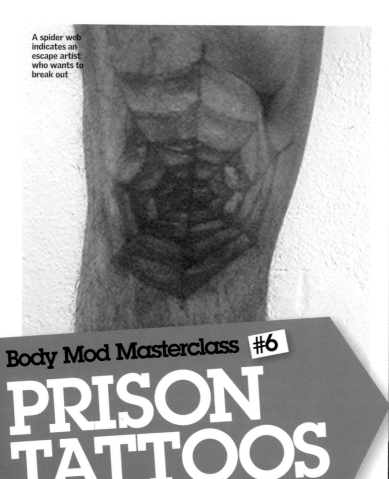

A spider web indicates an escape artist who wants to break out

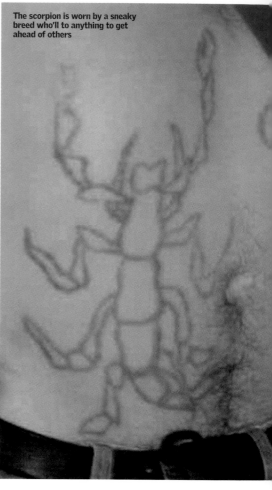

The scorpion is worn by a sneaky breed who'll to anything to get ahead of others

Body Mod Masterclass #6
PRISON TATTOOS

IMPORTANT!
DON'T TRY THIS AT HOME

IT'S DANGEROUS! IF YOU
WANT TO MODIFY YOUR
BODY IN ANY WAY,
SPEAK TO A PRO

Decoding criminal ink from the clink

By interpreting a few dots of ink on a felon's skin, it's possible to tell whether he's forgiven his enemies, holds grudges, or is even plotting to kill. Professor Eloy Emiliano Torales, a criminologist at the Ministry Of Justice in Argentina, says one of the most common prisoner tatts there is five spots, spaced as though on a dice, etched between the thumb and first finger. "On the left hand, the middle spot represents the prisoner and means he was once captured by four policemen," explains Professor Torales. "When the spots are on the right hand, the tables turn: the inmate has sworn an oath to track down and kill a cop as vengeance, and it'll soon be the policeman who finds himself surrounded."

Daggers also symbolise revenge, and an image of a blade entwined by snakes signifies that the wearer

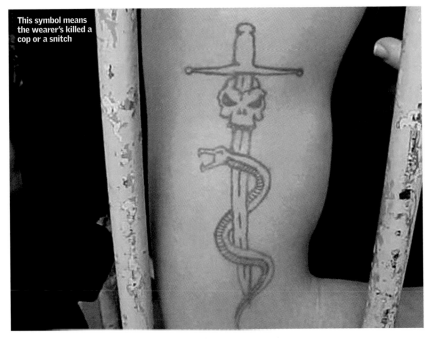

This symbol means the wearer's killed a cop or a snitch

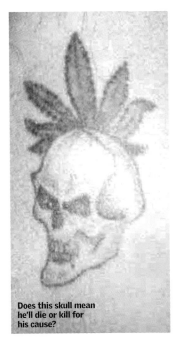

Does this skull mean he'll die or kill for his cause?

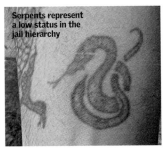

Serpents represent a low status in the jail hierarchy

Another man sports the symbol of escape

This man was captured by four police officers

This prisoner has skill with a 'shank', a crude home-made weapon

has already slain a police officer or a snitch. Snakes also indicate jail hierarchy status; serpents are a fairly lowly creed, although when drawn with a forked tongue they signal skill with a shank – a crude weapon fashioned from whatever the prisoner can smuggle into his cell. A scorpion marks a sneaky breed willing to do anything to advance up the jail food chain, while lions are always pictured with their claws out, ready to strike. At the very top of the tree are thugs branded with a badge known as 'La Santa Muerte' or 'The Saint of Death'; a shrouded female figure frequently holding a scythe and a globe. These prisoners are alleged to be part of a death-worshipping cult and are guilty of serious crimes, almost always murder.

"They often have a child's finger bone inserted under their tattooed skin as a black magic ritual to protect them from bullets," explains Professor Torales.

Some prisoners are part of a death-worshipping cult and have murdered

"Does it work? Well, we've encountered killers who've been shot eight times and survived..."

A symbol of a flaming skull reveals the prisoner will die or kill for their cause. "One inmate recently had this symbol inked on his arm just before he was released – when he went and kicked three old people to death in their own home," Professor Torales says. But one of the most dangerous designs is a spider web – displayed by an escape artist who'll try any trick to break out. ⑬

TRANSLATED BY JAMES MARRISON

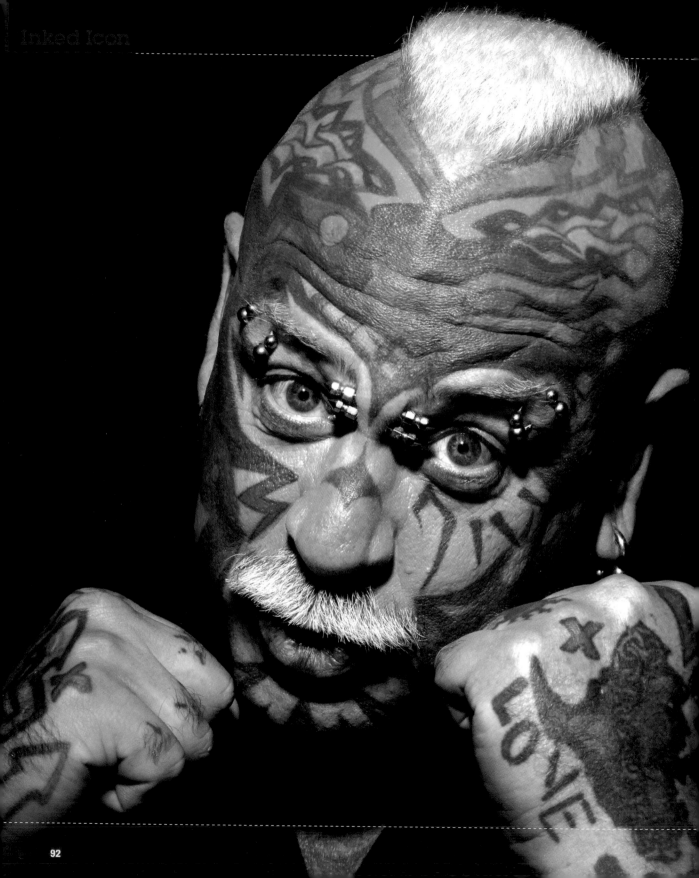

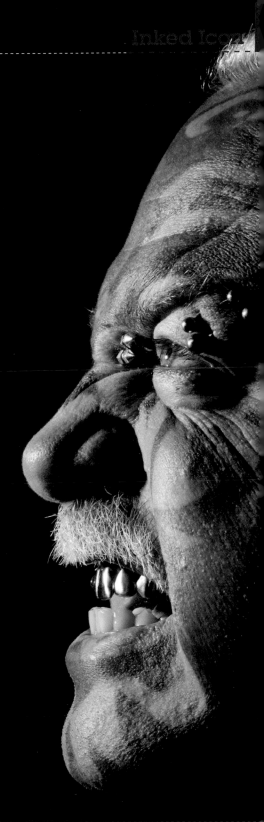

The SCARY Guy

He's angry, he's inked, and he's coming to teach you a lesson you won't forget…

WORDS **DENISE STANBOROUGH** PHOTOS **ABBIE TRAYLER-SMITH**

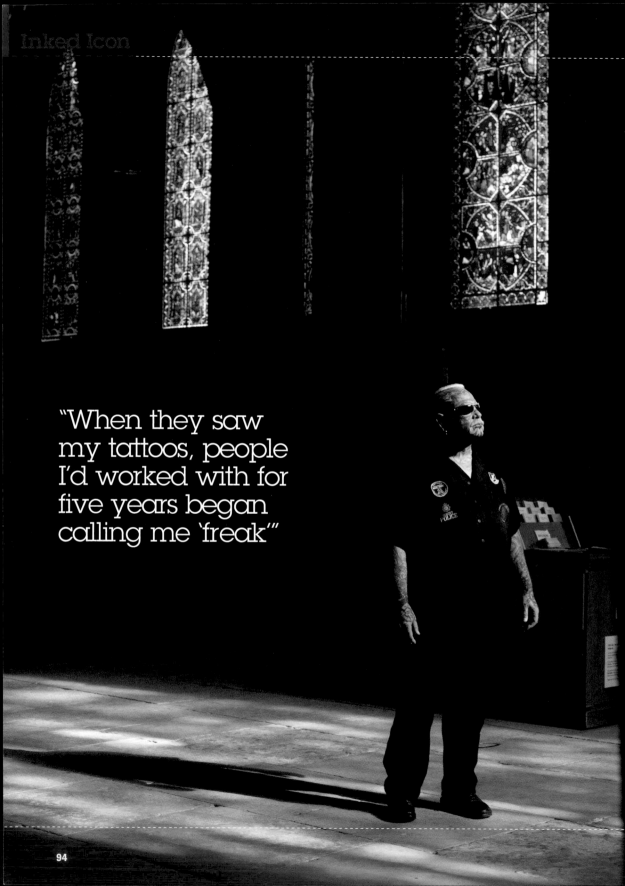

"When they saw my tattoos, people I'd worked with for five years began calling me 'freak'"

THE SCARY GUY WASN'T ALWAYS known by this name, but today it's officially his title. Battling dyslexia as a child, Earl Kenneth Kaufmann discovered an incredible ear for music but, accepted into one of the best vocal colleges around, he fell behind on his studies and left to work in a sheet metal factory. Life was looking bleak. A job in computer sales and one divorce later, he stuck two fingers up at the corporate world, opened his own tattoo parlour and gradually acquired an impressive collection of ink, including the striking patterns on his face. After an epiphany, Scary realised his calling was to hit the road armed with a powerful message.

Tell us a bit about your upbringing.

I was born in 1953 in New Hope, Minnesota, USA. My father was a product of WW2 so, for him, children were to be seen and not heard. He was one of those silent angry guys, but you didn't dare talk to him. He seemed to have a sense of humour because he was always making fun of those around him, cracking mainly racist jokes, and as a kid I didn't know the difference. If he laughed at something then I laughed along with him, and so I learned the same humour.

How did you first come into contact with tattoos?

My dad had two big anchors on his arms. All his buddies in the navy had tattoos on their forearms and biceps. I remember at eight years old standing in our garage looking at all these guys with tattoos and a beer in their hand, thinking, "So that's what a man is".

You got your first tattoo at age 30. What led you to finally take the plunge later in life?

That's a long story! I got married at 19 years old, but before that, I'd attended one of the finest vocal colleges in Minnesota to do a vocal performance major. I didn't know it at the time, but I was dyslexic and, to this day, I've never read a book. I struggled through school and I managed a year in college before I had to drop out. I was fine when I was singing, but I couldn't keep up with the reading. Moving from school to employment was horrifying and I was bent out of shape emotionally. I ended up working in a sheet metal shop.

How did that affect you?

It was a hard time for me. After I got hitched, I worked as a baby portrait photographer, and enjoyed it, but I was never quite happy with my career. I'd wake up and ask myself, "What am I doing here and what am I all about?" It was a nagging feeling that my peg didn't fit the hole. I went into computer sales next in 1980 and did really well at it. I was still in this job when I got my first tattoo.

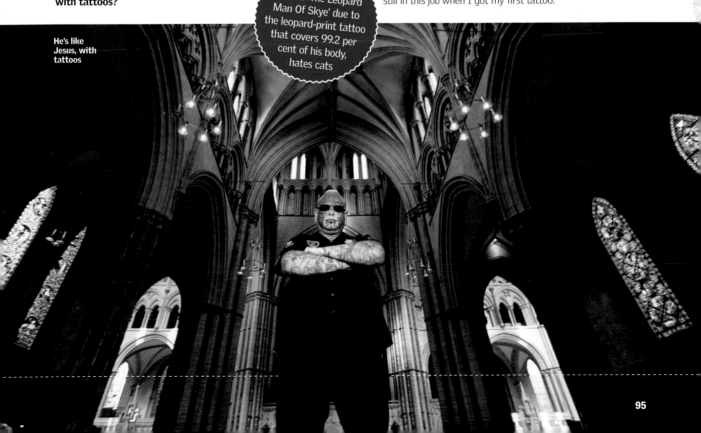

He's like Jesus, with tattoos

Mod Fact
Tom Leppard, dubbed 'The Leopard Man Of Skye' due to the leopard-print tattoo that covers 99.2 per cent of his body, hates cats

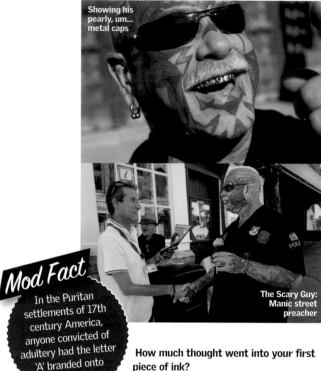

Showing his pearly, um... metal caps

The Scary Guy: Manic street preacher

How much thought went into your first piece of ink?

Not a lot! I was driving through Tucson, Arizona, while visiting my brother, when I spotted a tattoo studio. Impulsively, I stopped the car, went in, looked over the flash designs on the wall and picked out a green dragon because I thought it symbolised strength. I had it inked onto my bicep where I could hide it, but when I looked in the mirror I felt uneven, so the next day I drove back and had a tiger on the other arm. I was on a roll then, so the next day I drove back again and had a panther on my chest, and then the day after, a big dragon on my back.

Why the hurry?

I was in a bad marriage, but I didn't know it at the time. When I returned home, my wife was livid. Subconsciously I think I knew the tattoos would freak her out. Eventually, we split and went our separate ways.

When did the face ink start?

While I was working as a computer salesman, my company arranged a barbecue. My colleagues knew I was tattooed, but had never seen them. When I arrived in shorts and a T-shirt, these people, who I'd worked with for five years, began treating me differently, gossiping behind my back and calling me 'freak'. It was a real eye-opener. Around the same time, my mother passed away and left me some money, so I left the company,

learnt how to tattoo, opened a parlour in Tucson in 1994, and had 'Love' in Sanskrit inked on my neck. I did it so I could never go back. By 1995 half my face was tattooed.

So what changed?

In 1996, someone from a neighbouring tattoo studio in Tucson ran a full page advert in a local newspaper saying, "Are you tired of dealing with scary guys with war paint facial tattoos?" It was a personal dig at me. My first thought was to jump on my hotrod, find his house and run over his dog, but suddenly I had a lightbulb moment. I thought, "I'm a hater, a name caller, I stereotype and categorise people. Shit, I'm just like all the people I've been finding fault with all my life." I woke up to the fact I was full of shit like the rest of them.

Did you up and leave on the spot?

The next day I woke up angry. I found my friends and told them I was packing my bags and leaving to travel the world, to help people see each other differently from the inside out. They laughed and said, "How are you gonna do that?" I said, "I don't know, but I can tell you one thing for sure. I think I've just wasted 43 years of my life calling myself a good guy and living a lie."

Why did you change your name to The Scary Guy?

Because it's the first thing people think when they see me. It's what the tattooist called me in the paper advert so I picked up on it. I legally changed my name in February 1998 and had to go to court to do it. The story ended up in the newspapers, and a Tucson high school teacher read about me. She approached me in a restaurant one day and asked if I'd visit her school and speak to the kids, so I did and they were really engaged. That's how I began spreading the message.

What's the essence of your message?

To stop the name-calling and the hating, and help people to look in the mirror and take responsibility for how they behave. I work with schools because it starts there, but I've also worked with companies, social workers, governments, police – even military. The root of the problem is learnt behaviour, but the solution seems to be a reactionary programme focused on dealing with the behaviour after it's occurred, like jail, police, ASBOs and gun laws. None of those systems effect change in the human psyche, they just control people. There's nothing out there teaching people they have the power to stop producing negative energy, and that's the core of what I want to get across with my talks.

Have you got any more ink planned?

I'm still having my face tattooed and my most recent one was a lightening bolt. But last year I had 540 pending work requests in my inbox, so now I concentrate on tattooing the hearts and minds of millions of people. ⑬

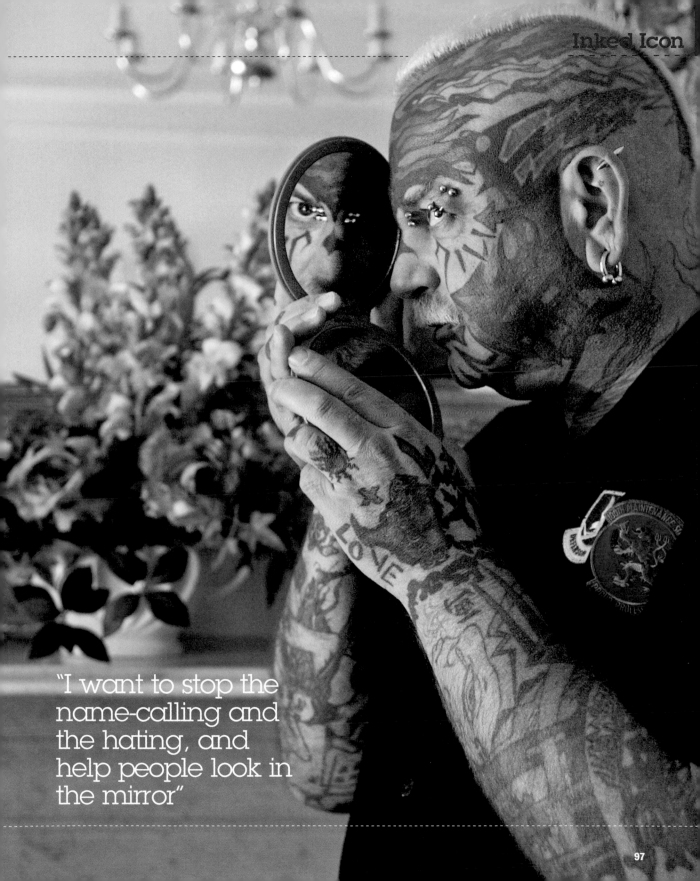

"I want to stop the name-calling and the hating, and help people look in the mirror"

FLOWERS

The secret gardens inked on your bodies

POPPY SCARLET

Tattoo by Charlie, Urban Ink Tattoo Studio,
Southend-On-Sea, UK

What is it? Two poppies on my left ribcage.

Why did you choose it? I painted the picture as a tribute to my grandfather after he passed away; he died on Remembrance Sunday at a church service, and had helped sell poppies for The Royal British Legion.

What response do you get from people? People probably think it's a pretty picture, but it means a lot to me.

What does your family think about it? I think my grandmother would be a little surprised.

GARETH MOORE

Tattoo by Arran Burton, Cosmic Tattoo,
Colchester, UK

What is it? A rose with diamonds around it.

Why did you choose it? It's the first part of a sleeve. I really liked the boldness of big roses but I wanted something a little different to go with them. Diamonds remind me of my childhood, as my dad always listened to 'Shine On You Crazy Diamond' by Pink Floyd!

What response do you get from people? Most people are amazed by the boldness of the colour and design, and my family love them.

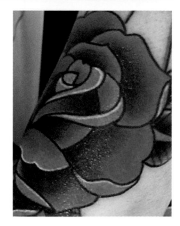

KIRSTY FRASER

Tattoo by Frank, Creative Art Tattoo Studio, Glasgow, Scotland, UK

What is it? Tiger lilies and vine work down my back.

Why did you choose it? Lilies are my favourite flower.

What response do you get from people? Everyone that's seen it loves it; they think it's beautiful.

How do you feel about it now? I still love it and I think it was well worth the 13 hours it took to complete.

Have you got any more ink planned? I'd like to fill my back and I'm working on flower and animal sleeves now.

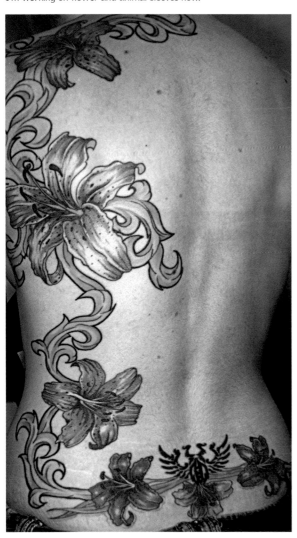

CRIS PATRICK

Tattoo by Darryl Gates, Diamond Jacks, London, UK

What is it? A Japanese lotus half sleeve.

Why did you choose it? I've always loved traditional Japanese art, especially the woodblock prints, and I see the lotus flower as a sign of beauty. The tattoo reminds me to be the best I can be.

What response do you get from people? Most people love it.

What does your family think about it? My mum secretly likes it and even admitted to it being "quite nice". My dad doesn't approve.

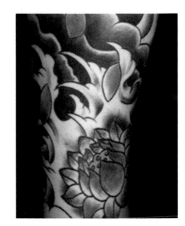

EMMA LOUISE GLOVER

Tattoo by Darren, Skin Graffiti, Wigan, UK

What is it? A lily.

Why did you choose it? I really liked the design.

What response do you get from people? People say it's really nice.

What does your family think about it? They like it.

How do you feel about it now? I really like it!

Would you change or add anything? No.

Have you got any more ink planned? Yes. I'll probably have something similar on my leg.

What do you like about having it? It looks good with short little tops.

LAURA JANE PHOTOGRAPHY

PAT HALL
Tattoo by Dan Sims, Life Family Tattoo, Kent, UK

NÍNA RÚN
Tattoo by Búri, Icelandic Tattoos, Reykjavik, Iceland

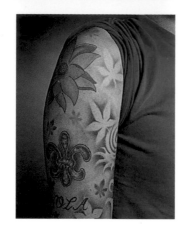

What is it? It's the front cover of Down's first album, *Nola*, framed with normal and reverse maple leaves, and a lotus flower.

Why did you choose it? After I saw Down play live for the first time, I knew I had to get something to represent the first piece of music I was passionate about.

What response do you get from people? Most people like it but some don't understand why I'd want tattoos.

How do you feel about it now? I still love it.

What is it? Five roses on my stomach.

Why did you choose it? It's in memory of my grandmother.

What response do you get from people? I get jaw-dropping responses. Usually everybody thinks that it's beautiful.

Would you change or add anything? I might put a dermal anchor in the middle of the roses.

Have you got any more ink planned? I'd like wings on my back and a sleeve representing my Viking blood.

MARIA DAVEY
Tattoo by Nick Gill, Black Rose Tattoo Studio, Warsop, Mansfield, UK

ANGELINE STANLEY
Tattoo by Fabio, Tattooing by Fabio, Cambridge, UK

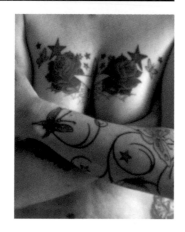

What is it? A rose and star chest piece.

Why did you choose it? It represents the cobwebs of the past and my love of the present – because, at age 48, I finally love myself – and the bright star of the future.

What response do you get from people? I've never had so many people wanting to examine my boobs!

How do you feel about it now? I've collected 24 pieces of body art over 30 years. I love them all and I'm still adding stuff.

What is it? An ivy vine.

Why did you choose it? It represents my life in the past, present, and hopefully future. Ivy has a will to survive through anything – cut it and it grows back stronger.

What response do you get from people? People say it looks feminine, even though it's big.

What does your family think about it? They love it because it's my life story.

Would you change or add anything? I'd like a body suit.

AMBER VERONA

Tattoo by Lee, Black Jacks Tattoos, Church Village, Pontypridd, Wales, UK

What is it?
Leopard print and lily three quarter sleeves.
Why did you choose it?
Lilies are my favourite flower. I adore leopard print and thought it'd break up the design.
What response do you get from people?
Generally people think it looks amazing.
What do your family think about it?
They understand that it's my decision.
Have you got any more ink planned? Old school roses for my chest and maybe stocking seams.

SARA TAYLOR

Tattoo by Chris, Ultimate Skin, Leeds, UK

What is it?
Stars running down my spine with cherry blossom falling behind.
Why did you choose it?
I love stars and colours. I wanted it to be quite girly but bold at the same time.
What response do you get from people?
Most people love the colours and that it goes all the way down my back. Most guys find tattoos sexy, which I'm surprised by!
What does your family think about it?
They hate tattoos!

KATHERINE

Tattoo by Halo, Passion And Pain, Weymouth, UK

What is it? A rose and swirly bits.
Why did you choose it? My middle name is Rose.
What response do you get from people? Everyone who sees it compliments me, and always asks, "Did it hurt?"
Have you got any more planned? I'd like to get a few more tattoos representing family members.
What do you like about having it? Its always on show, but because its so pretty everyone loves it.

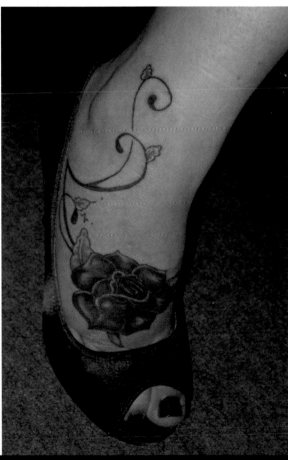

"My rose is always on show, but it's so pretty everyone loves it"

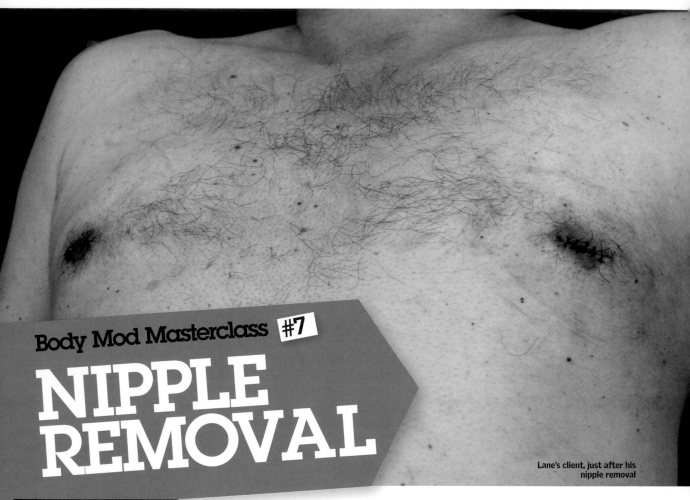

Body Mod Masterclass #7

NIPPLE REMOVAL

Lane's client, just after his nipple removal

When going under the knife improves the quality of life

Nullification is when a body part is removed, and people do it for a number of reasons. Some people feel psychologically 'incomplete' unless they get rid of an arm or a leg, while others just don't like the way a particular feature looks. Lane Jenson from Dragon FX studio in Alberta, Canada, was approached by a client who wanted to mod his large nipples because they were damaging his self-esteem.

A doctor had prescribed the female hormone oestrogen to try and restore the client's thinning hair, but didn't prescribe 'blocker' pills to avoid side-effects – which meant the client's nipples swelled up and became permanently erect. The man went on a waiting list to see a specialist plastic surgeon, but they moved away before he'd had a consultation, so he ended up wearing heavy

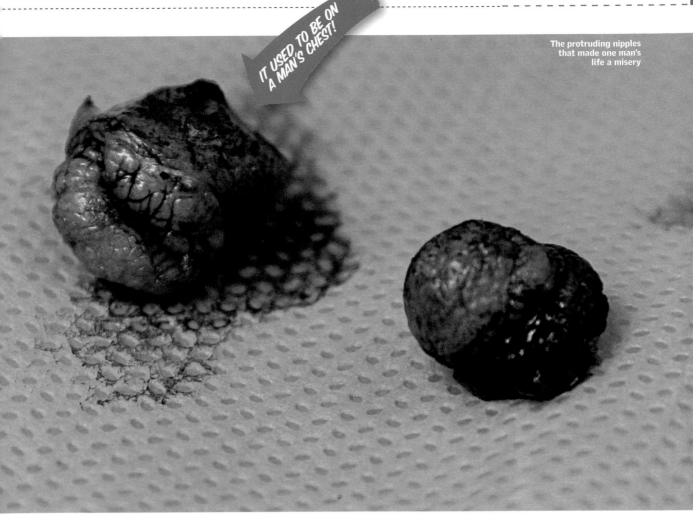

IT USED TO BE ON A MAN'S CHEST!

The protruding nipples that made one man's life a misery

PICTURES: LANE JENSEN

T-shirts with pockets filled with calculators and credit cards to disguise his chest. He asked Lane to fold his nipples in half and pin them down with a piercing, but Lane was worried that a build-up of scar tissue could make them even bigger. So they settled on removal.

First, Lane administered an anaesthetic. Next, he made a V-shaped incision on each nipple, as he thought straight scars might look more subtle than a circular one. Then it was time to remove the entire shaft of each nipple; the hormones had made them grow large internally as well as externally so, if he'd simply sliced them off level with the body, the plug of flesh inside would have become irritated and pushed out again. He removed some areola, sutured everything up, flushed it with saline, and sent the man to the hospital to get a course of antibiotics to prevent infection.

The client wore heavy T-shirts to disguise his swollen nipples

The man visited Lane every two days for the next six weeks to make sure the wounds were healing. He reinforced the scars with liquid Band-Aid to help prevent the weight of his chest reopening the wounds. "He now has small, male-looking areolas you wouldn't look twice at," says Lane. "This mod was on the house, as it was amazing to see a guy transformed from a shy little mouse to a happy, confident man again. He did buy me dinner... after he'd bought himself some new, pocket-free shirts!" 🅑

THE
TATTOO
TOURIST

Lars Krutak is the Indiana Jones meets David Attenborough of the tattoo world

WORDS **PETE NEWSTEAD** PHOTOS **LARS KRUTAK**

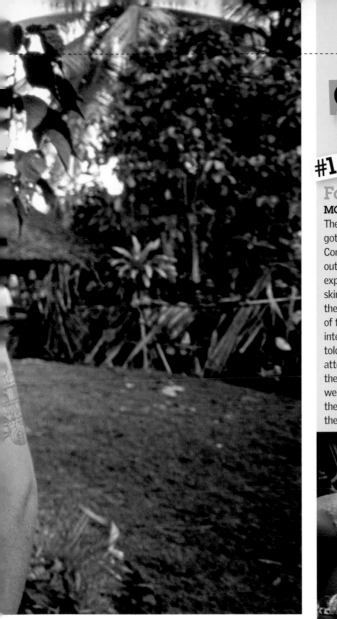

OLD SCHOOL TATTS
THE TRADITIONAL TATTS THAT REQUIRE MORE THAN A TRIP TO YOUR LOCAL PARLOUR!

#1

Forbidden body art
MOZAMBIQUE

The 'forbidden' tattoo of the Makonde people got its name because, in the 1960s, the Communist Mozambique Liberation Front outlawed tattooing as it promoted individual expression. It's performed by cutting the skin, then rubbing a form of ink into the wounds. "The skin-cut tattoos of the Makonde are pretty intense," says Lars. "I was told that boys and girls who attempted to run away while the cutting was taking place were sometimes buried up to their necks in the earth so that the tattoo artist could continue."

#2

Crocodile tears PAPUA NEW GUINEA

This scarification is a rite of passage for young Kaningara men. Before cutting takes place, the men spend two months of seclusion in a haus tambaran, a traditional worship house, where they form the strong fraternal bond necessary for them to undergo the ordeal of receiving hundreds of deep cuts. "The cuts around the nipples are the eyes of the crocodile spirit," says Lars. "The nostrils are etched around the navel, and the crocodile's limbs are cut into the shoulders and upper arms. The back cuts symbolise the tail and skin of the crocodile."

L ooking at the heavily scarred, inked body of Lars Krutak, you wouldn't think his interest in ritual tribal tattooing began as recently as 1996. The American academic turned into a globe-trotting adventurer thanks to his research at the University Of Alaska, where he studied the symbolism and practice of tattooing in the Arctic and saw an image of an Inuit woman with a skin-stitched tattooed chin. After doing more research, his interest became an obsession, and he travelled to St Lawrence Island off the coast of Alaska to interview elderly women who still had these traditional stitched tattoos. →

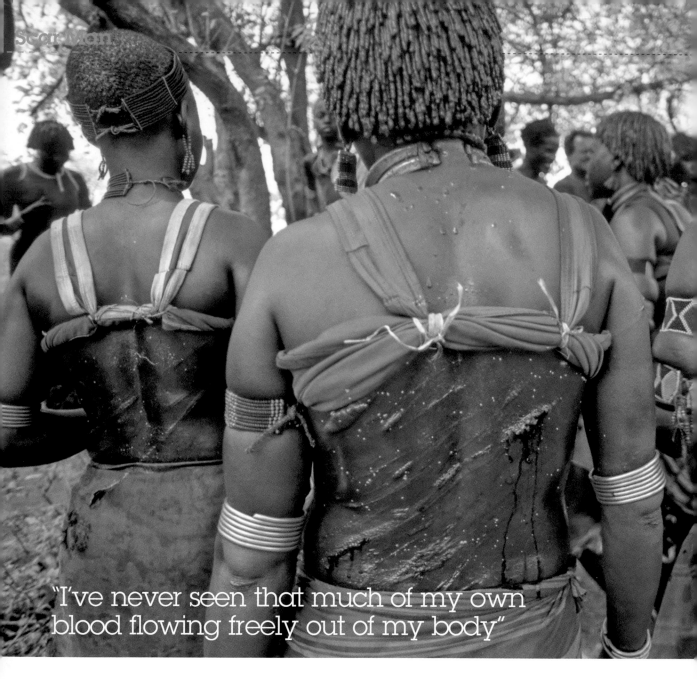

"I've never seen that much of my own blood flowing freely out of my body"

Above: Scars of the Hamar people

Now Lars, the 'tattoo anthropologist', is the star of the Discovery Channel show *The Tattoo Hunter*, where he travels the world to experience the beauty, pain and ritual of tribal tattoos first hand – by getting inked in indigenous traditional methods.

"I wouldn't be true to my research unless I actually participated in these rituals, which includes getting tattoos with the traditional methods of application," Lars explains. "Perhaps you can imagine what a hand-tapped tattoo feels like by reading someone else's written account in an anthropology book – but unless you experience it for yourself, I don't think you can get at the essence of it as a cultural practice and rite of passage that has physically and psychologically transformed its bearers since the dawn of time. It's a shared process of pain, recuperation, and personal memory."

Lars has yet to see a tattooing method he wouldn't try, and now wants a traditional skin-stitched tattoo like

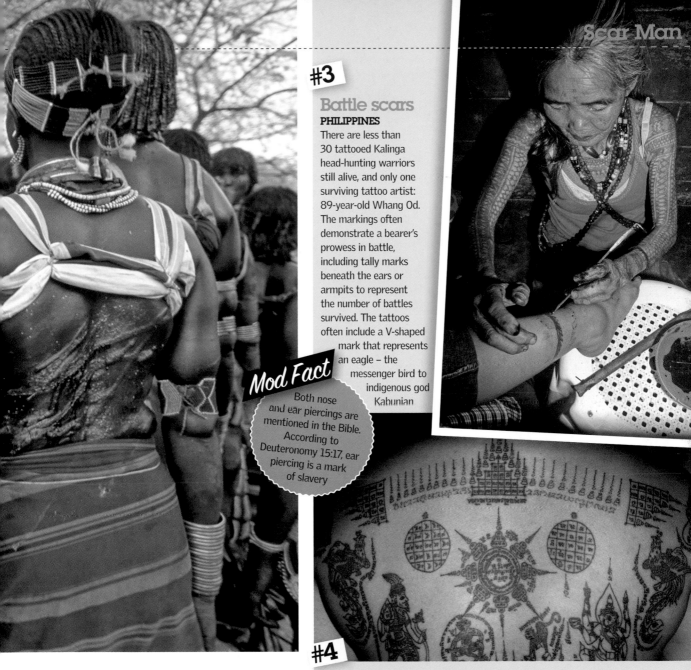

#3

Battle scars
PHILIPPINES

There are less than 30 tattooed Kalinga head-hunting warriors still alive, and only one surviving tattoo artist: 89-year-old Whang Od. The markings often demonstrate a bearer's prowess in battle, including tally marks beneath the ears or armpits to represent the number of battles survived. The tattoos often include a V-shaped mark that represents an eagle – the messenger bird to indigenous god Kabunian

Mod Fact
Both nose and ear piercings are mentioned in the Bible. According to Deuteronomy 15:17, ear piercing is a mark of slavery

#4

Monk-y magic THAILAND

Believed to give the bearer magical protection against everything from bad luck to bullets, and possibly attract a husband or wife, these tattoos are performed by a monk who recites a katha – a form of holy spell – while he does it. For the spell to be effective, Lars explains, the wearer must always obey at least one of the five Buddhist principles, which are to never kill, lie, steal, have 'improper' sex or become intoxicated. Before giving someone a tattoo, the monk will read their aura to determine what kind of design will be most appropriate for them.

the one that piqued his interest in ink. The method involves a reindeer sinew thread, coloured with soot and seal oil, being inserted under the skin. The thread passes through the flesh but the ink stain remains, creating a permanent mark. He's now tracked down a Danish tattooist who's mastered the technique. "I've always been curious about the amount of pain such tattoos produce," he says. "It'll be difficult not to flinch as my skin quivers with each pass of the needle and thread!" →

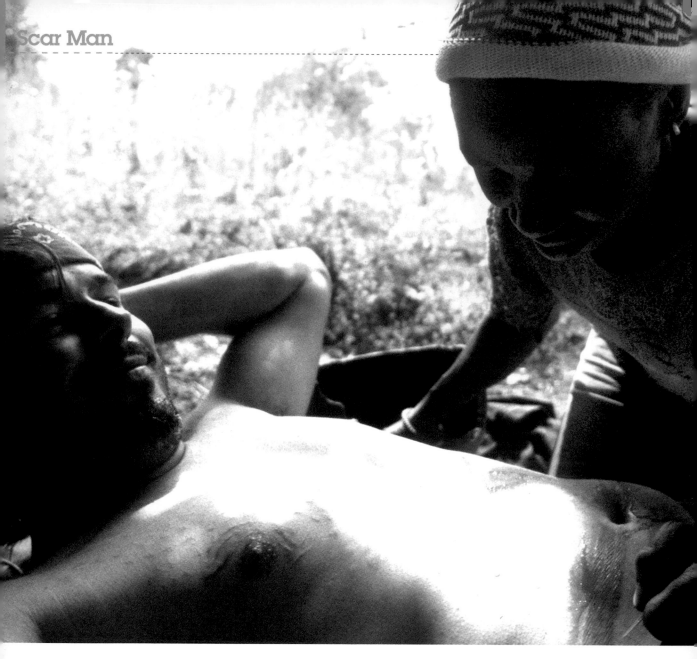

Above: Lars grins and bears it

Ink and insects

Lars' first tattoo – a Siberian-inspired design circling his left bicep – was done in New Orleans by Kosovan tattooist Naki. He now has eight in total, and his favourite is his first traditionally hand-tapped tattoo – where ink is applied by hand using a sharpened animal bone – of a rosette on his left shoulder. Lars received it while among the Iban people in Sarawak, Malaysian Borneo.

"Between the outlining and fill, it took about four and a half hours," he says. "I was extremely patient, lying on the floorboards of that longhouse as my shoulder was hammered for several hours in the moist jungle heat. The worst part was that the lighting we arranged for the camera attracted every large flying insect that evening. For over four hours, bugs would hit the lamps then fall down directly on my bare skin and crawl all over – and into – my body orifices. It was torture, like thousands of prickly legs crawling across my skin in every direction as the tattoo was hammered home hour after hour. I'll never forget that!"

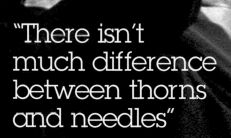

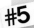

Fight club ETHIOPIA

The marks of the Hamar are known as pala or 'hero scars'. They're only given for warriors who've killed another man in battle. Lars describes the ritual as beginning with the blood of a freshly killed white goat being poured over the man's shoulders, before the hacked-off genitals of his enemy are displayed above the village gateway. He's then garlanded with leaves and his chest is cut to form vertical rows of pala. If he kills again, he'll get more scars on his arms and under his armpits. If he runs out of room for scars, one of his wives can wear them for him.

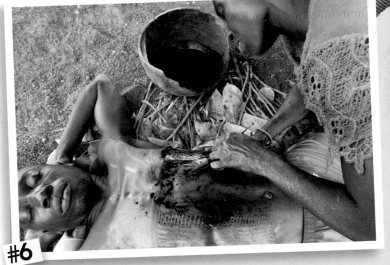

#6

"There isn't much difference between thorns and needles"

Despite this unpleasant experience, Lars has had several traditional tattoos since, almost every one using a different technique. He was hand-tapped with orange tree thorns by the Kalinga people in the Philippines, then with lemon tree thorns and brass nails by the Mentawai in Indonesia. He's been hand-poked with iron rods by Buddhist monks in Thailand, and pricked with palm tree thorns by the Kayabi people of the Brazilian Amazon.

"There isn't much of a difference between thorns and needles," explains Lars. "Although needles move in and →

Growing pains BENIN

The Betamarribe people practice a similar form of facial marking to the Makonde, but with no pigment put into the cuts. Instead, a razor-sharp tool resembling an arrowhead is used to cut patterns into the faces and bodies of two-year-old children. Hundreds and hundreds of cuts are given. The children scream in pain, some fall unconscious, and there's so much blood that they begin choking on it. But if a child doesn't receive these markings they aren't considered human. And if they die before they receive their skin-cuts, they won't be buried in the village cemetery with their relatives – because they're not considered Betamarribe.

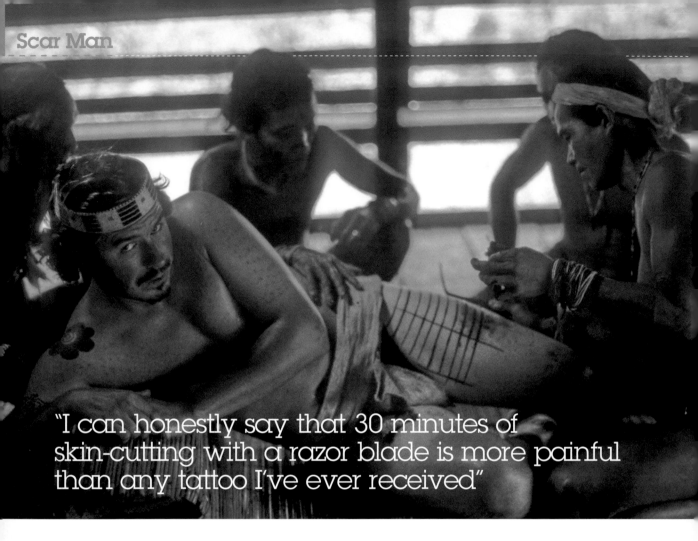

"I can honestly say that 30 minutes of skin-cutting with a razor blade is more painful than any tattoo I've ever received"

Above: The Mentawi try not to get distracted by Lars' Brüno pose

out of your skin more cleanly, whereas thorns occasionally grab the skin, increasing the amount of friction and pain. Occasionally, they even get stuck in the skin."

As painful as this sounds, it pales in comparison to his description of getting the stunning razor and knife scars that cover much of his upper body. Lars got these as part of a rite of passage for the Kaningara people of Papua New Guinea, which is intended to transform the body into a homage to a crocodile spirit.

"I can honestly say that just 30 minutes of skin-cutting with a razor blade, especially the circular cuts around the nipples, is more painful than any tattoo I've ever received," he winces. "When I was living with the Kaningara, I received over 400 skin cuts across my chest and I've never seen that much of my own blood flowing freely out of my body. It's no wonder that some men have died participating in this ritual in the past. When the cutting is over, the ritual area where the scarification takes place resembles a battlefield. There are bloody

rags, bloody buckets of water, and pools of human blood as far as the eye can see."

But the experience didn't dampen Lars' enthusiasm for his chosen field and, after dousing his cuts with cold water from a bucket, he was up and taking photos of the other initiates within minutes. "I think the Kaningara thought I was mad, running around shooting close-ups and stills with a bloody chest," he grins.

A few weeks later the scars had formed, although some stayed a raw, angry red for eight months. "My chest and arms are now covered by a series of fine white scars," he says. "These keloids are anywhere from 1 to 3cm in length, except the cuts around my nipples, which are three rings about 12cm in circumference. It looks as if someone was trying to remove my nipples!"

Pain and recuperation
Now he's spent over a decade unearthing the tattoo secrets of the world's tribal regions, Lars is convinced

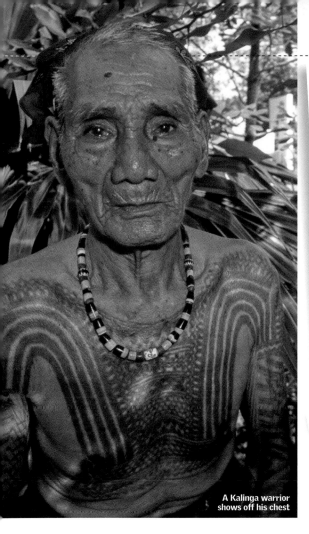

A Kalinga warrior shows off his chest

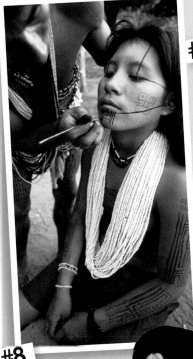

#7

Body snatchers
BRAZILIAN AMAZON
The origins of the tattoos of the Kayabi people stem from their great enemies, the Apiaká. The markings of the Apiaká included a black rectangle around the mouth that symbolised their right to eat human flesh. While not cannibals, the Kayabi were fearsome warriors who believed they took an enemy's soul when they killed him. Using palm tree thorns, their dead foe's name would be tattooed on themselves to represent the new soul they'd acquired.

#8

Spirit tattoos
SIBERUT ISLAND
The Mentawai people who inhabit the jungle island of Siberut, 60 miles west of Indonesia, have a tradition of tattooing going back thousands of years. The tattooing is part of a beautification ritual that keeps their body attractive to their souls, as well as warding off evil spirits. Tattoos are given with either a sharp piece of bark from the native karai tree, or a lemon tree thorn attached to a bamboo stick. They often represent the 'tree of life', with stripes on the thighs symbolising the trunk and dotted lines on the arms representing branches.

of their cultural importance. "For most tribal groups, these tattoo rituals represent a rite of passage marking the physical and psychological movement from one stage of life to the next," he says. "They also promise safe passage to the world of their ancestors – who also sacrificed their own skins to make them sacred."

Lars is also fascinated with the tradition of tattoos being given for medicinal purposes. "The oldest form of medicinal tattooing is from Europe," he says. "Over 80 per cent of the tattoos worn by Ötzi the Iceman (the 5,500 year-old body found frozen in the Austrian Alps in 1991) are located on acupuncture points used today to heal rheumatism. And X-ray analysis of Ötzi revealed a body racked by arthritis."

Lars is determined to carry on his research, but despite his love of tattooing culture he agrees that tattoos aren't for everyone. "I'm not trying to convince everyone to get some ink," he smiles. "It's a personal decision, and I wouldn't want to interfere with that." Ⓑ

THE REST
The best and most original tattoos around

BRANDON
Tattoo by Jesse Tretic, Renaissance, Abbotsford, British Columbia, Canada

What is it? A 1950s Adler secretarial desktop typewriter.

Why did you choose it? I was given this typewriter by my grandfather. During my teen years I formed a close bond with it as I wrote my way through alcoholism, speed and heroin addiction. Two years ago a vital part broke and I hated the thought of throwing it out, so I had it tattooed on me.

What response do you get from people? So far everyone has loved it!

NICOLA
Tattoo by Jed, Blue Dragon Tattoo, Brighton, UK

What is it?
The chemical structures for the crazy drugs I've taken or am taking. A direct translation is Citalopram, Venlafaxine, Valpourate, and Olanzapine.

Why did you choose it? My past year's journey through the brick walls of the NHS has taken a lot of inner strength. I want to remember it.

What response do you get from people? I work in a dispensing chemist, so all the chemistry students get an on-the-spot test!

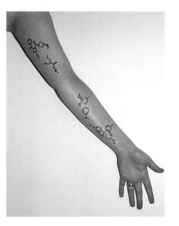

ART

Tattoo by Rob, Smartbomb Tattoo, Dayton, Ohio, USA

What is it? Johnny Eck, a classic sideshow performer and cast member of Tod Browning's *Freaks*.

Why did you choose it? I've always found Johnny's story to be inspiring. He was a jack of all trades and, for the most part, kept a positive self-image despite adversity.

What response do you get from people? The most common question is, "Are you going to get his legs done?"

How do you feel about it now? I'll never grow tired of it.

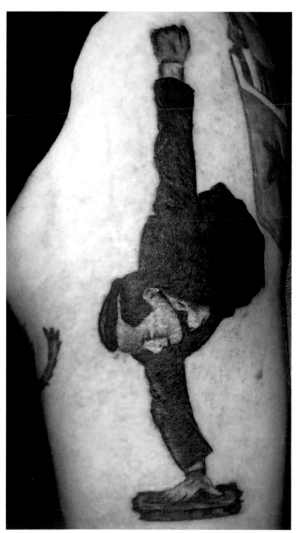

JESSICA CONATSER

Tattoo by Kyle Hoffman, A Brand New Tattoo, Eau Claire, Wisconsin, USA

What is it?
The characters from *Where The Wild Things Are*, on my calves.

Why did you choose it?
My mother was raised on the book, so she raised my brother and I on it. It means a lot.

What response do you get from people?
Mothers stop me all the time and ask if they can show their children.

What does your family think about it?
My mother loves to show off my ink to people she knows. She thinks it's beautiful.

RUSSELL SHIRE

Tattoo by Jack Watney, a friend

What is it?
A Polaroid camera.

Why did you choose it?
They've stopped making Polaroid film, and I have hundreds of Polaroids of me and my mates with beautiful memories trapped inside them.

What response do you get from people?
I get drunk and show it to bikers in pubs. They say, "You're an idiot, but I like it." (I may have made up that last bit).

Would you change or add anything?
I might add a typewriter, a phone and a SNES.

ANDY MCBANE
Tattoo by Albert, Skyn Yard, Southend, Essex, UK

MELONIE SYRETT
Tattoo by Danny, Wilson Ink, Wickford, Essex, UK

What is it?
A biomechanical
back piece.

Why did you choose it?
I've never found a piece
of art in this style I don't
like. HR Giger was the
main inspiration for it.

**What response do you
get from people?**
The usual response
is "Wow", or
some expletives!

**What does your family
think about it?**
They haven't seen it.

**Have you got any more
ink planned?** I'll be
extending it over my left
shoulder for a chest

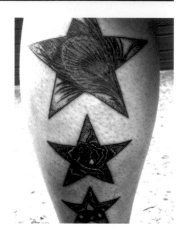

What is it? Three stars
with things I love inside.

Why did you choose it?
I'm really indecisive and
couldn't decide what
I wanted. I amassed
a collection of pictures
of things I loved and
then saw empty stars on
someone's leg. I decided
I wanted the things I like
to be inside stars.

**What response do you
get from people?**
I'm a teacher. The other
staff tend to nod slowly
or say, "They're bigger
than I thought". But
everyone appreciates
the detail.

BECCA
Tattoo by Ami and branding by Quentin, Kalima,
Worthing, UK

LEE MCPHEE
Tattoo by Wayne, ABH Tattooing, Scunthorpe, UK

What is it? A half sleeve
of medical and cute Hello
Kitty madness, with
a large cross branded
in the middle.

Why did you choose it?
I was ill during childhood
and hospital was my
second home. Over the
years I've developed
a medical fetish.

**What response do you
get from people?**
People say they've never
seen anything like it!

**What does your family
think about it?**
They understand it.
My mum is a nurse,
so I think that helps!

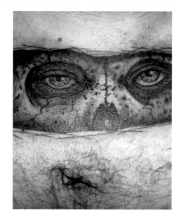

What is it? A pair
of eyes on my chest.

Why did you choose it?
Wayne found the design
in a fantasy book. He
showed it to me and
I really liked it.

**What response do you
get from people?** I get
a really mixed response,
but I'm glad to say that
most people love it.

**What does your family
think about it?**
My tattoo collection has
inspired my wife to start
an ink collection of her
own, with the help of
Pam who also works
at ABH Tattooing!

CHARLOTTE WINTER

Tattoo by Loz, Tattoo Addiction, Newport, Wales, UK

What is it? A teapot with legs, pouring tea into a teacup.
Why did you choose it? I'm a tea addict! I wanted something more unusual than just a teapot, so my boyfriend drew legs.
What response do you get from people? I also have a ship behind my ear. People's first reaction is, "Are those real?" Followed by a positive comment.
What does your family think about it? They dislike tattoos but agree mine are nice.

GLEN TREVITHICK

Tattoo by Darren, Body Images, Portsmouth, UK

What is it? A negative space star sleeve.
Why did you choose it? I was going to go for a totally black sleeve, but decided to bung a few stars in as negatives.
What response do you get from people? When people ask me what it means, I just tell them each star represents someone I've killed. It's funny to watch their reactions!
What does your family think about it? I think my parents always knew I'd get tattoos. I always used to ask about them.

DAVID GAMBLE

Tattoo by Paul 'Myth' Naylor, Indigo Tattoo, Northwich, Cheshire, UK

What is it? The late, great artist Robert Lenkiewicz (1941 – 2002).
Why did you choose it? I was one of Robert's students. I knew him for five years and he's the biggest influence in my art.
What response do you get from people? At least 30 people have stopped me in the street, pubs and supermarkets to talk about it.
What do you like about having it? It gives me a great deal of inspiration to paint because he's on my painting arm. It gives me a great deal of pride and confidence, too.

"At least 30 people have stopped me to ask about my tattoo"

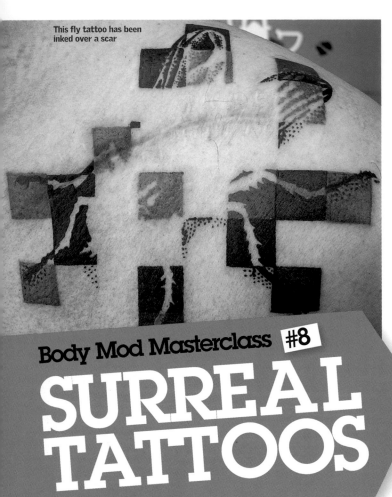

This fly tattoo has been inked over a scar

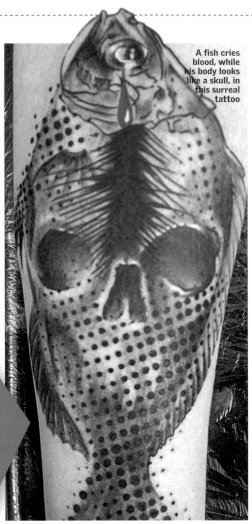

A fish cries blood, while his body looks like a skull, in this surreal tattoo

Body Mod Masterclass #8
SURREAL TATTOOS

From the sublime to the ridiculous, they have multiple meanings

A picture can speak a thousand words, and tattoos are no exception. They might represent significant events in people's lives, their hopes or fears, or just the desire to have a cool-looking design. Some tattoos suggest these ideas through existing art traditions, and Surrealism is perfect for suggesting multiple meanings. Tattoo artist Jef from Boucherie Moderne Salon in Brussels, Belgium, likes to design surreal tattoos that juxtapose unrelated items. "The result is an absurd chimera; aesthetically pleasing and entertaining to look at, but also a simple way of putting across a philosophical message," he says.

One of the images he's created is the Virgin Mary crossed with a fish, which reflects his religious views. "The basic teachings of many faiths, such as loving

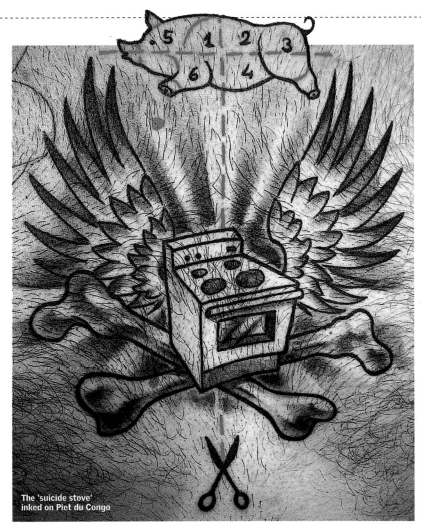

The 'suicide stove'
inked on Piet du Congo

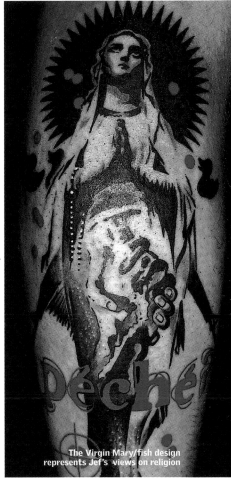

The Virgin Mary/fish design
represents Jef's views on religion

your fellows and treating others as you would like to be treated, are great values," he explains. "But stick a label like Christianity or Islam on them, and conflicts begin. People who believe the same things become segregated hypocrites, preaching peace and love while fighting and killing one another. It's bullshit! Like a salmon that's been hanging around in the back of the fridge, religion can soon start to smell really bad! The handshake inside the tattooed Virgin's stomach represents my hope that one day, like the miracle of Mary carrying Christ, people might miraculously stop fighting. Perhaps we can start by saying hello in the street and smiling more."

There are other ways to turn negative emotions into messages of hope. Once Jef was feeling depressed after breaking up with a girlfriend, and – even though

The result is a simple way of putting across a philosophical message

he says he'd never have done it – thought about sticking his head in an oven. He started doodling stoves, when colleague Piet du Congo came along and decided they should have a barbeque. The result was another great surreal tattoo. "He's so passionate about chargrilling, we turned my oven drawings into a crest, now emblazoned on his chest," says Jef. "We also inked the cuts of pork from a pig, to reflect both his love of meat feasts and our studio name: 'Modern Butchers'. Ⓑ

PICTURES: BOUCHERIEMODERNE.BE

Man Woman

His visions told him to reclaim the swastika, and now he's covered in them

WORDS **STEPHEN DAULTREY** PHOTOS **MARK BERRY**

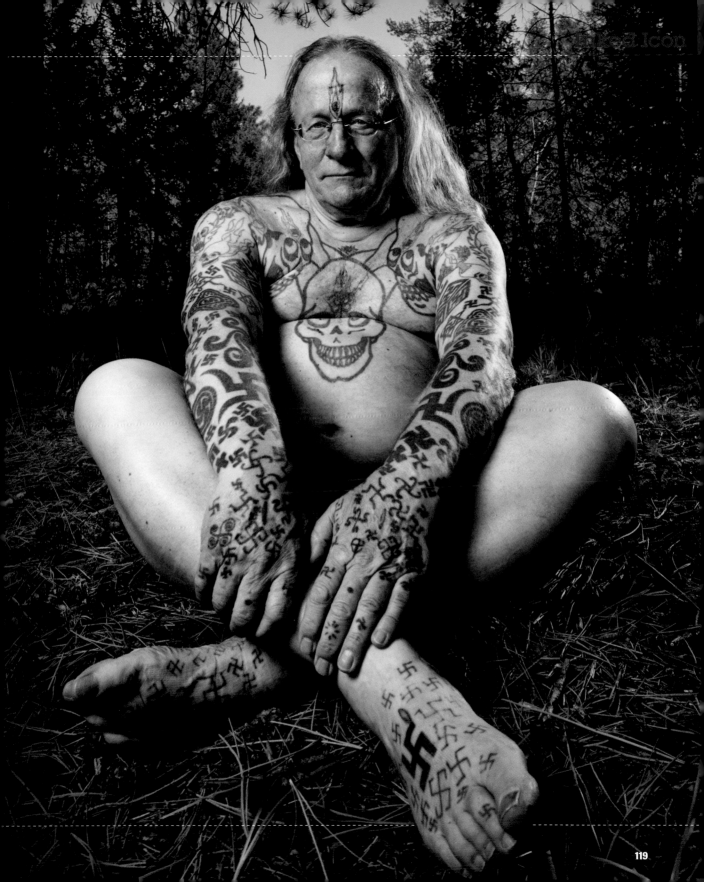

MANWOMAN WAS BORN PATRICK Charles Kemball in British Columbia, Canada. At age 27 he started having visions that told him he was both genders inside one body, and his mission was to reclaim the peaceful meaning of the swastika as used in ancient cultures and religions. He called these visions 'The Secret Doctrine Of The Holy Fuck', changed his name to ManWoman and set about spreading his message by getting inked with swastikas. Now 'Manny' has over 200 of the symbols on his body, a museum in his home and has written a book called *The Gentle Swastika*. But his mission isn't over yet...

What were your visions like?

They started in 1965 and went on for about a year. In most, my spirit soared up through a vortex of energy and melted into a pure, white light that was the source of everything – peace, love, god, eternity. I was always half male and half female in these dreams and was given the name ManWoman, which signified my wholeness. I called it 'The Secret Doctrine Of The Holy Fuck' because I was going up in that vortex of energy almost like a penis, and ejaculating my spirit up into the sacred, and the sacred was like a womb with this incredible light in it.

How did you react when you started dreaming about the swastika?

When I started dreaming it was a sacred symbol, that was shocking. And then in a dream, a wise old man came up to me and marked my throat with a swastika, and he told me that I should speak out about the sacredness of this symbol, and take it as my personal symbol, and I choked on that too. My mum was a Polish immigrant and her sister and her niece were put into Auschwitz. I was born just as the war was starting, so I inherited all the usual western hatred for the swastika.

How did you feel about the visions?

This was a very trying period as you might imagine, where I was being given the swastika to reclaim and restore, and I was also being told I was ManWoman and I wasn't even sure what that meant. In the dream, it was an energetic figure, a healing figure, and people would line up in mental hospitals to be healed by me. Most people would think he's some kind of transexual, and I tried wearing woman's panties once but it just made me horny! And you know, there ain't no room for balls in those knickers!

When did you start getting swastika tattoos?

In 1969 I had one little swastika tattooed onto my little finger. And that was long before the whole tattoo revolution started. I knew a few ex-cons and bikers who had tattoos, but they weren't mainstream, and were →

Mod Fact

Lucky Diamond Rich got his first tattoo in London when he was 17, the same night he lost his virginity to a prostitute

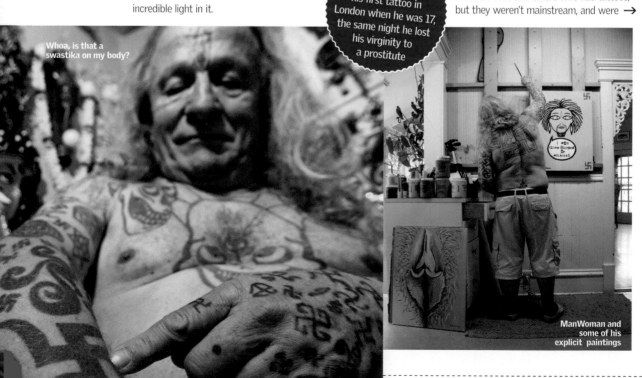

Whoa, is that a swastika on my body?

ManWoman and some of his explicit paintings

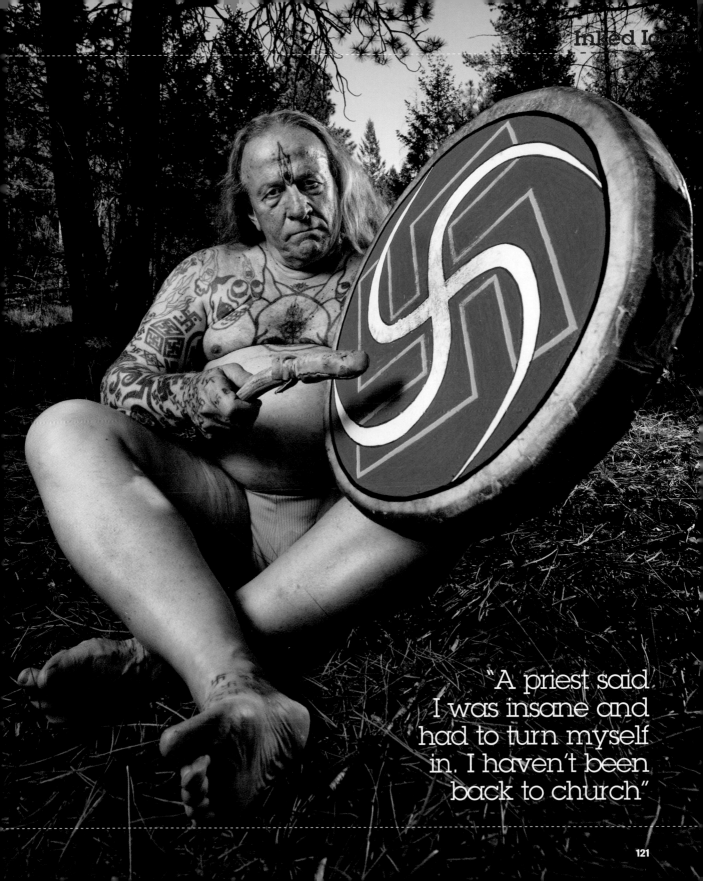

"A priest said
I was insane and
had to turn myself
in. I haven't been
back to church"

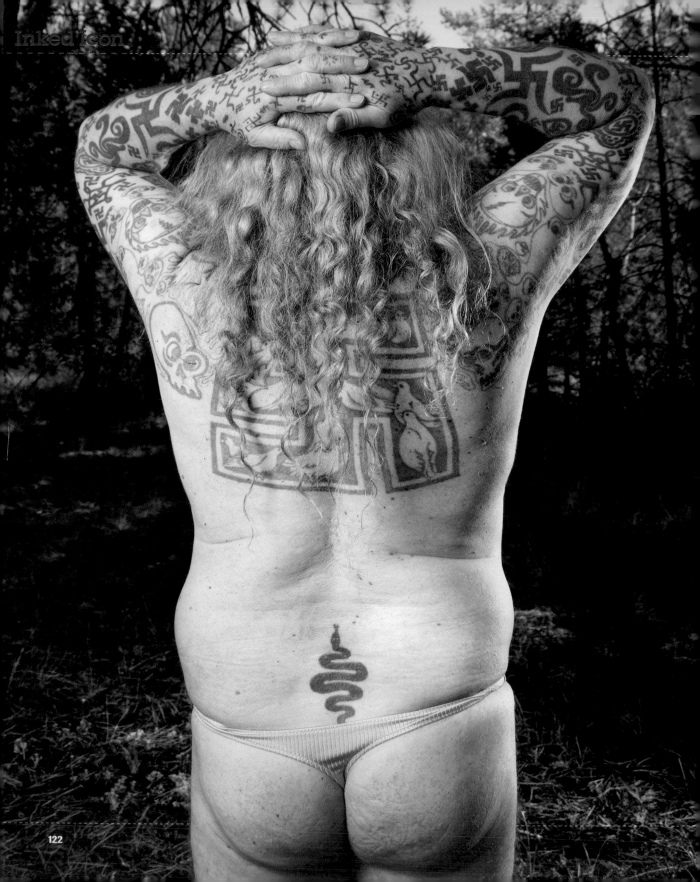

a real stigma. I knew one guy who had Tasmanian devils tattooed on the back of his hands and he had butt flesh transplanted over them so he could get a job! I tried to find someone to tattoo my hands and forehead but every tattoo shop said "no". In 1971 I finally found a guy to do my hands, and he put all the ancient swastikas on them.

What did your family think?

My wife freaked out. She was worried about how we were going to feed the family – we had a couple of kids. She said I had to see the local priest so I told him about the sacred experiences and he said, "My son, I'm sorry to have to tell you this but you're insane and you need to turn yourself in". I haven't been back to church since!

Were you aware of the meaning of the swastika before the visions?

No, I learned about them through my dreams. And it wasn't until a guy showed up with some Indian beadwork piece he'd picked up and told me about how Indians had used it that the idea clicked. His grandmother was in an Alberta hockey team who had swastikas on their Jerseys. Then there was a town called Swastika Ontario that had to fight for its name during WW2. Most people would be shocked to hear Jews used swastikas in the synagogues as one of their sacred signs, and if you go to the Catacombs in Rome, you'll find swastikas alongside the Star Of David. The Vikings used it, the Druids used it, and all the Neolithic tribes who worshipped the goddess used it.

Were you worried about people's reactions?

You know, I was always a rebel. When I was at school I was called 'Pat The Brat' and I was the class clown; I was the kid with the Hot Rod with the flames on it. I was very defiant and hated authority. This was a huge challenge for me and I jumped into it with both feet!

What's the most extreme reaction you've had?

Once I was on Muscle Beach in California, where lots of people were lifting weights. These guys surrounded me and asked me about my symbols. I explained they were Buddhist symbols – I would never have convinced them it was a Jewish sign; that would've been asking for trouble – and they were hopping mad. After about 5 minutes these guys went away and actually shook my hand. My friends were absolutely astonished at how I managed to avoid a good thrashing.

Have you met any Holocaust survivors?

I was recently at a health spa sitting in a hot tub, and this old lady pointed an arthritic finger over the railing and said, "hakenkreuz", which is the German name for the symbol. She said, "They told us children we were

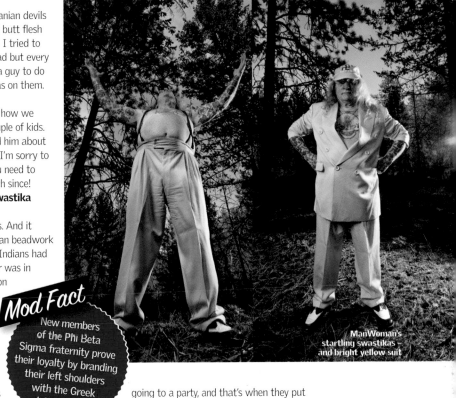

ManWoman's startling swastikas – and bright yellow suit

Mod Fact

New members of the Phi Beta Sigma fraternity prove their loyalty by branding their left shoulders with the Greek letter sigma

going to a party, and that's when they put us in Auschwitz". I'm sitting here with my buddies and this poor old lady's a survivor. I tried to tell her it had nothing to do with Nazis.

Do you know anyone else with swastika tattoos?

You'd be amazed at how many people have swastika tattoos. There's Xed Le Head, and a guy called Marc who runs a tattooing and piercing shop in Germany. He's got an outrageous "Save The Swastika" tattoo on his foot. I think I'd have problems in Germany, because there's so much guilt and shame over what happened in WW2.

Do you think the symbol will ever be 'detoxified'?

There was a time when I thought it wasn't going to happen in my lifetime, and universally that's probably true – but I've planted incredible seeds. My book has gone into many different countries and pilgrims have shown up at my door wanting to see my swastika museum, which is basically my front room filled with Navaho rugs, baseball caps from a team called the swastikas, and pictures of Ganeisha – a deity that opens the way for everyone who has a swastika on the palm of their hand. But I'm still shocked for people who don't know me and what my history is. Sometimes people can be very nervous in elevators when they find themselves alone with me! ⓑ

YOUR MODS

The most extreme studs, spikes and implants

ELLIS HOWE
Mod by Hype Tattoo, Newcastle, UK

What is it?
A tongue piercing.

Why did you choose it?
A variety of reasons, but mostly because I like how it looks!

What response do you get from people?
Some people think it's disgusting, some are intrigued, some don't blink an eye, and some really like it!

What does your family think about it?
My mum found out when I was 15, but at this point I had a small collection of piercings, so she didn't mind.

KATIE WASHFORD
Mod by Marcus, 777 Body Piercing, Canterbury, UK

What is it?
Three nape piercings.

Why did you choose it?
Not many people I know have nape piercings, and I wanted to be different.

What response do you get from people?
They think I'm a freak – but I like it that way.

What does your family think about it?
They hate it.

How do you feel about it now? I don't regret it one bit – it was well worth the pain.

Have you got any more mods planned?
Two tongue piercings.

BETHANIE ZELLARS

Mod by Tony Snow, Bad Apple, Las Vegas, Nevada, USA

What is it? Subdermal horn implants.
Why did you choose it? I liked the look of them.
What response do you get from people? I get a lot of questions. Some people assume that I'm a Satanist; others are just curious.
What does your family think about it? They're relaxed about it, and are always wondering what I'm going to have done next.
Have you got any more mods planned? I'd like to add a few more custom carved pieces for my collar bones and chest.

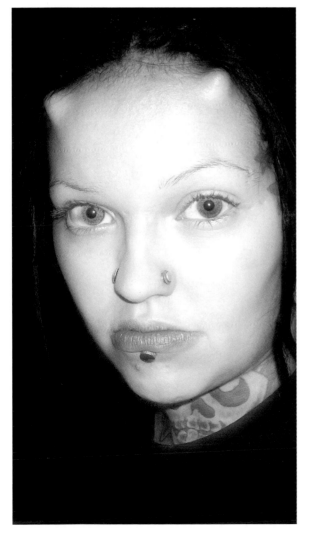

HANNAH

Mod by Quentin, Kalima, Worthing, UK

What is it? A two point suicide suspension.
Why did you choose it? It was a rite of passage because I'd just turned 18, I was moving out. and I was starting university. I figured if I could hang from hooks then I could deal with anything. Plus, it looked like fun!
What response do you get from people? Most people think I'm crazy, or are interested.
What does your family think about it ? I never bothered mentioning it to them.

AMANDA ROBSON

Mod by Kim Hutchinson, Steel Paintbrush, County Durham, UK

What is it? A collection of surface piercings. I call it 'The Pinhead'.
Why did you choose it? It started as a double cat's eye and developed from there, but it isn't finished yet.
What response do you get from people? People usually ask me how each ball is put into the skin and assume they're dermal implants.
How do you feel about it now? I totally love it and will expand it, possibly over the top of each eyebrow.

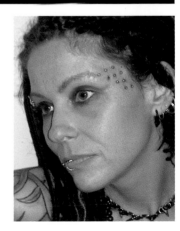

LAURELLE DE-GISI

Mod by Marcus and Kate, Holier Than Thou Body Piercing, Manchester, UK

What is it?
A microdermal implant on my forehead.

Why did you choose it?
I love the way they look and how easily they heal.

What response do you get from people?
They ask, "How does it work?"

What does your family think about it?
I also have microdermals on my hand, chest and back. My mum's had two chest ones done as she loves mine, but she thinks my head one makes me look like I've been attacked with a nail gun.

CUNTFEATURES

Mod by herself

What is it? Play piercing with buttons.

Why did you choose it?
I sewed myself for the first time when I was 12, just using ordinary thread running up my fingers. For this mod, I used fishing wire and sewed the button through the skin as if I was attaching it to a coat. It's only designed to last for a week.

How do you feel about it now? It's like a quirky accessory. Body mods are art, they're brilliant, and I love them – which is why I do them.

HOLLY-ANNA KNOX

Mod by Mark Gibson, Mikes Tattooz, Carlisle, UK

What is it?
A corset piercing.

Why did you choose it?
Mark asked if he could do it because the local tattoo convention was coming up. I liked the idea and agreed.

What response do you get from people?
Where I live in Penrith, most people just stare at me. I quite like it – I wouldn't like to be another blank face (or back).

How do you feel about it now? It's an extension of me and it makes me feel prettier.

HELEN SADLER

Mod by Kim Hutchinson, Steel Paintbrush, County Durham, UK

What is it? An anti-lobe ear piercing.

Why did you choose it?
I don't know anyone who's ever had it.

What response do you get from people?
Some people are completely stupid and ask if I've shoved a thumb tack into my head, but everyone else has been interested.

What does your family think about it?
My mum absolutely adores them and, out of the 12 piercings I've had, it's the first one she likes!

MICHELLE
Mod by Boo, INK Tattoo And Piercing Studio, Exeter, UK

What is it?
Microdermals in my forearm.
Why did you choose it?
I first saw microdermals in *Bizarre*. Boo explained the pros and cons and I knew I'd love them.
What response do you get from people?
Shock! People think they're just stuck on, or are intrigued as to how they stay fixed.
What does your family think about it?
They haven't seen them!
How do you feel about it now? I love them and I want more.

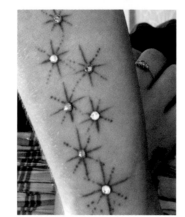

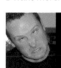

BRAD
Mod by Quentin, Kalima, Worthing, UK

What is it? A nipple reconstruction.
Why did you choose it?
I'd stretched my nipple up to 10mm, but then I got bored and took the jewellery out, which left a huge lump of saggy skin. It had to go!
What response do you get from people?
Everybody loves my new nipples and I wouldn't change a thing.
Have you got any more mods planned?
I'm getting my lobes done. I'd also like some more tattoos, to go with my Halloween leg sleeve.

JASON AHAD
Mod by Sarah, No Pain No Gain Piercing Studio, Shipley, UK

What is it? A surface bar piercing.
Why did you choose it? I wanted something different – initially I wanted an implant in my forearm (which I saw years ago in *Bizarre*), but no-one would do it, and I thought this was a cool idea.
What response do you get from people? People are usually shocked. Lots of people stare a lot without asking me anything.
How do you feel about it now? I love it, especially the fact that I can feel the bar underneath the skin, between the spikes.

"I love feeling the bar underneath the skin, between the spikes"

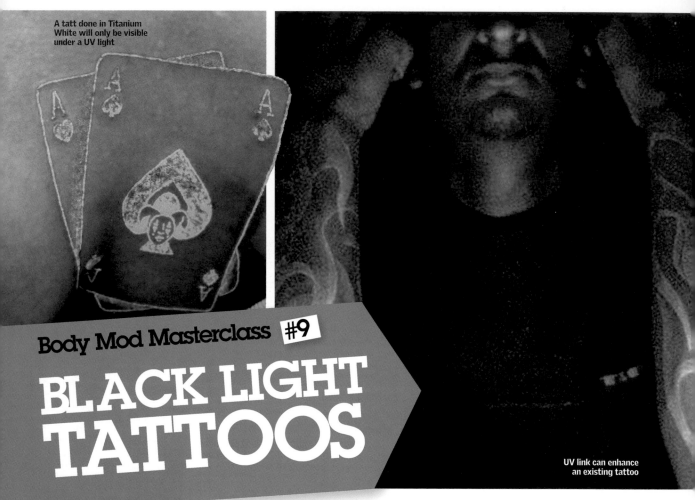

A tatt done in Titanium White will only be visible under a UV light

UV link can enhance an existing tattoo

Body Mod Masterclass #9
BLACK LIGHT TATTOOS

Discover how glow you can go with UV ink

Imagine going to a club and seeing glowing tattoos! It sounds like something from a sci-fi movie, but it's possible with ultraviolet (UV) inks. Some people worry they're unsafe, but pioneer Richie Streate buys his from Chameleon Inks – found at Blacklightink.com – and reckons they're just fine. "Before they started being used for tatts on humans, Chameleon's inks had already been approved by the US Food And Drug Administration for widespread use on fish and other wildlife to track migration and feeding patterns," says Richie. "So most Americans have probably been harmlessly eating the stuff for years..." Chameleon inks don't contain potentially dangerous chemicals called phosphors, which are sometimes found in glow-in-the-dark products, and each molecule is encased in an acrylic compound called PMMA. The PMMA means

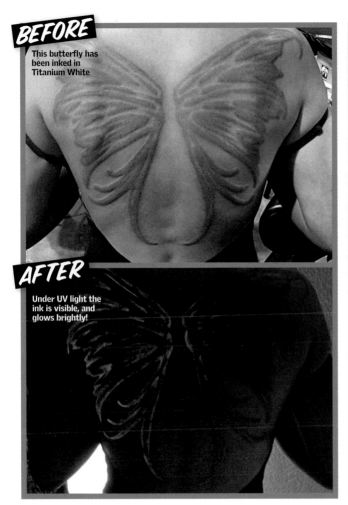

BEFORE
This butterfly has been inked in Titanium White

AFTER
Under UV light the ink is visible, and glows brightly!

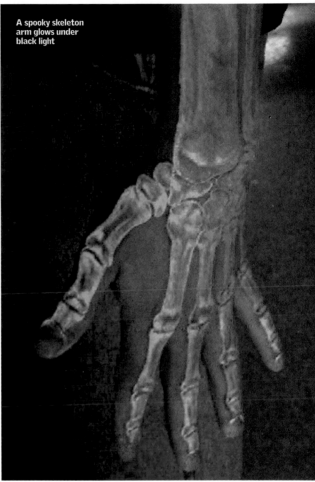

A spooky skeleton arm glows under black light

the inks don't dye the skin, but sit safely between cells. But beware any ink containing EverGlow – this is used to make photoluminescent products and wasn't designed for bodily use, so it could be dangerous.

You can have shading done in a UV tattoo but the inks are hard to blend, which is why they come in so many different hues. It's easier to use ready-prepared tints than mixing them on skin. All colours are visible under normal light except Titanium White, which is only visible when you shine a black light on it. Even if you have a completely white tattoo, you'll still be able to see scars where the needle has pierced the skin. "These scars usually fade within the first few months, although they can take over a year to completely disappear," says Richie. "As with all work, you'll get a better result if you look after the tattoo responsibly."

All colours are visible under normal light except Titanium White

Chris from Chameleon says the artist should slow the machine a little, use a bigger needle (a size 7 is good), and take their time. He also says it's important to remove as much of a stencil as possible before drawing with Titanium White. This is because Gentian Violet – the dye often used to transfer a design template onto a client's skin – can stain the skin for up to two weeks, and will be noticeable if the ink that usually covers it up is actually 'invisible'. Tatts magic! 🅱

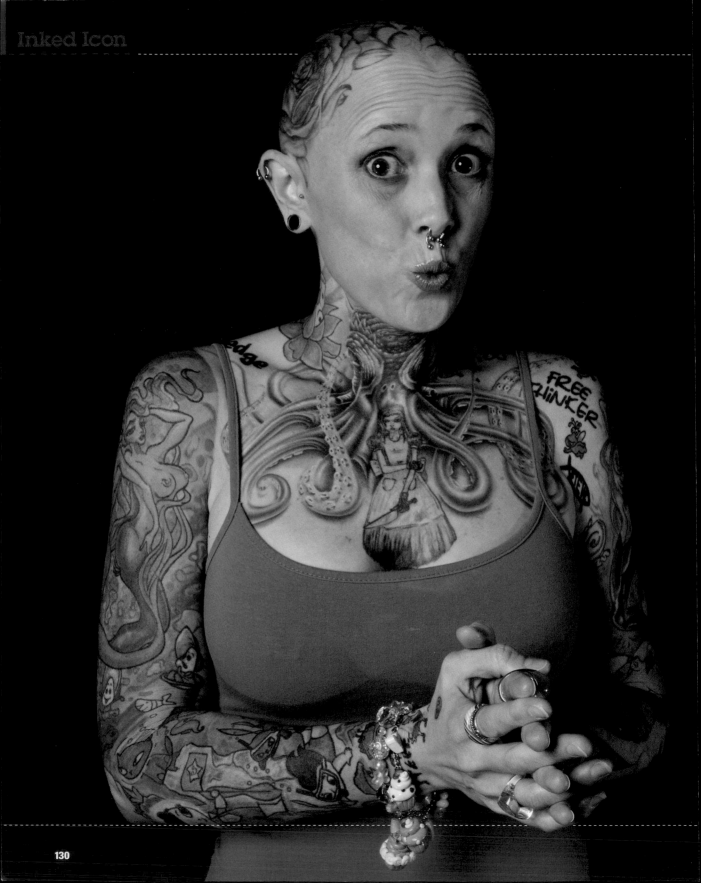

JINXI
Boo

Ever since her first tattoo, this
mum's been addicted to ink
– and freedom of expression

WORDS **DENISE STANBOROUGH** PHOTOS **MARIA ROSENAU**

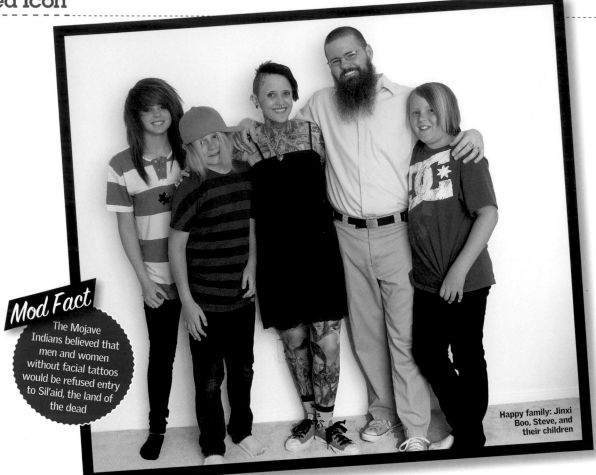

Mod Fact
The Mojave Indians believed that men and women without facial tattoos would be refused entry to Sil'aid, the land of the dead

Happy family: Jinxi Boo, Steve, and their children

JINXI BOO WAS 30 YEARS OLD WHEN she got her first tattoo. Eight years on, she's wasted no time in decorating her flesh with a black and white dairy cow to signify her dedication to veganism, right through to a sprawling octopus across her throat and chest. She's let two tattooists work on her scalp at the same time and, when she's not looking after her three children or being featured in countless tattoo magazines across the globe, she's exposing her bold skin etchings to horrified God-fearing folk on ABC's *Wife Swap*. It's all in a day's work for this California girl...

What was life like for you before your ink journey?
I lived in a conservative household. My parents were, and still are, Mormons, and my dad was a Mormon bishop. Mormons don't drink caffeine and aren't allowed to wear shorts; it's a strict religion. That was all I knew up until I turned 19 years old and left home to go to college.

What was your first exposure to tattoos?
I was at Disneyland aged 16 years old, and I remember seeing a girl with a Cheshire Cat tattoo on her back. I thought it was the dreamiest thing I'd ever seen. I think at that moment I fell in love with tattoos, and I knew I wanted to get one, but I was a little scared.

When did you first go under the needle?
My husband and I married young and he supported me and made it possible for me to explore outside my sheltered world, so I had my first tattoo aged 30. It was a little cherry on my ankle.

What was the inspiration behind it?
There wasn't one! I just thought it was cute. From that day, I became a regular collector. Tattoos haven't made me the person I am, but they've given me confidence.

In the nine years since your first tattoo, you've covered a fair bit of ground...
No kidding! I'm running out of room now. I have so many themes on my skin, but the colour portraits of →

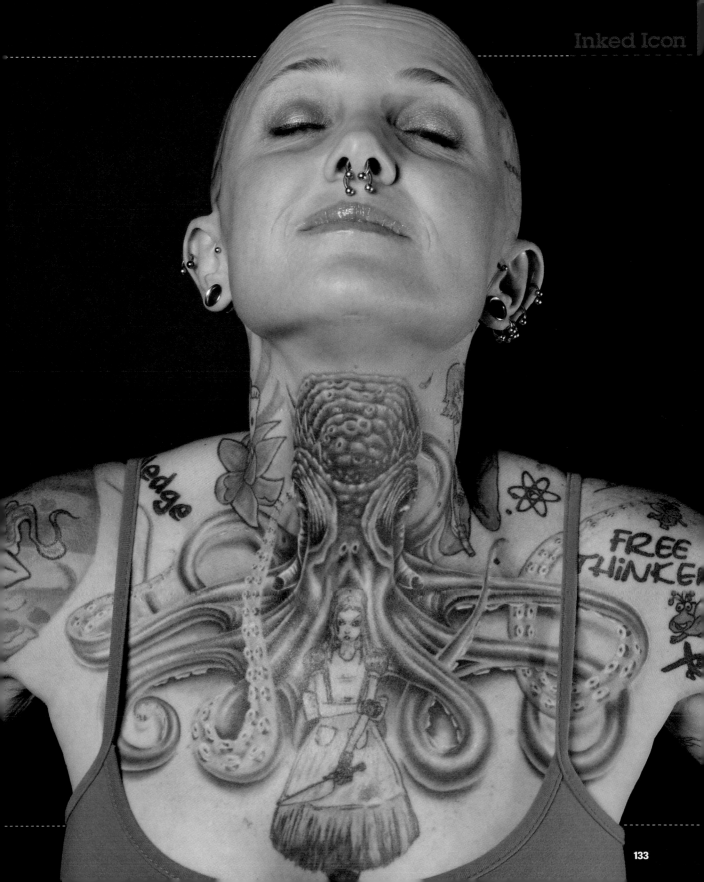

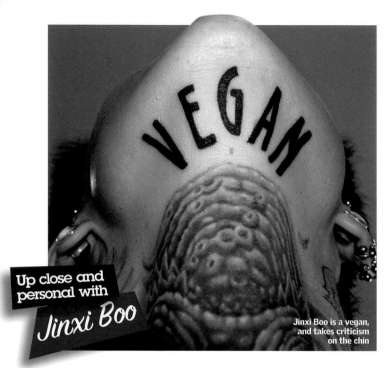

Up close and personal with *Jinxi Boo*

Jinxi Boo is a vegan, and takes criticism on the chin

Now 1980s fashion has been immortalised!

Family portraits are a little different in Jinxi Boo's home

my husband and children are most special to me. Not everything I have is meaningful. It's great that some people have tattoos for spiritual reasons, but I don't feel there needs to be a big story behind everything.

What do you think is your weirdest tattoo?
To me it's not weird, but people get confused about the cow. It has meaning for me because my husband and I are both vegans, and our kids are all vegetarian. She's safe there on my leg, so no one will ever eat her! I have plans to have a pig tattooed right above the cow. It'll be a vegan-themed leg.

Do your children ever ask you to get certain tattoos?
I often ask their opinions. It's difficult sometimes to have a mum stand out so much. But one cool thing is that they seem to appreciate people more for the person they are, rather than their appearance.

How do you deal with the attention?
One time, my husband Steve and I were at Disneyland, and a lady came right up to me and said, "You're grotesque." Isn't that lovely? I often get parents pulling their kids closer or saying loudly, "Oh my gosh, look at that!". It's normal when kids do it to their parents, because if they've never seen someone with tattoos then it's a new experience for them. But I think it's so awful when parents do it to kids, because they're

teaching their kids to judge somebody. I usually just smile. Sometimes that takes people aback.

Your octopus tattoo is striking. Where did the inspiration come from?
That one is probably the one I'm most well-known for. Initially, I just wanted the space on my neck and chest filled in. I chose a tattoo artist called Mike DeVries who's renowned for his amazing animal portraits. I thought an animal tattoo would be cool and was trying to find one that'd fit the area. I started reading about octopuses and they're such amazing creatures. They're intelligent, beautiful and I'd already been collecting octopus objects, so that's how I made my final decision.

What was it like having a tattoo over your chest and neck?
It was painful and took 26 hours to finish! The tattooist usually stretches the skin as the ink's going in, but it's difficult to do this on the throat because you'd choke the person. But it was nothing compared to my head – that takes the cake for the most painful experience! I had two tattoo artists inking either side of my scalp at the same time. I have a butterfly, a ladybird, a grasshopper and a bumble bee – it's like a garden.

You and your family appeared on the US version of *Wife Swap*. How did that go?

Mod Fact
When Johnny Depp broke up with Winona Ryder in 1993, he had his 'Winona Forever' tattoo changed to 'Wino Forever'

A cupcake, near Spongebob Squarepants

"Mooooo! No abattoir for me! I'm staying alive!"

Husband Steve bares his bushy beard with pride

The television company messaged me through MySpace and it was obvious they were looking for a tattooed mum. We were under the impression that the show would be focused on our appearance, but we ended up swapping with a family of fundamental Christians. We're atheists so that caused massive conflict between us.

When did you realise what you'd let yourself in for?
On the plane they wouldn't even tell me what state I was travelling to. I walked into the family's house and there was an African-American family holding out a bible. The lady who came to stay with my husband and children insisted on being called 'Big Momma'. Steve had some tattooed and gay friends come over during the show. The woman took Steve to one side after five minutes of meeting them and said, "Aren't you afraid that these people will molest your children?" It was crazy.

What did they think of your tattoos?
The husband told me I was going to hell and shouldn't be a mum. I'd have debates with this man on religion and he would mock me saying, "Oh, you're such a free thinker." So when I got home I arranged to have those words tattooed on my shoulder in time for filming the 'catch up' segment.

Did you get hate mail after the show aired?
We had thousands of positive emails, but poor Steve had a few nasty ones. During filming, Steve broke a house rule, so Big Momma ordered him to go to the local supermarket, stand on a soapbox and preach from the bible. After a while, Steve thought, "Fuck this" and started telling people there was no God. Then he threw the book in the bin. A few Christian organisations boycotted ABC after seeing the programme and a few people emailed us to say we needed to be 'saved'.

What other ink do you have planned for the future?
My daughter and I are really big fans of The Cure. I saw

> **"The colour portraits of my husband and children are the most special to me"**

them at my first concert aged 13 and then I took my daughter to see them too when she reached the same age 25 years later! The guitarist, Porl Thompson, is co-founder of an art company called Parched Art; they've done all the album covers for The Cure. Their logo is a fuzzy teacup, and I'm having that on my shoulder soon. Overall, I really want to have full coverage apart from my face, but I'll never say "never" as I'm running out of skin fast! **B**

BIZARRE'S
Ultra Vixen TATTOOS

Bizarre's fiestiest readers reveal their needlework for your eyes only

WORDS **DENISE STANBOROUGH**

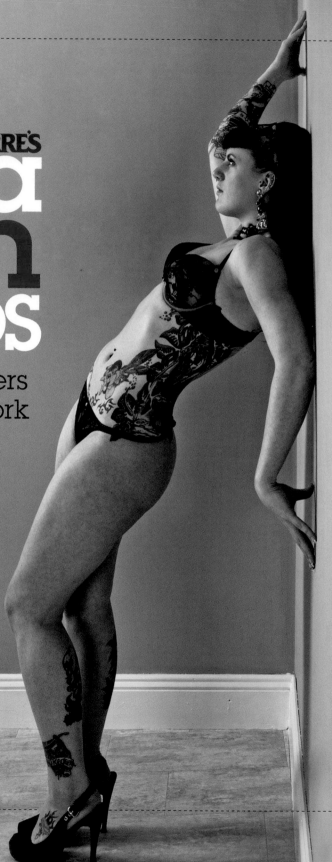

Suki
22, Waterford, Ireland

Tattoos by Samy, Swineline Tattoo, Waterford, Ireland
"I saw this design of a comicbook geisha surrounded by a *Lilo & Stitch* flower design, and knew I had to have it. People always ask me if it hurt, and I tell them it did! It's the most painful tattoo I've had done, but I've never regretted any of them because I think life's far too short. I plan to be well-covered – in fact, judging by the designs I've got, I'm already running out of space."

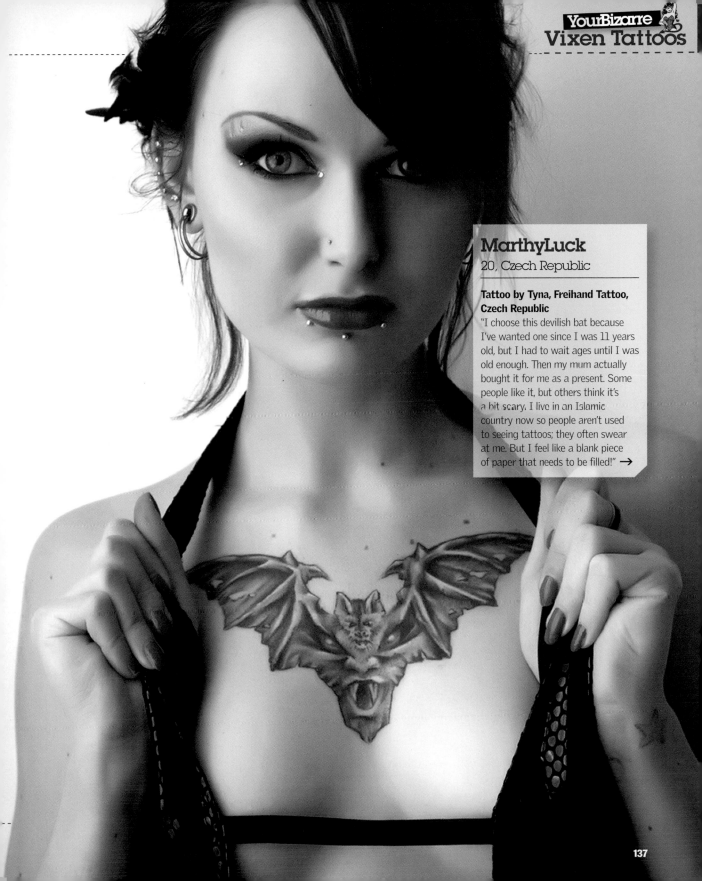

MarthyLuck
20, Czech Republic

Tattoo by Tyna, Freihand Tattoo, Czech Republic
"I choose this devilish bat because I've wanted one since I was 11 years old, but I had to wait ages until I was old enough. Then my mum actually bought it for me as a present. Some people like it, but others think it's a bit scary. I live in an Islamic country now so people aren't used to seeing tattoos; they often swear at me. But I feel like a blank piece of paper that needs to be filled!" →

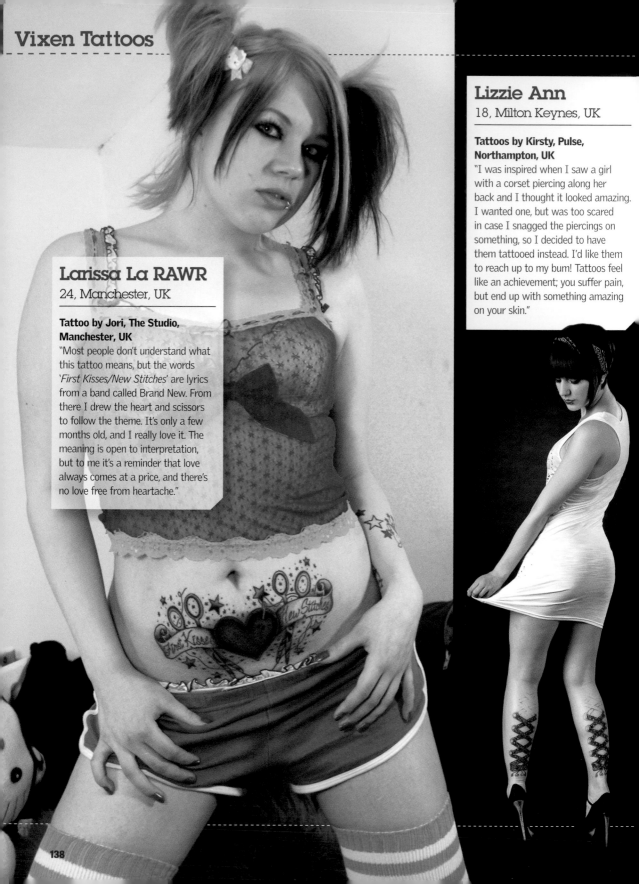

Larissa La RAWR
24, Manchester, UK

Tattoo by Jori, The Studio, Manchester, UK
"Most people don't understand what this tattoo means, but the words '*First Kisses/New Stitches*' are lyrics from a band called Brand New. From there I drew the heart and scissors to follow the theme. It's only a few months old, and I really love it. The meaning is open to interpretation, but to me it's a reminder that love always comes at a price, and there's no love free from heartache."

Lizzie Ann
18, Milton Keynes, UK

Tattoos by Kirsty, Pulse, Northampton, UK
"I was inspired when I saw a girl with a corset piercing along her back and I thought it looked amazing. I wanted one, but was too scared in case I snagged the piercings on something, so I decided to have them tattooed instead. I'd like them to reach up to my bum! Tattoos feel like an achievement; you suffer pain, but end up with something amazing on your skin."

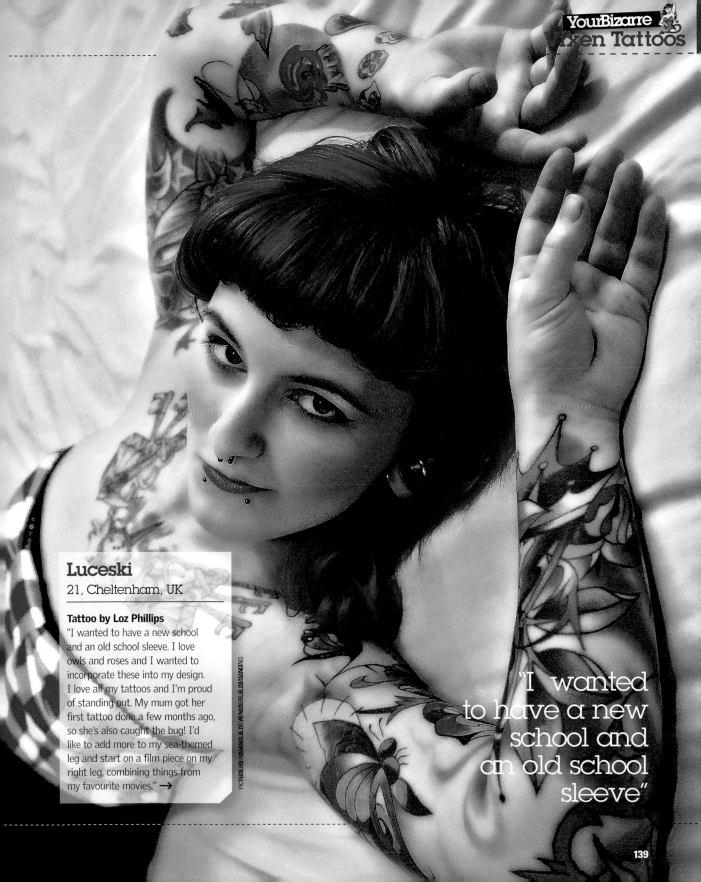

Luceski

21, Cheltenham, UK

Tattoo by Loz Phillips

"I wanted to have a new school and an old school sleeve. I love owls and roses and I wanted to incorporate these into my design. I love all my tattoos and I'm proud of standing out. My mum got her first tattoo done a few months ago, so she's also caught the bug! I'd like to add more to my sea-themed leg and start on a film piece on my right leg, combining things from my favourite movies." →

PICTURES: REBORN IMAGE/REBORN IMAGING

"I wanted to have a new school and an old school sleeve"

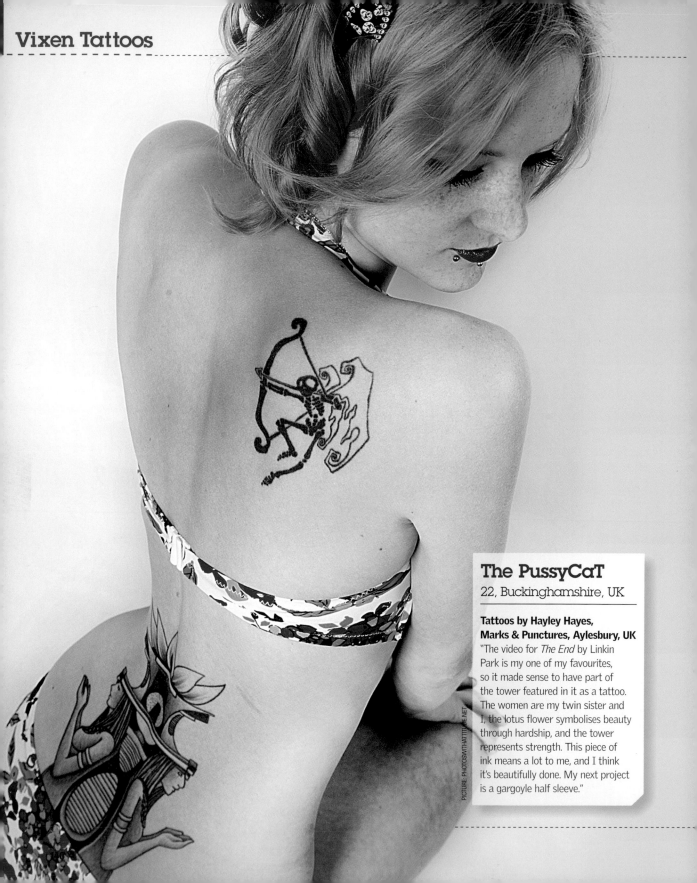

The PussyCaT
22, Buckinghamshire, UK

**Tattoos by Hayley Hayes,
Marks & Punctures, Aylesbury, UK**
"The video for *The End* by Linkin Park is my one of my favourites, so it made sense to have part of the tower featured in it as a tattoo. The women are my twin sister and I, the lotus flower symbolises beauty through hardship, and the tower represents strength. This piece of ink means a lot to me, and I think it's beautifully done. My next project is a gargoyle half sleeve."

PICTURE: PHOTOSWITHATTITUDE.NET

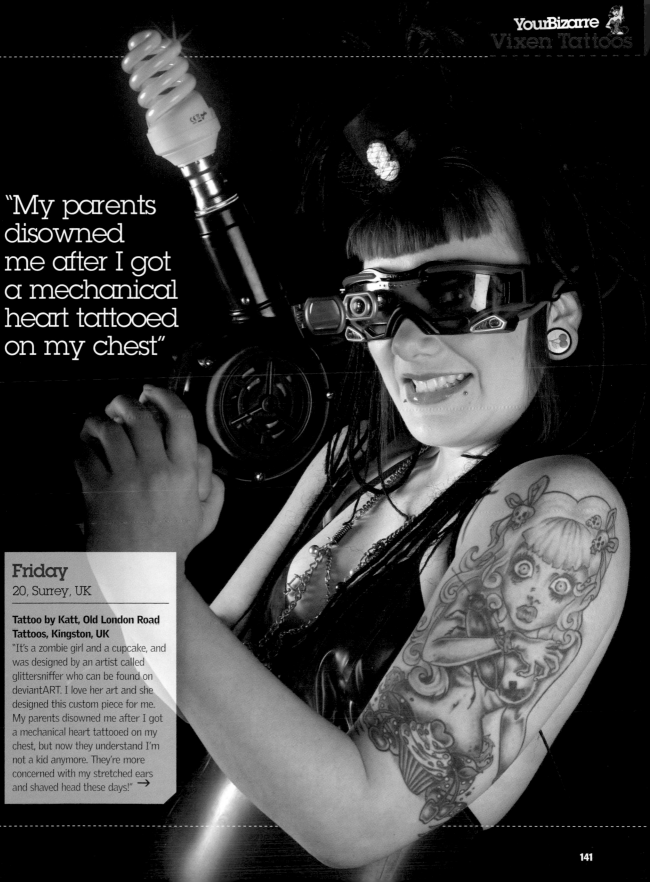

"My parents disowned me after I got a mechanical heart tattooed on my chest"

Friday
20, Surrey, UK

Tattoo by Katt, Old London Road Tattoos, Kingston, UK

"It's a zombie girl and a cupcake, and was designed by an artist called glittersniffer who can be found on deviantART. I love her art and she designed this custom piece for me. My parents disowned me after I got a mechanical heart tattooed on my chest, but now they understand I'm not a kid anymore. They're more concerned with my stretched ears and shaved head these days!" →

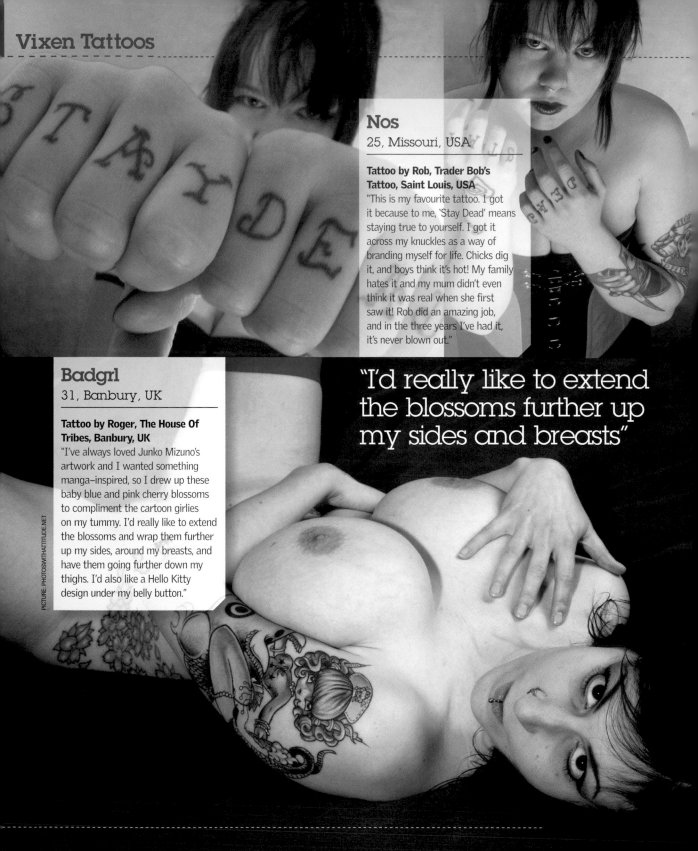

Nos

25, Missouri, USA

Tattoo by Rob, Trader Bob's Tattoo, Saint Louis, USA

"This is my favourite tattoo. I got it because to me, 'Stay Dead' means staying true to yourself. I got it across my knuckles as a way of branding myself for life. Chicks dig it, and boys think it's hot! My family hates it and my mum didn't even think it was real when she first saw it! Rob did an amazing job, and in the three years I've had it, it's never blown out."

Badgrl

31, Banbury, UK

Tattoo by Roger, The House Of Tribes, Banbury, UK

"I've always loved Junko Mizuno's artwork and I wanted something manga-inspired, so I drew up these baby blue and pink cherry blossoms to compliment the cartoon girlies on my tummy. I'd really like to extend the blossoms and wrap them further up my sides, around my breasts, and have them going further down my thighs. I'd also like a Hello Kitty design under my belly button."

PICTURE: PHOTOSWITHATTITUDE.NET

"I'd really like to extend the blossoms further up my sides and breasts"

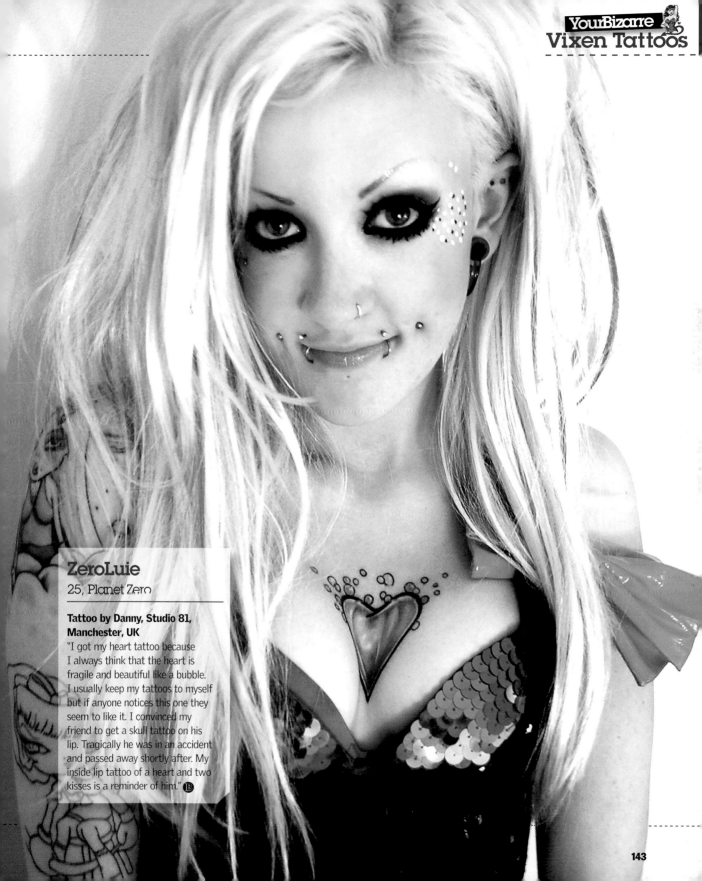

ZeroLuie
25, Planet Zero

Tattoo by Danny, Studio 81, Manchester, UK

"I got my heart tattoo because I always think that the heart is fragile and beautiful like a bubble. I usually keep my tattoos to myself but if anyone notices this one they seem to like it. I convinced my friend to get a skull tattoo on his lip. Tragically he was in an accident and passed away shortly after. My inside lip tattoo of a heart and two kisses is a reminder of him."

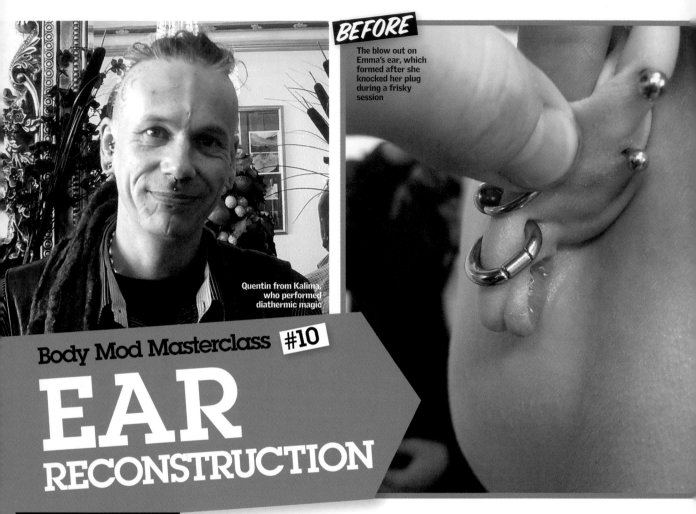

BEFORE

The blow out on Emma's ear, which formed after she knocked her plug during a frisky session

Quentin from Kalima, who performed diathermic magic

Body Mod Masterclass #10

EAR RECONSTRUCTION

Lobes can be fixed if they've been stretched too much

Many people have plugs or hollow flesh tunnels in their ears, but problems can occur when earlobes are stretched too quickly. To widen a hole in the ear you need to push on it constantly, which puts a lot of tension on the tissue. There's a chance some tissue will be forced out of the back of the lobe, and it'll look like an extra fold or lump of skin. This type of scarring is called a 'blow out'.

Most blow outs are painless, but some feel sore and tight, or continue to grow because they're irritated by jewellery or rubbing on the person's neck. Blow outs can be removed by using a scalpel, but Quentin from Kalima studio in Worthing, UK prefers to use a diathermic machine. It uses an electric current passed through a fine electrode to 'cut' skin away from the body.

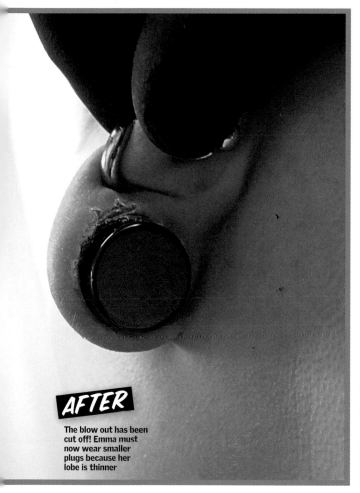

AFTER

The blow out has been cut off! Emma must now wear smaller plugs because her lobe is thinner

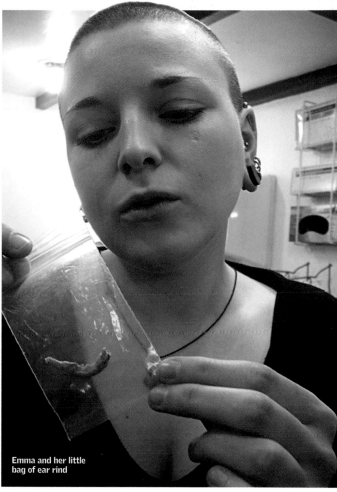

Emma and her little bag of ear rind

He performed this procedure on *Bizarre* writer Emma Mendes da Costa, who had a hefty blow out after stretching her holes from 22mm to 24mm. "Even though she'd been responsible and taken things slowly, she'd developed a bulge after knocking her left plug during a frisky session with her fella!" Quentin explains. "I advised her to take out the jewellery for a few days, so the hole would shrink back down to about 18mm. Sometimes, you can leave a plug in before a blow out removal, but in Emma's case I was worried the lump was so big there wouldn't be enough lobe left to support such heavy plugs."

The process took about three minutes. Quentin marked up Emma's ear, and then carefully ran the diathermic machine over the guideline a few times. He advised her to bathe her ear with saltwater and iodine to help keep the area dry, and to wear lighter plugs now her lobe is thinner.

Sometimes tissue is forced out of the back of the lobe, causing a 'blow out'

Emma's over the moon with the result. "It felt more like a tattoo than a burn as the electric current makes the diathermic pen vibrate," she says. "My boyfriend Adam said the electrode sparked like an arc welder, and my skin smelled like roast chicken! The bit of ear looks like bacon rind, and I've named it Owen. Adam wanted to eat it but I'm going to preserve it in vodka. For the first hour after being chopped off, the blow out behaved like living tissue, returning to its original shape if I squeezed it." **B**

PICTURES: EMMA MENDES DA COSTA; ADAM FUTCHER

BODY MOD GLOSSARY

WORDS **ALIX FOX**

Do you know your pocketing from your plugs? Test yourself and learn freaky new terms

AGITATION

The act of deliberately irritating a wound left by a fresh **branding**, **cutting** or other **scarification** process in order to make the resulting scar more raised, indented or coloured. Methods of agitation range from covering a wound with a bandage coated in petroleum jelly in order to stop scabs forming and extend healing time, to repeatedly removing scabs with wire wool or a toothbrush, to **ash rubbing** or **ink rubbing**. Care must be taken to keep wounds scrupulously clean as agitation can increase the risk of infection. See also: **hypertrophic scarring**.

APOTEMNOPHILIA

The erotic desire to become or look like an amputee, even if the body is healthy and an amputation is not medically required. In its strongest form, this can lead to a condition known as Body Integrity Identity Disorder (BIID), in which a person begins to detest their 'complete' body and believe they'd be happier and ironically more 'whole' with a limb, digit, or other part removed. Apotemnophiliacs sometimes undergo **nullification** to achieve their wishes.

ASH RUBBING

After **cutting** or **skin peeling**, ash can be rubbed into wounds as a form of **agitation**. This increases scarring and can also add colour, although usually in a patchy, non-uniform way that looks different from a tattoo. Ash rubbing sometimes holds emotional significance, for example if the cremated remains of a loved one are used, or it is performed as part of a tribal ritual.

BODY HACKTIVISM

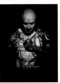

A term coined by leading body mod figure Lukas Zpira, 'body hacktivism' is a philosophical movement. It holds that ideas of self-awareness, ownership of one's own body, and evolution beyond apparent biological barriers can be explored via the advancement of body modification practices. As body hacktivism is a way of thinking, 'body hackers' don't necessarily have to be modded. The movement places great emphasis on pushing the science of modification forward by experimenting with new medical techniques and technology, and is influenced by manga culture, comics, science fiction films and literature. Contrast with the ancient influences of **modern primitives**.

BODY SUIT

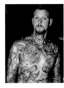

A tattoo that covers the torso or even the entire body, frequently using just one consistently themed design, e.g. inked icon The Enigma sports a head-to-toe body suit of blue jigsaw pieces. In some cultures body suits represent social standing, or mark an event such as marriage.

BLACKING OUT

Tattooing over an area of skin with black ink until it's a solid block of colour. This is sometimes done to cover up previous work. Decoration can be added on top of blacked-out skin by **cutting**, **branding** or **skin peeling** – resulting scars stand out as white or pink against the black, and can even be tattooed over again with a different colour.

BLACK WORK
Tattoos done in black ink only, often depicting tribal-style designs.

BLOW OUT

If a piercing is **stretched** too quickly or gets knocked, the pressure can force an extra 'lip' of flesh to squeeze out around one edge of the jewellery, called a blow out. These are common in people who increase the size of their **flesh tunnels** or **plugs** too swiftly or wear ones that are too heavy for their earlobes to bear. They can be solved by downsizing jewellery and allowing the body to reabsorb the blown out tissue. For a quicker fix or in bad cases, removal is possible via methods such as **diathermic cutting**. Blow outs are mostly painless, but sometimes they can feel unpleasantly tingly. They're not considered aesthetically pleasing.

BRANDING

A form of **scarification** in which the skin is marked by burning with heat or electricity. A small number of modders have also experimented with 'cold branding', which is created by dipping a metal tool into liquid nitrogen and freezing a design into the epidermis. See also: **diathermic branding**, **electrocautery branding** and **strike branding**.

CUTTING

A form of **scarification** in which the skin is marked by making incisions, usually with a surgical scalpel and to a depth of no more than 3mm. The skin is split but no tissue is removed – contrast with **skin peeling**. Cuttings can be **agitated** to affect how scars form.

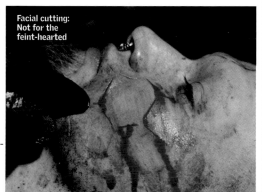

Facial cutting: Not for the feint-hearted

DERMAL PUNCH

A round 'cookie cutter' needle that removes a disc of skin.

DERMAL SEPARATOR

A small, blunt, spatula-type instrument that's inserted into an incision and used to lift up the skin layers to create a 'pocket' for jewellery or implants.

DIATHERMIC BRANDING

Diathermic machines are used to create **brands** by passing a high frequency current directly into the skin via a pen-type instrument. They can also be used to cut off small pieces of flesh such as **blow outs** by running the pen over the same area multiple times. The method is sometimes called Hyfrecator branding because it's used to cauterise wounds in hospitals, where the Hyfrecator is a popular brand of electrosurgical unit. 'Laser branding' is a misleading term that was coined by mod master Steve Haworth as a gimmick; no lasers are involved. Diathermy is considered one of the most superior forms of branding; because electricity rather than heat is passed into the skin, tissue damage does not 'spread' beyond where the pen touches the body, allowing for far more intricate designs than those possible with **strike** or **electrocautery branding**. It's also more comfortable for the artist, because the pen doesn't get hot in their hand.

EAR POINTING

The process where a wedge of tissue is cut from the top of the ear and the two edges are sewn together to produce a pointed, elfin look. →

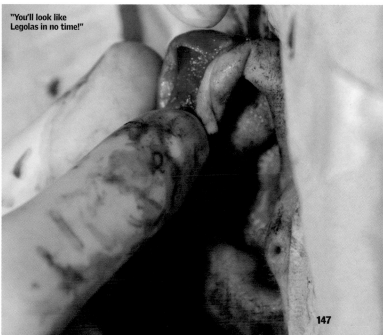

"You'll look like Legolas in no time!"

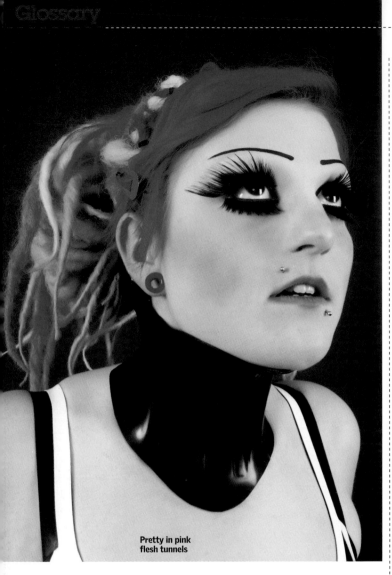

Pretty in pink flesh tunnels

ELECTROCAUTERY BRANDING

Electrocautery machines pass an electric current through a pen-shaped electrode to make it red hot. The electrode is then applied to skin to create a **brand**. This method is more accurate than **strike branding**, but still uses heat, which travels through the skin and damages tissues beyond the point of contact; this results in branded marks 'spreading' to become around three times their initial width, so details in designs can be lost. Such spreading does not occur with **diathermic branding**.

FLESH TUNNEL

Hollow tube-shaped jewellery worn in **stretched** piercings. Contrast with **plugs**.

GAUGE QUEEN

A derogatory or joke term for someone fixated with **stretching** their piercings, or who shows off their stretched holes in an effort to look cool.

HAND-POKED TATTOO

A tattoo created without the use of a modern electric gun. Instead, ink is inserted into the dermis by manually 'tapping' or 'poking' with a needle, sharpened stick, animal bone or clay disc. Hand-poked tattooing methods may be chosen for ritualistic reasons (see **modern primitives**), but are also favoured by some artists for facial tattooing as they're quieter and don't involve vibrating machinery, so can offer a more controlled experience in such a delicate area. Also known as: hand-tapped tattoo.

HYPERTROPHIC SCARRING

Heavy scarring that does not extend past the original site of a wound – contrast with **keloid scarring**. Hypertrophic scars can be desirable if they emerge after **branding**, **cutting** or **skin peeling**, and can be encouraged to form by **agitation**. They're less aesthetically pleasing if they form around piercing holes, where they take the form of shiny, pimple-like lumps. They should not be squeezed as there is no pus inside them, but they can sometimes be removed by taking out jewellery and/or applying treatments such as compresses, tea tree oil or steroids.

INK RUBBING

After **cutting** or **skin peeling**, ink can be rubbed into wounds to colour them. Absorption can be encouraged by 'holding in' the ink with a layer of petroleum jelly applied immediately afterwards. Results are unpredictable.

KELOID SCARRING

Fibrous, raised scars that extend far beyond the original site of the wound – contrast with **hypertrophic scarring**, which is far more common. The body's tendency to keloid is genetic, and darker-skinned people are more prone to it. Like **hypertrophic scars**, keloids can be the positive result of deliberate **scarification**, or an unfortunate by-product of piercing. Undesired keloids can itch, smell, or feel uncomfortable and, although steroid treatment is possible, they often have to be surgically removed.

METAL MOHAWK

Single or multiple rows of **transdermal implants** placed on the scalp in a mohawk style, as famously sported by body mod legend Samppa Von Cyborg (right). →

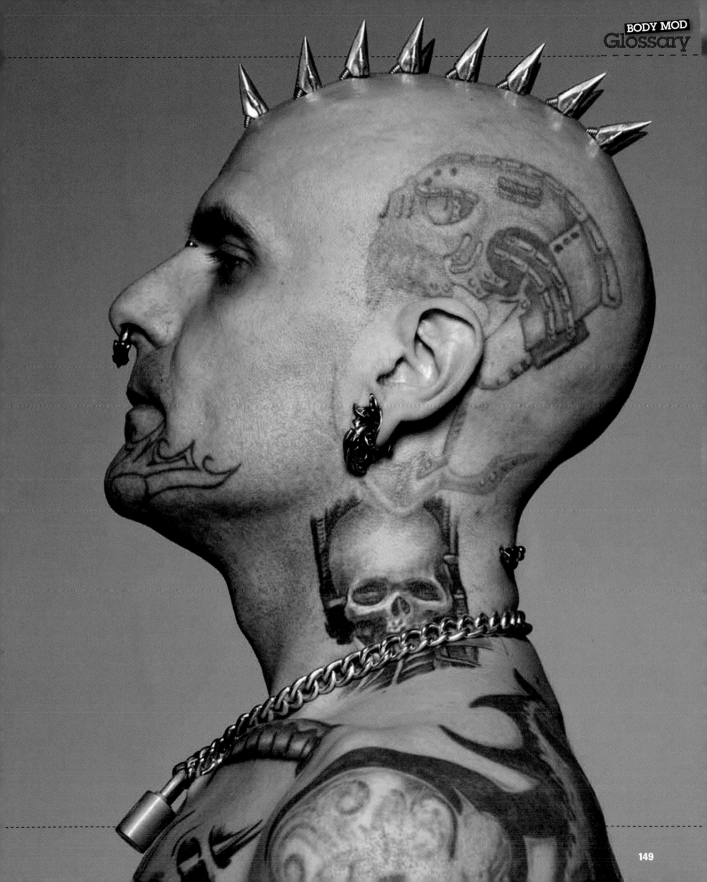

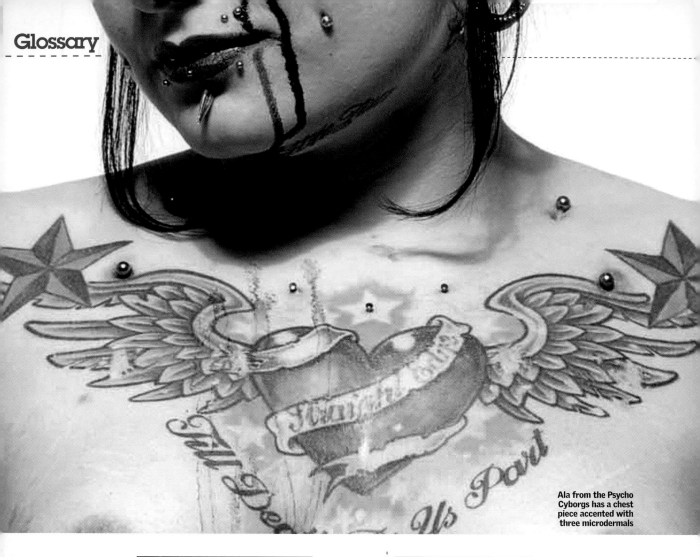

Ala from the Psycho Cyborgs has a chest piece accented with three microdermals

MICRODERMAL IMPLANT

A miniature form of **transdermal implant** which allows a decorative ball, gem or charm around 5mm in diameter to be screwed into a tiny base anchored beneath the skin. Because of their small size, the method of insertion for microdermals is much simpler than for transdermals; an incision is made using a needle or **dermal punch**, then the base of the jewellery itself is used to create a 'pocket' where it will sit beneath the skin. Microdermals have a low rate of **rejection**. Also know as: surface anchor.

MIGRATION

Movement of an implant or piercing caused by the body **rejecting** it. It's possible for mods to migrate some distance without fully rejecting; after initially pushing jewellery out, the body can eventually accept it, and the mod heals in a slightly different place to where it was originally inserted.

MODERN PRIMITIVE

Body modders who live in developed countries but look to ancient tribal rituals and 'primitive' practices as inspiration. Contrast with the futuristic thinking of **body hacktivism**.

NULLIFICATION

The voluntary amputation of a body part, e.g. a toe, finger, tooth, nipple, limb, penis (a penectomy) or testicles (castration). Nullification can be undertaken as an experiment (e.g. one modder had his nipples removed and cast in resin **plugs**), to correct a modification mistake (e.g. earlobes ruined by extreme **blow outs** or **thinning** can be removed), or because of **apotemnophilia** or a similar unusual body image.

PIERCING THINNING

If a piercing is **stretched** too fast or with heavy weights, or if the hole was originally made in a poor, off-centre location, tissue doesn't stretch evenly and weak 'thin' spots can develop. Sometimes these even break, and require reconstruction by scalpelling and/or stitching.

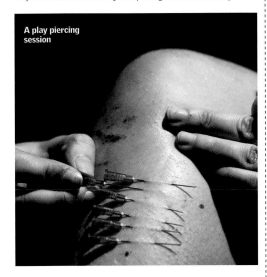

A play piercing session

PLAY PIERCING

Temporary piercings undertaken for sensory reasons, to induce the adrenaline rush that occurs when the skin is punctured, rather than to create a lasting modification. Play piercings are usually made with hypodermic needles, sometimes arranged in eye-catching patterns or laced together with ribbons, and can be used in performance, ritual, as part of BDSM games, or to help self-harmers break the cycle of cutting themselves.

PLUG
Solid disc or cylinder-shaped jewellery worn in **stretched** piercings. Contrast with **flesh tunnels**.

POCKETING

In a piercing, the middle of the jewellery is submerged within flesh and the two ends stick out either side as decoration. Pocketing is the opposite: the two ends of a curved bar are buried in the flesh in 'pockets' made with a **dermal separator**, and the middle of the bar sits on the skin surface. Pocketings often **reject** for the same reasons as **surface piercings**. Also known as: Anti-piercings.

REJECTION

What happens when the body decides that it does not like having a foreign object like a piercing or implant inside it, and 'rejects' it by pushing it out through the skin as it would a splinter, often leaving a scar. See also: **migration**.

SCARIFICATION

The deliberate creation of decorative **hypertrophic** or **keloid scars** via methods such as **cutting**, **skin peeling** or **branding**. Some modders have also experimented with using caustic chemicals to create scars, but this is very difficult to do in a safe, controlled manner and the resulting markings tend to be messy. →

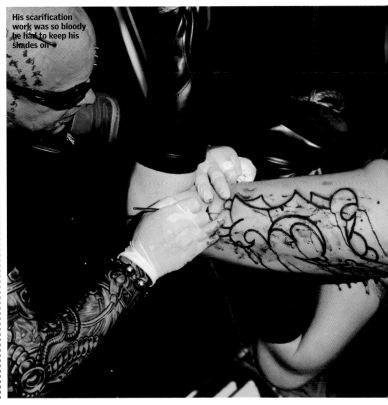

His scarification work was so bloody he had to keep his shades on

PICTURES: JOE PLIMMER; REGIS HERTRICH; BEA HILL

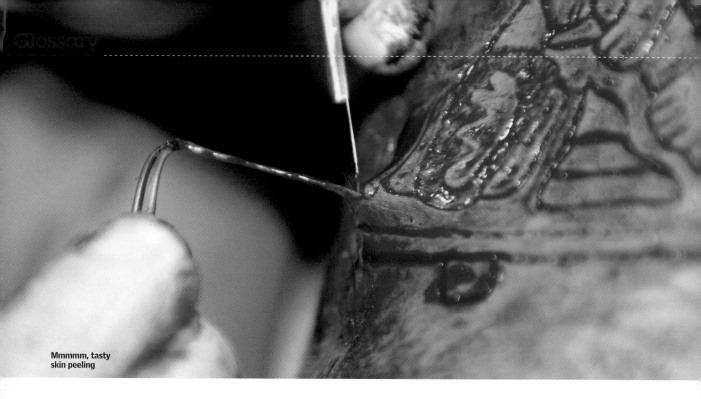

**Mmmmm, tasty
skin peeling**

SKIN PEELING

A form of **scarification**. The outlines of a design are cut into the flesh, and then the skin within the outlines is removed in small sections. To achieve this, each section is pinched up with a small clamp and pulled back, while a scalpel is used to slice underneath the skin so it peels away from the body. Contrast with **cutting**. Also known as: skin removal, skinning, tissue removal.

STRETCHING

Increasing the size of a piercing or implant by inserting increasingly larger or heavier jewellery. In addition, pierced holes can be stretched by pushing through a tapered rod, and earlobes can be stretched by taking out **plugs** or **flesh tunnels**, wrapping PTFE (Teflon) tape or bondage tape around them to increase their diameter, then reinserting. Stretching with weights is not recommended as it can cause **piercing thinning**. This can also happen if the skin is stretched too fast, which may also result in **blow outs**.

STRIKE BRANDING

The most basic form of **branding**, which involves heating a piece of metal and applying it to the skin. The metal may be a single line applied several times in different places to form a pattern, or it may be moulded into a shape that only needs to be applied once, e.g. a star. Because heat spreads through the skin and damages surrounding tissues as well as those touched by the metal directly, a line made by strike branding will spread to around four times its original size; marks made this way are thick and can look clumsy. **Diathermic branding** is recommended for intricate work.

SUBDERMAL IMPLANT

A 3-D implant placed entirely under the skin to create a decorative raised 'sculpture' on the surface. Examples include horns (right), beads, heart, ring and star shapes, and rows of short cylinders arranged to give a ribbed effect. Subdermal implants are largely made from silicone or PTFE (Teflon), although in theory any biocompatible material may be used; masters such as Steve Haworth are beginning to experiment with coral, which some modders speculate could be calcified and assimilated by the body, so over time the implant would become an organic feature made of bone with blood vessels growing though it. Subdermals are inserted by first making an incision in the skin, then poking a **dermal separator** into the cut horizontally to create a 'pocket' which the implant is slid into before the wound is sutured up. This method means that the incision can be made a significant distance away from the implant's final location, e.g. forehead implants can be pushed through tunnel-shaped pockets extending from entrance cuts hidden in the hairline, giving a neater finish with no visible scars. Subdermals can be **stretched** by re-opening incisions and switching to larger implants. →

PICTURES: REGIS HERTRICH; MARTIN DE POZO AND EDUARDO BAEZ ARIAS

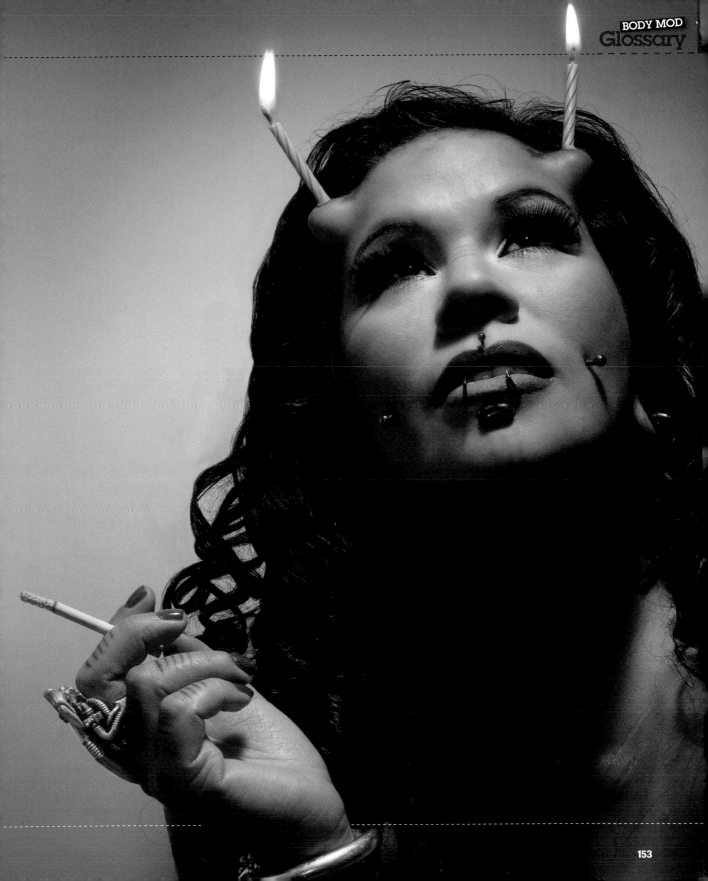

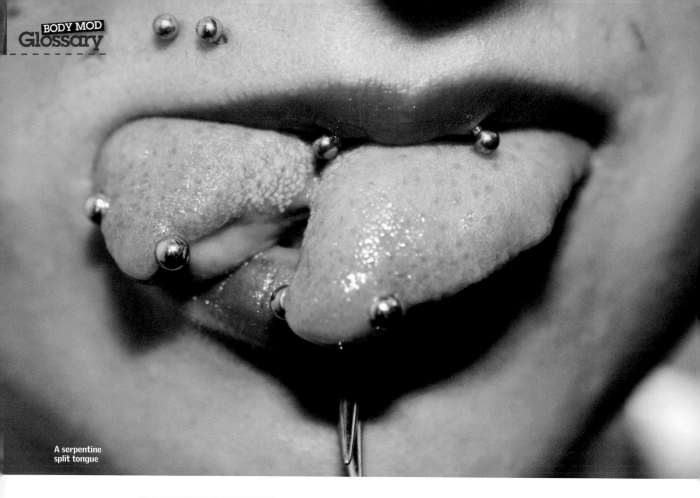

**A serpentine
split tongue**

SURFACE PIERCING

A piercing that passes through the surface of a flat area
of skin, so the entrance and exit holes are on the same
plane. Surface piercings are notoriously difficult to heal
and often reject, because the jewellery puts a great deal
of pressure on the tissue holding it in, and even more
stress occurs whenever the skin moves. Best results
are achieved by custom bending a metal bar to fit the
desired location on an individual's body.

TATTOO GUN SCARIFICATION

A form of **scarification** in which the skin is 'tattooed'
with an electric gun, but without using ink, so the needled
area heals to form a faint but accurate scar design.
Sometimes the machine tip is dipped in a mild abrasive
to rub off extra tissue. Also known as: etching.

TONGUE SPLITTING

The procedure by which the tongue is laterally split in half
up to the point where it joins to the base of the mouth,
giving a 'forked' effect. This may be done with a scalpel,
cautery tool, or laser. It's also possible to pass a loop of
thread through an existing tongue piercing and tie it so
tightly that it cuts the tongue in two over time, although
this is a dangerous and unreliable process. Modders often
learn to move both halves independently, and speech and
taste are not usually affected in the long term.

TRANSDERMAL IMPLANT

 An implant that's rooted within the
body but – unlike a fully-enclosed
subdermal implant – it has
a threaded section that sticks
through the skin surface, which
means decorative jewellery such as spikes or beads may
be screwed onto it. Transdermals are usually made from
metal such as titanium, and the flat base which anchors
them below the skin often has holes in it so that scar
tissue can grow through and help keep it in place. The
method of insertion is the same as for **subdermals**,
except an additional exit hole for the thread is made
using a scalpel or **dermal punch**. Transdermals carry
a high risk of infection, **rejection** or bad scarring.
See also: **metal mohawk**, **microdermal implant**. Ⓑ

PICTURES: REGIS HERTRICH

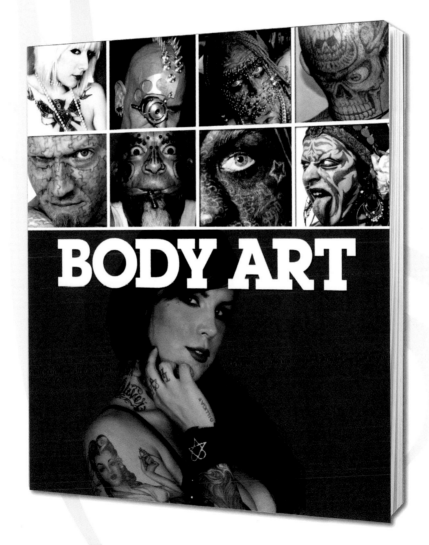

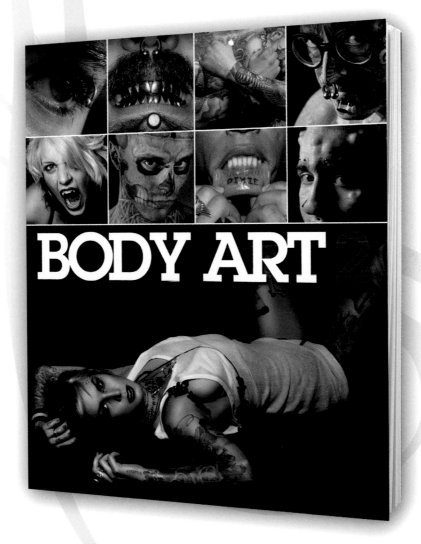

COMING SOON

FROM THE MAKERS OF

FETISH GODDESS
DITA